Victorian
Fairy Painting

Jeremy Maas

Pamela White Trimpe · Charlotte Gere

and others

Edited by Jane Martineau

Victorian Fairy Painting

Royal Academy of Arts · London

The University of Iowa Museum of Art · Iowa

The Art Gallery of Ontario · Toronto

in association with

Merrell Holberton
publishers london

First published on the
occasion of the exhibition 'Victorian Fairy Painting'
Royal Academy of Arts, London, 13 November 1997 – 8 February 1998
The University of Iowa Museum of Art, 28 February – 24 May 1998
The Art Gallery of Ontario, Toronto, 10 June – 13 September 1998

The Exhibition was organised by the Royal Academy of Arts, London
and the University of Iowa Museum of Art

The exhibition in London has been supported by Friends of the Royal Academy

The exhibition at Iowa has been supported in part by the National
Endowment for the Arts, United Airlines, and private individuals

Additional support has been received from United Airlines Worldwide Cargo

Exhibition Curators: Pamela White Trimpe, Charlotte Gere,
Jeremy Maas and Jane Martineau

Catalogue Editor: Jane Martineau

Exhibition Organiser: Sue Thompson

Exhibition Assistant: Harriet James

Photographic and Copyright Coordinator: Miranda Bennion

Editorial Coordinator: Sophie Lawrence

UIMA staff involved in the exhibition: Betty Breazale, David Dennis,
Jo Lavera Jones, James Lindell, Donald J. Martin, Estera Milman,
Victoria Rovine, Donna Shaler, Susan Spray, Emily J.G. Vermillion

The Royal Academy of Arts is grateful to
Her Majesty's Government for its help in agreeing to indemnify the
exhibition under the National Heritage Act 1980, and to the Museums and
Galleries Commission for their help in arranging this indemnity.

British Library Cataloguing-in-Publication Data
A catalogue record for this book is available from the British Library

ISBN: 0 900946 58 X (Royal Academy paperback)
ISBN: 1 85894 043 5 (hardback)

Produced by Merrell Holberton Publishers
Willcox House · 42 Southwark Street · London SE1 1UN
Printed in Italy

Cover illustrations
Front: J.A. Fitzgerald, *The Artist's Dream* (cat.36, detail)

Back (Royal Academy paperback): Richard Dadd, *Contradiction: Oberon
and Titania* (cat.26)

Back (UIMA paperback and hardback):
Daniel Maclise, *The Faun and the Fairies*
(cat.15)

The dedication (p. 8) reproduces in part the title-page from Richard Doyle,
The Doyle Fairy Book, London, Dean & Son, 1890

CONTENTS

ACKNOWLEDGEMENTS

—◆—

The Royal Academy is deeply grateful to the following people who contributed towards the costs of the catalogue in memory of Jeremy Maas:
Dr Judith Bronkhurst; Mrs B.M.L. Bullen; John L. Cook Esq; Mr and Mrs Robert Cottam; Mrs Paul Hobhouse; Lady Montagu Douglas Scott; The Hon. Peter and Mrs Strutt; Mrs Virginia Surtees.

The curators would like to thank the following people who in many different ways helped in the preparation of this exhibition and its catalogue:
Guy Acloque; Chris Beetles; Martin Beisly; Pam Bingham; Robin Braun; Martin Butlin; Susan Casteras; Barry Clarke; Michael Clarke; Elisabeth Etheridge; Camilla Gamble; Oliver Garnett; Cathy Gere; Charles Gere; Paul Goldman; Cathy Haill; Fiona Halpin; Robin Hamlyn; Sven Hansell; Jo Hedley; Emma Hicks; Imogen Loke; Mrs Cyril Luckham; Ralph Hyde; Rosemary Lomax-Simpson; Antonia Maas; Rupert Maas; David L. Mason; Mrs S. Masterman; Olivier Meslay; Peter Nahum; Daniel Parker; Ron Parkinson; Richard Schindler; Helen Smailes; Celia Stahr; Hugh Stevenson; Marilyn Stokstad; Julian Treuherz; Brett Van Hoesen; Sarah Warren; Andrew Wilton.

The curators also salute The Players' Theatre, where both Planché's and Blanchard's fairy pantomimes are periodically revived.

EDITORIAL NOTE

The artists in the catalogue are arranged by chronological order of birth (see list, p.155). The biographies and entries for cat.3 and 10 were written by Lionel Lambourne.

FOREWORD

'In an utilitarian age, of all other times, it is a matter of grave importance that fairy tales should be respected' (Charles Dickens, *Frauds on Fairies*). Fairies had always been a part of folk culture in Britain and Ireland and permeated the work of Spenser, Shakespeare and Milton, but from the late 18th century fairy painting flourished. It was not confined to one single style or to a particular group of artists but was embraced by painters as diverse as Turner and Dadd, Landseer and Rackham. In fact it touched all the arts – opera and ballet, literature and pantomime. Fairies and fairyland occupied a unique position in the workings of the collective Victorian imagination, and this exhibition and its catalogue attempt to give some explanation for the phenomenon.

The idea for the exhibition arrived at the Academy with Jackson Pollock's great painting, *Mural*, lent by The University of Iowa Museum of Art to the exhibition *American Art in the Twentieth Century* in 1993. It was accompanied by Pamela White Trimpe, and she was working on plans for an exhibition of fairy painting. The idea was hers, and we are very grateful to her for all the work and commitment she has given to the project. The collaboration between the UIMA and the Academy has been a particularly happy one for the staff of both institutions, and we are delighted that the show travels on to Toronto, where Alan Chong has been in charge of the project.

In the early stages of planning, the exhibition was championed by Lionel Lambourne and the late Jeremy Maas, to whose memory this catalogue is dedicated. These pioneers in the appreciation of Victorian art in all its manifestations gave tirelessly of their scholarship and enthusiasm throughout the long gestation of the exhibition: we are greatly indebted to them, and to Jeremy Maas's widow Antonia and to his son Rupert, as well as to Emma Hicks, who worked with Jeremy on his essay and wrote the artists' biographies. We thank all the contributors to the catalogue, in particular Charlotte Gere, who wrote much of it, and Jane Martineau, who edited it.

We greatly appreciate the generosity of all those lenders, both private individuals and public institutions, who so generously parted with their treasures for the duration of the exhibition: without them it would not have taken place. We are particularly appreciative of a grant from the US National Endowment for the Arts which permitted us to proceed with the initial planning of the exhibition.

For the London show we owe a great and special debt to the Friends of the Royal Academy, who responded to the Academy's appeal with overwhelming generosity and made this exhibition possible. This is the first time that the Friends have sponsored an exhibition, and many of those who contributed are listed at the back of the Royal Academy edition of the catalogue. In 1894 John Ruskin wrote: 'A man can't always do what he likes, but he can always fancy what he likes': in 1997 we trust that all our visitors will enjoy the fantasy of this exhibition.

SIR PHILIP DOWSON CBE
President, Royal Academy of Arts

STEPHEN PROKOPOFF
Director, The University of Iowa Museum of Art

DEDICATED
TO THE MEMORY OF
JEREMY MAAS
CHAMPION OF
VICTORIAN
ART

LENDERS TO THE EXHIBITION

———◆———

Bedford, Cecil Higgins Art Gallery

Andy and Susan Borowitz

Barbara Brill

Bristol Museums and Art Gallery

Mr and Mrs K.A. Carter

Edinburgh, National Gallery of Scotland

Mr and Mrs A. Essex

Glasgow Art Gallery and Museum

Glasgow School of Art

Hartford, Wadsworth Atheneum

Knebworth House Collection

Leeds Museums and Galleries
 (City Art Gallery)

Liverpool, National Museums and
 Galleries on Merseyside
 (Walker Art Gallery, Liverpool)

Lord Lloyd-Webber

London, British Museum

London, The Maas Gallery

London, Pollock's Toy Museum

London, Royal Academy of Arts

London, Tate Gallery

London, Victoria and Albert Museum
 (Bethnal Green Museum)

London, Victoria and Albert Museum
 (Theatre Museum)

London, Victoria and Albert Museum

Mrs Violet Luckham

Melbourne, National Gallery of Victoria

New Haven, Yale Center for British Art,
 Paul Mellon Fund

New York, The FORBES Magazine
 Collection

Oldham Art Gallery and Museum

Jimmy Page

Paris, Musée du Louvre, Département
 des Peintures

Caroline Parker

Princeton University Library, Cotsen
 Children's Library

Rhode Island School of Design and
 Museum of Art

Sheffield Art Galleries and Museums

Stratford-upon-Avon, Royal Shakespeare
 Company Collection

Vancouver Art Gallery

Mrs Nicolette Wernick

*and other owners who wish to remain
anonymous*

Fig.1 Richard Dadd painting *Contradiction* (cat.26) at Bethlem Hospital, London, *c.*1856, photograph, Bethlem Royal Hospital Archives and Museum

JEREMY MAAS

VICTORIAN FAIRY PAINTING

Of all the minor creatures of mythology, fairies are the most beautiful, the most numerous, the most memorable ...
(Andrew Lang, *Encyclopaedia Britannica*, 11th edition, 1910–11)

FAIRY painting, particularly when produced in its Golden Age, between 1840 and 1870, is a peculiarly British contribution to the development of Romanticism. Its influence was less pervasive than Pre-Raphaelitism, although it endured for longer and owed much of its technique to that movement, particularly in the work of Noël Paton, John Anster Fitzgerald, and to some extent Richard Dadd. Paton, as the French critic Ernest Chesneau remarked, 'gave just as much skilful manipulation and earnestness to the representation of Shakespeare's fairyland as other painters have bestowed on the world of reality'. Fairy pictures drew so close to the visible world that to go through and beyond its visible surface, like Alice through the looking-glass, seemed perfectly natural. Some of the disciplines of the Pre-Raphaelite and fairy painters were identical. Kate Perugini observed that '[Daniel] Maclise had the most acute and long eyesight that it is possible to possess, and could see so far and so minutely that my father [Charles Dickens] attributed many of the defects in his paintings to this too wonderful sight'. The same might have been said of the Pre-Raphaelite Holman Hunt or like-minded still-life painters, such as William Henry Hunt.

Yet fairy painting owes its origin fundamentally to a more mundane consideration than such obsessive, almost supernatural powers of observation: the perennial, insatiable Victorian appetite for subject-matter. Subject-matter was the very life-blood to the Victorian painter. It was not unknown for painters of the period, when approaching each other, to cross to the other side of the street, so as to avoid accidentally divulging the subject of their next painting. The world of legend and fancy provided a useful counterpoint to the crowded canvases of the genre subject-painters, such as William Powell Frith.

Many of the works of Richard and Charles Doyle and of Noël Paton are every bit as crowded as W.P. Frith's *Derby Day* (Tate Gallery, London) and *Railway Station* (Royal Holloway College, London) and equally teem with drama and emotion, essential components of the crowded canvas. It is, therefore, no surprise that several artists preoccupied with subject-matter, such as Millais and Landseer, should have departed from the norms that they set themselves in order to paint at least one notable fairy picture.

Fairy painting was close to the centre of the Victorian subconscious. No other type of painting concentrates so many of the opposing elements in the Victorian psyche: the desire to escape the drear hardships of daily existence; the stirrings of new attitudes towards sex, stifled by religious dogma; a passion for the unknown; psychological retreat from scientific discovery; the latent revulsion against the exactitude of the new invention of photography. The collision of such new elements with the securely held beliefs of former generations resulted in paintings which are peopled by creatures of the old mythology in fantastic settings, visualised in the obsessive reality demanded by the doctrine of 'truth to nature'.

From William Blake to J.M. Barrie, 19th-century British culture is threaded with allusions to the unseen and the occult. Foreign influences made an important contribution to this fascination. As early as 1823, *Kinder- und Hausmärchen* by the two German brothers Grimm were published in England under the title *German Popular Stories* and illustrated by Dickens's illustrator George Cruikshank: 'How', asked Thackeray, 'shall we enough praise the delightful German nursery tales, and Cruikshank's illustrations of them?' There were many later editions and selections from these vastly popular stories. Twenty-four years later the Danish writer Hans

Christian Andersen's *Fairy Tales* were translated by Mary Howitt, whose husband, the writer William, became a spiritualist in the same year. Andersen himself paid two visits to Britain in 1847 and 1857.

Although fairies make frequent appearances in British literature from as early as the 14th century, it was the works of Shakespeare which provided the first rich source of subject-matter, and one which attained added stimulus in 1789 with the foundation of Boydell's Shakespeare Gallery. Boydell commissioned numerous works from leading artists, notably Sir Joshua Reynolds and Henry Fuseli, and these were engraved for publication four years later. Compared with works by later fairy painters, Reynolds's highly popular *Puck* (private collection, England) of 1789 is very human and substantial. However, Fuseli's *Titania and Bottom* (1786–90; Tate Gallery, London) and *Titania's Awakening* (1785–90; Kunstmuseum, Winterthur; fig.2) take us into an erotic dreamworld, and are in their own way an entirely plausible evocation of an aspect of the fairy world. A rich vein was quarried from Spenser's *Fairie Queen* (1596) through to Pope's *Rape of the Lock* (1714) and beyond. Queen Mab ruled from Drayton's *Nimphidia* (1627) to Shelley's eponymous poem of 1813.

Fig.2 Henry Fuseli, *Titania's Awakening*, 1785–90, oil on canvas, 222.3 × 280.7 cm, Kunstmuseum, Winterthur

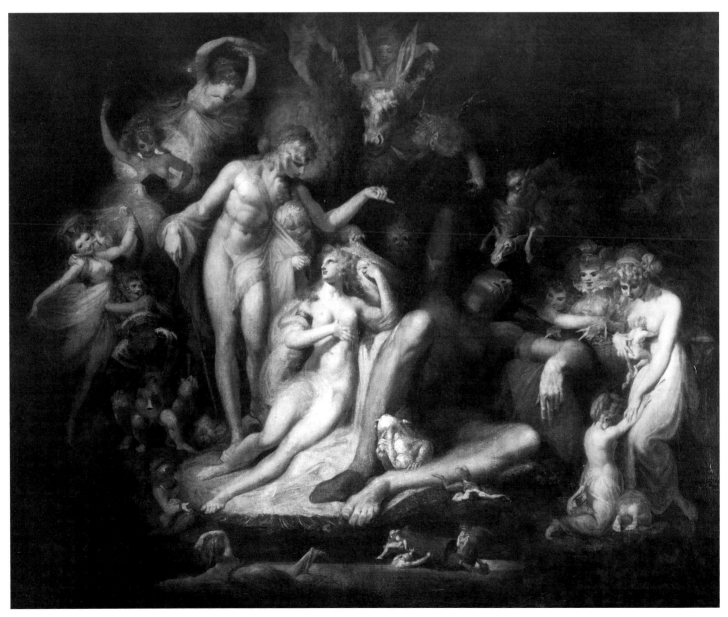

Literature provided the thematic material, but the visual impact of contemporary pantomime, theatre, ballet and opera was paramount. The early 1830s to the late 1840s in London saw the emergence of the Romantic ballet, a most influential source of imagery to the fairy painter. Romantic ballet was in itself a revolt against the stiff classical ballet's obsession with form. One of its main themes was the supernatural, in which a spirit forms a relationship with a mortal, with dramatic consequences. *La Sylphide*, named after its principal character, a spirit who does just this, was the model for a series of similar ballets, populated by nymphs, sylphs, dryads, wilis, piris, naiads and Undines. For now the ballerina became a vision draped in white, gliding gracefully across the stage in defiance of the laws of gravity. In response, artists were quick to imbue their pictures with a heightened ethereality and graceful movement. But the most striking innovation, pioneered in London by the great ballerina Marie Taglioni (1804–1884; see cat.3), who brought *La Sylphide* to London, was the development of point work from an athletic feat into a vehicle for artistic expression. The ability to skim effortlessly across the stage on the tips of one's toes noticeably affected the representation of human movement in pictures – it was an innovation no less revelatory than the publication in 1887 of photographs of *Animal Locomotion* by Eadweard Muybridge, which had a similarly dramatic effect on horse painting. The new possibilities in human movement are discernible, for example, in Richard Dadd's *'Come unto these Yellow Sands'* of 1846 (fig.6), in which all the figures in the foreground run on tiptoe; most of the figures to the left in Huskisson's version of the same subject (cat.29) stand on tiptoe as, many years later, do both the fairies in Atkinson Grimshaw's *Dame Autumn* of 1871 (private collection) and *Iris* of 1886 (cat.65).

For most of the early years of the 19th century, stage productions were often truly spectacular, owing much to the new gaslight, as well as startling stage effects and the splendour of the scenery. Ingenious devices abounded, holding audiences spell-bound. Colours of costumes, stage effects and scenery were rich, vibrant and sharply defined. As early as 1823 prancing steeds and cascades of real water were not uncommon. Some of the best fairy spectacles were provided by the libretti of J.R. Planché (see cat.53) and the elaborate scenery of William Beverley (1811?–1899). The more magic moments became known as 'transformation scenes'. All kinds of disasters from earthquakes to avalanches were enacted. Fairies suddenly materialised and vanished as quickly, until plots were almost submerged by the ever more elaborate stage machinery.

There were some particularly memorable productions, notably *A Midsummer Night's Dream*, staged by Charles Kean at the Princess's Theatre in 1856 (cat.10). The eight-year-old Ellen Terry played Puck, making her entry on a mechanical mushroom (fig.14). The production ran for 250 nights, doubtless due to some awesome stage effects, such as an expanding palm-tree in the fourth act, which rose gradually through the stage and when it had attained its fullest height rained down garlands of multi-coloured flowers and glittering fairies who performed a fantastic and graceful ballet, which was usually encored. In the following year, 1857, Kean put on an equally spectacular production of *The Tempest*, notable for the incredible scene changes and mechanical effects, to the accompaniment of ethereal music from an unseen choir. Ariel, played by Kate Terry (Ellen's elder sister), sailed on a dolphin's back and rode on a bat; Prospero's spirits were released and rode through the air. Pantomimes were even more colourful and exotic: they teemed with fairies, both good and bad, usually culminating in an apocalyptic ending, spiced with dazzling pyrotechnics. After 1850 many of these pantomimes were based on famous fairy stories, sometimes two or three combined.

The world of fairy in music was almost entirely German. Perhaps the most influential was Weber's opera *Oberon* (with a libretto by Planché, given its première in London in 1826). Strongly influenced by Weber was the young Wagner, whose first opera, written in 1834 (but not performed until 1888), was *Die Feen* (*The Fairies*). Mendelssohn wrote his celebrated overture to *A Midsummer Night's Dream* at the age of seventeen in 1826, adding the rest of the incidental music some seventeen years later. Literature, the stage and the world of music amply provided the subject-matter, the imagery and the climate for fairy paintings.

The advent of spiritualism was undoubtedly another stimulus. On 31 March 1848, in the town of Hydesville, New York, a family of three sisters named Fox were disturbed in their humble frame dwelling by strange manifestations. They posed questions to an unseen rapper and received apparently cogent answers. Thus was modern spiritualism born. These unusual occurrences in the Fox family received remarkable publicity throughout the

United States. The Fox sisters swiftly embarked on careers as mediums. Other mediums soon began to gain renown. In 1852 the first American medium of note arrived in England. The new interest became a craze and spread rapidly: ladies, from the highest to the lowest on the social scale, sent out invitations to 'tea and table-turning'. The Society for Psychical Research was founded, numbering among its members a bishop, dons and a Minister of the Crown. In August 1860 *The Cornhill Magazine*, edited by Thackeray, contained an article on spiritualism entitled 'Truth Stranger than Fiction', which caused a great commotion. In the following decade psychic literature abounded.

Spiritualism, though by itself hardly a decisive element, acted as a peculiar stimulus to Victorian painting, offering a common ground which the artist and his public could readily share. The early history of modern spiritualism coincided with the conception, expansion and revival of the Pre-Raphaelite manner. Many painters in the 1850s and 1860s found that they could draw nourishment not only from the spectacle of theatre and the subject-matter of literature, but also from the newly discovered passion for the supernatural and unseen.

Richard Dadd is often regarded as the quintessential fairy painter. In fact he painted less than a dozen true fairy pictures, of which two at least, *Contradiction: Oberon and Titania* and *The Fairy Feller's Master Stroke*, are masterpieces of the genre.

As a student Dadd had been a founder member of the artistic group known as 'The Clique'. His early paintings were unremarkable exercises in landscape, marine and animal painting. But by 1841 his choice of subject began to anticipate the astonishing pictures of his last period. In that year he exhibited at the Royal Academy his *Titania Sleeping* (cat.23). In 1842, he exhibited '*Come unto these Yellow Sands*', which draws on *The Tempest*. In the same year, encouraged by his friend the artist David Roberts, Dadd embarked on a journey to the Middle East with Sir Thomas Phillips. They travelled to Venice, Corfu, Greece and Baalbek and made their way up the Nile to Thebes. A letter to Frith was prophetic: 'At times the excitement of these scenes has been enough to turn the brains of an ordinary weak-minded person like myself, and often I have lain down at night with my imagination so full of wild vagaries that I have really and truly doubted my own sanity'.

On his return to London Dadd entered the competition for the decoration of the Palace of Westminster. His design, a St George, was rejected, partly on the grounds that the dragon's tail was of inordinate length. Shortly after he was taken by his father to the country on the advice of his doctor. While staying overnight at Cobham, Dadd stabbed his father to death, and then fled with all speed to France. He intended to murder the Emperor of Austria, but got no further than stabbing a passenger on a diligence at Fontainebleau before he was arrested.

On being brought back to England he was placed in the Hospital of St Mary of Bethlehem, known as Bethlem. After a rough start he was treated kindly and was given materials for painting and drawing. From then on his work attained a marvellous quality, but always characterised by a gentleness, which was, by all accounts, in accord with his character. Eleven drawings done in 1854, still in the possession of the Bethlem Royal Hospital, vary in quality and obsessiveness. In that year also Dadd began the first major work of his sadly unnatural maturity, *Contradiction: Oberon and Titania* (1854–8; cat.26; see fig.1). This extraordinary picture, with its congested detail and leaden colouring, is nevertheless a harmonious composition which takes its place among the great imaginative pictures of the Victorian age. But his greatest achievement was *The Fairy Feller's Master Stroke* (1855–64; cat.27), similar in colouring and intensity of observation to *Contradiction*. The picture took him nine years to complete, and even then was not entirely finished. It reminds one of a medieval tapestry with its quaint figures almost invisible to the naked eye.

Oberon and Titania were familiar figures to Joseph Noël Paton, whose handful of fairy pictures are charming adornments to the Victorian era. Born in Dunfermline, he was imbued with a wild Celtic imagination, and many of the subjects of his pictures were developed from Northern legend. *The Quarrel of Oberon and Titania* of 1846–7 and its companion *The Reconciliation of Oberon and Titania* of 1847 (cat.32, 33; see fig.3) are quintessential fairy pictures on the grandest scale, linking the Romantic world of Fuseli, Etty and Frost with the as yet unborn Pre-Raphaelite Brotherhood.

The sleeping figures are symptomatic of the Victorian fascination with the subconscious. Images of such slumbering figures occur frequently in paintings of Fuseli and Fitzgerald. Dreams indeed were 'one of the more unexplored regions of art', Fuseli declared. There is no

doubt that Paton's fairy pictures brought out the very best of his painterly qualities: they are rapt hallucinatory asides, while the greater part of his career was devoted to the painting of somewhat arid religious pictures.

Obsessive attention to naturalistic detail led many an unlikely artist into the imaginative intricacies of fairy painting, although one of the most striking of all fairy pictures – by Edwin Landseer – was the result of an unusual commission. In December 1847 the celebrated engineer Isambard Kingdom Brunel commissioned several artists to paint a set of Shakespearean subjects for his dining-room. These included Charles West Cope, Sir Augustus Wall Callcott, Augustus Egg, Thomas Creswick, C.R. Leslie, Daniel Maclise and Clarkson Stanfield. The

pictures, Brunel stipulated, should display the qualities of each painter's art 'and their peculiar style in which his prominence has been most universally acknowledged ... to produce as it were a characteristic picture of himself'. Landseer unerringly chose a ready-made anthropomorphic subject in *A Midsummer Night's Dream* (1848–51; cat.12). He placed Bottom in the centre of the picture, with Titania (the least successful element) clinging to his arm, and cavorting fairies mounted on white hares to the right. In the foreground stands a miniature Fuseli-esque figure. Somehow the picture seems closer in spirit to Mendelssohn's

Fig.3 John Ballantyne, *Joseph Noël Paton in his Studio*, 1867, oil on canvas, showing *The Fairy Raid* (cat.35) on his easel, Scottish National Portrait Gallery, Edinburgh

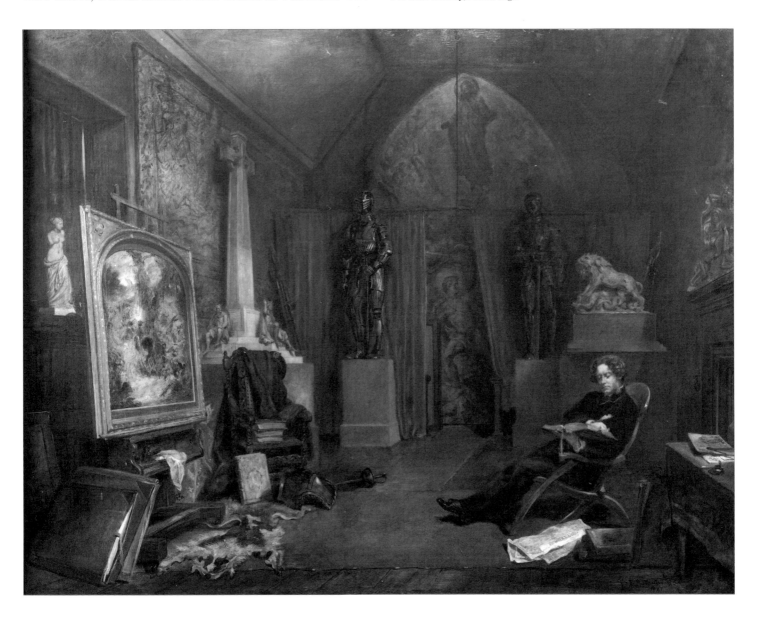

overture than to the highly populated extravaganzas of Noël Paton, yet the essence of Shakespeare's play is enchantingly captured.

It was *The Tempest* rather than *A Midsummer Night's Dream* that provided Sir John Everett Millais with the subject for his sole venture into fairyland. *Ferdinand Lured by Ariel* is an early work (1849; fig.33, p.62), for which his Pre-Raphaelite Brother, F.G. Stephens, posed as Ferdinand. To Millais's great disappointment the dealer who had commissioned the picture for £100 turned it down, expressing strong disapproval of the 'greenness of the fairies'. Millais did, however, resist the urge felt by most of his contemporaries to people the sumptuously painted naturalistic background with numerous fairies, benign or malevolent. Turner's solitary venture into the world of fairy, *Queen Mab's Cave* (1846; cat.2), looks at first sight like another of his visionary landscapes until one sees the fairies almost dissolving into the luminous haze by the cavern.

It is hardly surprising that the greater number of the most eminent fairy painters were either born in Ireland or were of Irish extraction. These include Francis Danby, two of whose watercolours illustrate *A Midsummer Night's Dream* (cat.6, 7). As one would suspect from his romantic temperament he painted several fantasy pictures, but his ventures into the fairy kingdom appear to have been limited to just three watercolours. Daniel Maclise, on the other hand, ventured more widely into fairy painting. Already imbued with an imagination susceptible to Celtic myth, he was particularly open to the influence of French and, above all, German art, especially in his book illustration and, later, in his fresco paintings, although it seems he did not visit Germany until 1859. The illustrations of Moritz Retzsch (1779–1857) were to have profound influence, providing Maclise with an entire repertory of symbolic imagery.

Like so many painters of the fairy genre, Maclise was fascinated by the theatre, and his pictures frequently resemble stage-sets. Although he painted several illustrations to Shakespeare's plays, he seems to have ignored the traditional *Midsummer Night's Dream* and *Tempest*; in his more celebrated fairy pictures he preferred German sources. *Undine and the Wood Demon* (1843; fig.38, p.66) is based on an episode in Chapter Nine of the novel *Undine* by the Romantic German writer Friedrich Heinrich Karl, Baron de la Motte Fouqué (1777–1843). The engraving of *Undine* in *The Art-Journal* of 1855, following

two similar engravings after Robert Huskisson in 1846 and 1847, attests to the popularity of the genre. Somehow Maclise's picture suggests an anticipation of a Wagner opera, with Siegfried, Brünnhilde and Fafner and a chorus of Rhinemaidens singing in the background.

One of the more prolific and consistently attractive of all the fairy painters was Richard Doyle. The *Dictionary of National Biography* eulogised him elegantly: 'He left behind him the memory of a singularly sweet and noble type of English gentleman, and of an artist of "most excellent fancy" – the kindliest of pictorial satirists, the most sportive and frolicsome of designers, the most graceful and sympathetic of limners of fairyland. In Oberon's Court he would at once have been appointed sergeant-painter'. Dickie Doyle was already an accomplished and popular illustrator before he made some of his first fairyland illustrations for *The Fairy Ring* of 1846, a new translation from the brothers Grimm. A rich vein of fantasy had coursed through all his previous work and was to culminate in his masterpiece, *In Fairyland*. This justly celebrated book, printed by Edmund Evans with a verse framework supplied by William Allingham, was published in 1870 (cat.54).

Here Doyle gave the fullest rein to his fancies. All the ingredients of fairyland are displayed on a sustained note of pure enchantment: elves, pixies, goblins, trolls, kobolds, wood-spirits, birds and butterflies. In one scene the fairy queen takes a drive through the air on a flimsy floral carriage, a twelve-in-hand, drawn by thoroughbred butterflies (Plate XIII). Dickie Doyle is never mawkish, and all his fantastic creatures are treated with a quirky glee and spritely sense of mischief. Like other fairy painters he loved the theatre and the ballet. As the catalogue of the 1983 Doyle exhibition at the Victoria and Albert Museum tells us, '… troupes of Bottoms and Ariels, Prosperos and Calibans as well as swirling companies of ballerinas fed his imagination…. Like Prospero in his *The Fairy Tree* [cat.56] he was the artist-wizard who could sweep his pen across the page and fill it with fantasies'. In moonlight scenes the gauze comes down casting a dreamlike spell.

Dickie Doyle was one of seven children, all of whom inherited talent from their father, the illustrator John Doyle (1797–1869). His brother Charles was no less talented, but his life was tragic. Although, like Dickie, a man of great charm, he was virtually banished to a boring, inadequately paid job as an assistant surveyor at the Scottish Office of

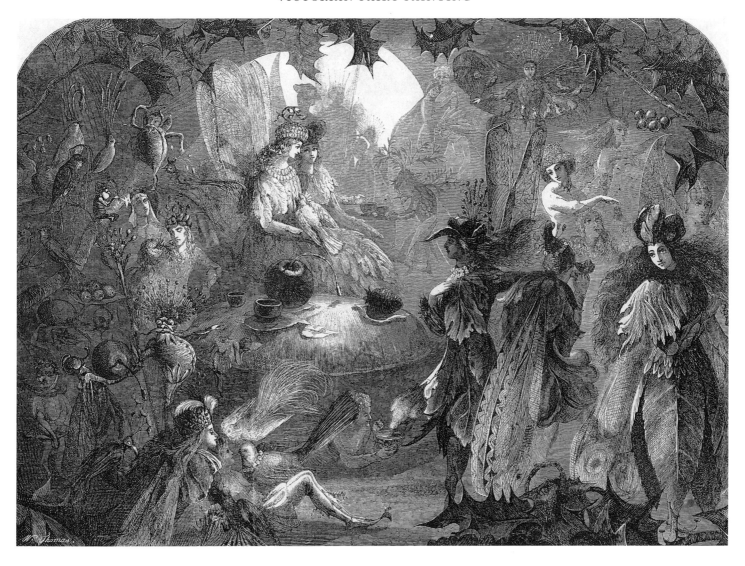

Fig.4 J.A. Fitzgerald, *Fairyland*, engraved by W. Thomas, *The Illustrated London News*, 21 December 1867, p.688

Works in Edinburgh, where, unable to cope with the ever increasing demands of a large family, he took to drink and then refuge in a lunatic asylum called (by him) 'Sunnyside'. Here he lived out a fantasy world in his sketchbooks, producing watercolours (cat.61, 62) often no less populated than his brother's, but possessing a sometimes disturbing hallucinatory quality. His was a world of fantasy rather than fairy. The Victorian obsession with the paranormal was inherited by his son the writer Arthur Conan Doyle, who became a champion of spiritualism.

'"Fairy Fitzgerald"… was an artist who will probably be more appreciated in time to come than he is in his own lifetime', wrote Aaron Watson in *The Savage Club* (1907). As more and more of his pictures have come to light, so his reputation has increased by leaps and bounds. The earliest fairy pictures from Reynolds to Blake and Fuseli illustrate

the written word of Shakespeare, with little suggestion of the theatre. Indeed most early fairy pictures are based on literary sources. John Anster Fitzgerald broke loose from the literary source and deliberately eschewed the perennial favourites of fairy painters, *A Midsummer Night's Dream* and *The Tempest*. Instead, he took his subjects from folk tales or from his own fertile imagination and plunges us into the front row of the stalls to revel in the sheer spectacle of the stage. Though it is not immediately apparent, this source of inspiration is detectible. The scenes he painted, although usually intended to have a nocturnal environment, are always brilliantly lit, an effect clearly inspired by gaslight or by the relatively new-fangled limelight, believed

to have been first used on the English stage in 1826. A section of a playbill advertising the Royal Surrey Theatre's programme for a week in November 1837 contains a revealing announcement: it promised the use of a light of such intensity as to produce distinct shadows in the brightest sunshine; '… it will also illuminate objects 10 miles off …. One of the great advantages of this light in its application to the Arts is the peculiar property of exhibiting all shades of color with a faithfulness unattainable by ordinary Artificial Light; many colors, as is well known, being either changed or destroyed after Sunset – a circumstance immensely regretted by all Artists'. Worked by a skilled operator, limelight was very adaptable: it could illuminate the centre stage, or be used as a spotlight to illuminate a limited area, or, presumably by varying the intensities of more than one limelight, produce variations of stage illumination. By the 1850s limelight was in general use, particularly in pantomime. The ability of limelight to imitate bright sunlight in surrounding areas of comparative gloom is particularly noticeable in Fitzgerald's *The Stuff that Dreams are Made Of* (cat.37, 38, 39). In short, he exploited a new source of light denied to earlier painters, its intensity adding resonance to his brilliant, almost garish, palette. Fitzgerald contributed drawings to special numbers of *The Illustrated London News* in the 1850s and 1860s, all based on scenes from pantomimes, some of them double-page spreads (fig.4). His creations are pure magic. The first great era of British pantomime, from 1840 to 1870, coincided exactly with the golden age of fairy painting.

Fitzgerald's fairy paintings, at their best, present us with a world of vivid yet harmonious colours. They are inhabited by beautiful fairies with translucent wings and diaphanous garments, wood sprites with glittering hair, goblins with fantastic heads, sleeping, walking, dreaming, or tormenting mice or birds. Deep in sunless forest glades or bathed in moonlight, they are framed by honeysuckle, cowslips and Morning Glory, 'nodding violets', 'sweet musk-roses' and 'wild thyme', entwined with writhing branches. Any eroticism is discreetly veiled and transmuted into suggestions of love and marriage.

The fantastic shapes of some of Fitzgerald's elves and goblins and other beings of unearthly provenance suggest a familiarity with the paintings of earlier masters such as Pieter Bruegel the Elder and Hieronymus Bosch. (Both Bosch and Fitzgerald delight in the violation of birds' eggs by fantastic creatures.) As we scarcely know anything about Fitzgerald's travels, if any, we do not know if he was familiar with pictures by Bosch in the Prado, or in museums in The Netherlands and Austria. However, Bosch was known to English collectors, and engravings of his work circulated. Fitzgerald needed only to have seen one typically fantastic picture by Bosch to have absorbed the influence. On the other hand, his imagination was fertile enough to have created his own fantastic creatures.

At his club, The Savage, Fitzgerald was known for his impersonations of long-dead actors such as Kemble, Kean and Macready, all in a rich Irish brogue which, in view of his English upbringing, had probably been assumed for its entertainment value. Harry Furniss recollected him affectionately in *My Bohemian Days* (1919). 'He was a picturesque old chap, imbued … with the traditions of the transpontine drama [i.e. that of the Old Vic] …. He had a mobile face, a twinkling eye, and his hair was long, thick and thrown back from his face …. He was known as "Fairy Fitzgerald" from the fact that his work, both colour and black-and-white, was devoted to fairy scenes, in fact his life was one long Midsummer Night's Dream'.

Details of Fitzgerald's origin and family are known, although they shed little light on his highly individual work as an artist. His grandfather and namesake, John Anster Fitzgerald, was Irish, but married in London and became a colonel of an Irish regiment in the Dutch army. His son William, John Anster's father, was a versifier, earning a mocking tribute from Byron in the opening lines of *English Bards and Scots Reviewers*: 'Let hoarse Fitzgerald bawl his creaking couplets in a tavern hall'. William married Maria Howarth in about 1820, when he was about sixty, and fathered six children in quick succession, John Anster being the third. Apart from his membership of the Maddox Street Sketching Club and the list of his exhibited works, little is known of John Anster's life. He exhibited a total of 196 pictures at the Royal Academy, the British Institution and Suffolk Street and seems to have made a living painting portraits, a few Etty-like nudes and some illustrations. He was eligible eventually for a Royal Academy pension. His fairy paintings of the 1850s and 1860s are his sole claim to immortality. Fitzgerald's pictures present a soft target for those who are looking for erotic symbolism, but even less covert is the suggestion of opium influence in his series of dream pictures.

Opium dreams tended to intensify colours: reds became

redder, darkening to maroons and blood crimsons; blue blackened to the colour of night sky; yellows became yellower and more luminescent. With sleep came fantastic dreams, with violently enhanced, even orgasmic imagery. Opium offered a veritable paradise of kaleidoscopic sensation, colours being felt as much as seen – almost a description of fairy painting, those by Fitzgerald in particular. In 1862 an American physician, D.W. Cheever, wrote in *The North American Review* that in an opium dream 'the senses convey a false impression to the brain; all that is seen, heard or felt is faithfully delineated, but the imagination clothes each object in its own fanciful garb. It exaggerates, it multiplies, it colours, it gives fantastic shapes'

The most obviously opium-inspired of Fitzgerald's paintings is *The Pipe Dream* (fig.5), a term which owes its origin to opium-smoking. Five more paintings deal with dream states; in *The Artist's Dream* (1857; cat.36), the artist himself is shown asleep in front of an easel on which there is a painting of a fairy figure. In his dream he sees the figure turn her head as if she were a living being. The evil influence of opium is not merely suggested, it is clearly indicated in the malicious goblins offering him drinks. Perhaps the goblin over his head is putting magic dust or ointment in his eyes.

The three pictures of sleeping women haunted by dreams (cat.37, 38, 39) indicate an advancing thraldom,

Fig.5 J.A. Fitzgerald, *The Pipe Dream*, c.1870, oil on canvas, 25.4 × 30.5 cm, Private Collection

with a suggestion – only a suggestion – in the final version of retreat from a too terrifying abyss. Malicious goblins dance attendance on the unfortunate dreamer, as they offer trays of steaming hot punches and honeyed beverages of the opium derivative, laudanum. The probable earliest of the three is by far the most sinister: here Fitzgerald drops his guard. He has followed a favourite Victorian practice in making this the sketchiest of the series, and by progressing from the overt to the covert as finish is achieved. The procedure is strikingly exemplified in Holman Hunt's *Claudio and Isabella* (Fitzwilliam Museum, Cambridge, and Tate Gallery, London) in which between the earlier sketch and finished picture a hint of incest is transmuted into bland piety. These modifications are analogous to the adaptations by the brothers Grimm of their *German Popular Stories*, purged between 1812 and 1857 of imagery unacceptable to the sanctimonious public.

In what seems the earliest of the three *Dream* paintings the symbolism is too obvious to be overlooked: the full moon suggests both women's monthly cycle (frequently alleviated with laudanum) and a time of supernatural manifestations. The dreamer, in Turkish costume, lies sprawled and writhing in anguish; on her bedside table are two medicine bottles. The wreath she is wearing has fallen on to the pillow, suggesting cruelly dashed expectations; her brilliantly coloured silk sash has fallen on to the bed with the fringe reaching to the floor, like a wound dripping blood. A goblin band, barely indicated in thin paint, plays by the bed, while others proffer red and yellow drinks, matching the liquid in the medicine bottles. The progression from painkiller to poison is vividly conveyed. It is chillingly mirrored in the description by Oswald Doughty in his biography of D.G. Rossetti of Elizabeth Siddal's death from an overdose of laudanum in 1862: 'Returning at half past eleven, Rossetti, on entering his wife's room found her lying in bed unconscious and breathing heavily. The room reeked of laudanum and on the small table by her bedside stood an empty Laudanum phial She lay as if sleeping save for her cold pallid face and strangled breathing'.

From Fitzgerald's two later and more finished *Dream* paintings the incriminating medicine bottles have disappeared, although goblins still advance with trays of drinks. A new model has been chosen for the sleeping girl; she wears the embroidered Turkish jacket but the sash has gone and the trousers have changed into a skirt. She is so

deeply unconscious that she is oblivious to the din of the drums and trumpets. In the second version the full moon still features, but in the third waving goblin hands have altered it into a round and faintly smiling face, changing it from lunar symbolism into a fairy-story emblem.

As mentioned above, several artists better known as painters of genre or landscape painted, in deference to prevailing fashion, the occasional fairy painting. These included John George Naish, Edward Hopley, John Atkinson Grimshaw and Thomas Heatherley, but two artists stood out from the others: Robert Huskisson and John Simmons.

Robert Huskisson was a gentle, lyrical artist whose fairy paintings can be numbered on the fingers of one hand, while those of his entire surviving oeuvre can scarcely span a pair. Like Doyle and Fitzgerald he found his main source of inspiration and composition in the theatre. However, he added an original contribution: both his finest finished pictures, 'Come unto these Yellow Sands' (1846; cat.29) and The Midsummer Night's Fairies (1847; cat.28) are contained in a beautifully painted proscenium arch, decorated with classical figures. The proscenium arch was a structural feature of almost every theatre built in Britain from the 17th century to the 19th and was often of very elaborate design, just as a picture frame might be. Benjamin Wyatt, who designed the new Drury Lane Theatre of 1811, was insistent that the proscenium arch, however decorated, would not distract attention from the stage any more than the contemplation of a picture would be 'diverted … from the richness of the Picture-frame'. That the two could be mutually complementary is borne out by the success of Huskisson's two pictures. It should be noted, however, that the proscenium arch had already been employed as a pictorial device, with exuberance, if less subtlety, in the fantasy picture The Cave of Spleen (August Laube Collection, Zurich) by the London-born Theodore von Holst,[1] who had died two years before the first of Huskisson's fairy pictures was painted.

In The Midsummer Night's Fairies, the sleeping nude Titania assumes the appearance of a fairy odalisque, garlanded with fronds of honeysuckle and guarded by diaphanous attendants, while Oberon stands over her and a snail fights with its horns miniature assailants who are denying it access to a pearl of dew. The wonderfully poetic composition owes much to Etty and to such pictures by William Frost (1810–1877) as Sabrina (private collection)

of 1845. Although he never painted fairies, Frost's nereids and wood nymphs were of crucial importance to the development of the fairy genre. The theatrical origins of Huskisson's picture are suggested by the spotlighting of Titania and her attendants and to a lesser extent by the right foreground. 'Come unto these Yellow Sands' is contained in an even more elaborate proscenium arch and is perhaps one of the most enchanting of all fairy pictures. Huskisson, who had moved to London from his native Nottingham in 1839, must have seen Dadd's own version of the subject (fig.6), which was exhibited at the Royal Academy in 1842 and was the last picture Dadd exhibited before he went mad. Somehow it is strangely disturbing. Dadd's sprites look like tormented souls being herded into a bath-house. Huskisson, on the other hand, matches Shakespeare's poetry with an exquisite lyricism of his own, with sea-nymphs holding hands and dancing in the early evening air, while a group of white marble-limbed nymphs luxuriate and cavort against a darkening sky. Rarely can the shades of twilight blue have been so delicately rendered. Even the lapidary figures at the base of the proscenium arch are in perfect harmony with the scene above. Both Huskisson's pictures were bought by his oleaginous patron Samuel Carter Hall, editor of The Art Union, later Art-Journal, and were engraved in it. A third, The Mother's Blessing, a delightful design with miniature nude fairies disporting themselves around the young mother, was engraved as the frontispiece to Midsummer Eve: A Fairy Tale of Love (1848) by Mrs S.C. Hall (see

Fig.6 Richard Dadd, 'Come unto these Yellow Sands', 1842, oil on canvas, 55.3 × 77.5 cm, Private Collection

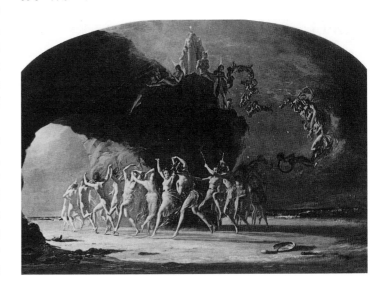

cat.30, 31). Huskisson's untimely death in 1861 (of an aneurism of the abdominal aorta) went unnoticed by Mr Hall, who sent both pictures to auction, remarking only in his lengthy autobiography that Huskisson 'slipped out of the world, no one knew when or how'.

Two highly literate letters from Huskisson written in an elegant hand, one to Henry Bicknell telling him that '*Come unto these Yellow Sands*' was already sold and was 'in fact painted for Mr Hall of Brompton', and another to S.C. Hall himself, are now at the Getty Museum, Malibu. They serve to disprove at least the latter part of W.P. Frith's allegation in his reminiscences, in which he describes Huskisson after meeting him at a dinner party given by Lord Northwick as 'a very common man, entirely uneducated. I doubt he could read or write. The very tone of his voice was dreadful', though Frith concedes that he 'had painted some original pictures of considerable merit'. He recalled Lord Northwick calling to him, 'Mr Huskisson, was it not a picture dealer who bought your last "Fairy" picture?' 'No, my Lord! No, my Lord!' replied Huskisson. 'It were a gent'. There is little doubt that Huskisson was of humble origin and, as a native of Nottingham, probably spoke with a strong Midlands accent.

John Simmons is as obscure as Huskisson. All that is known of him is that he was a Bristol artist who lived in a modest house in Clifton. He came to fairy painting relatively late, in the mid-1860s. Most of his pictures are painted in aseptically pure watercolours and almost all feature Titania as a paragon of Victorian maidenhood (see cat.49). He depicts the still centre of fairyland undisturbed by any suggestion of malice or mischief in a setting of beautifully observed convolvulus, honeysuckle and musk-rose. All is sweetness unalloyed.

Nudity in fairy painting ranged from the grotesquely erotic in Fuseli to the idealised visions of Huskisson and Simmons. Prim-lipped prudery was only too ready to stalk the corridors of the Victorian consciousness. But it was a prudery that was inconsistent and easily disarmed by a change of context. The world of fairy provided a beguiling and seemingly innocent carapace behind which naked nymphs and statuesque Titanias could be depicted without risk of censure. It even enabled Huskisson, in an innocuous dilution of the sacred and profane, to people his Madonna and Child-inspired *The Mother's Blessing* with naked fairies.

Dickie Doyle's *In Fairyland* of 1870 marked the end of the Golden Age of fairy painting, but the genre has never really died, it has merely passed through gradual scenes of transformation. As Titania and Oberon began to lose their sovereignty to more generalised forms, fairies became merged into fantasy, dissolving into personifications of night, moon and stars – typified by the highly imaginative creations of Edward Robert Hughes, nephew of the painter Arthur Hughes and friend and pupil of Holman Hunt. It was as though artists had become reluctant to exercise their former willing suspension of disbelief and had banished fairies to their natural domain, the nursery. The fairy kingdom was more and more linked to children's fairy tales, to the world of *Alice in Wonderland*, *The Water-Babies* and *Peter Pan*. In fact, Fitzgerald's last picture exhibited at the Royal Academy, in 1902, was *Alice in Wonderland*. The fairies themselves lose their transparency and become opaque. Perhaps inevitably fairy painting continued to flourish in book illustration, notably in the exquisite designs of 'E.V.B.' (Eleanor Vere Boyle; 1825–1916), Arthur Rackham (cat.69, 70) and Edmund Dulac (cat.73, 74).

Rather surprisingly the fairy picture which achieved the greatest fame in its day was not painted until 1914. The artist was Estella Canziani, of Anglo-Italian descent. Her mother, Louisa Starr (1845–1909), had exhibited *A Fairy Tale* in 1869 and *Undine* in the following year at the Royal Academy. Her daughter's picture, entitled *The Piper of Dreams* (cat.75), depicts a boy seated at the foot of a tree playing a pipe to a robin sitting on his shoe, while a cloud of diaphanous fairies flies over his head. All around are clumps of primroses (associated with fairies). The popularity of the picture was phenomenal. It quickly joined Holman Hunt's *The Light of the World* as one of the most popular prints published by the Medici Society, reaching France, Egypt and India. It was particularly popular in the trenches during the Great War. However, one wounded Tommy was heard to observe that 'she's got them primroses all right and that there wood', but the fairies bothered him. 'Don't you think she made them gnats rather large?' The prints are still selling today. The print, Mary Clive noted in *The Day of Reckoning*, 'hung over many a child's bed as a sort of honorary guardian angel'. Although it features fairies, the dominant element is the boy with his pipes in a setting of silvan tranquillity.

1 See Gert Schiff, 'Theodore Matthias von Holst', *Burlington Magazine*, CV, 1963, pp.23–32

Fig.7 Thomas Stothard, Illustration to Alexander Pope's
The Rape of the Lock, Du Roveray edition, 1798

STELLA BEDDOE

FAIRY WRITING AND WRITERS

❧

FAIRIES have always eluded capture, in fact and in fiction. The time of the fairies was already set in the distant past as early as the 14th century, as Chaucer's Wife of Bath explains in *The Canterbury Tales*:

> *In th'olde dayes of Kyng Arthour …*
> *Al was this land fulfild of fayerye.*
> *The elf-queene, with hir joly compaignye*
> *Daunced ful ofte in many a grene mede.*
> *This was the olde opinion, as I rede;*
> *I speke of manye hundred yeres ago.*
> *But now kan no man se none elves mo …*

They are described as an older race which had taken to the hills (specifically the Celtic heartlands of the British Isles) or had fled the country. Bishop Corbet, in the *Fairies Farewel* (1647), suggests that they '… were of the old profession …' (i.e. Catholics), who had fled the country on the advent of the new Puritans, a view echoed much later by Kipling in *Puck of Pook's Hill* (1906) as the explanation for 'The Dymchurch Flit'. John Aubrey, one of the earliest of the antiquarian folklorists, is nearer the mark, however, when he notes with shrewd insight in *Remaines of Gentilisme and Judaisme* (1686), which chronicles popular beliefs in England at the time of the Civil War: '… the many good Bookes, and variety of Turnes of Affaires, have putt all the old Fables out of doors: and the divine art of Printing and Gunpowder have frighted away Robin-goodfellow and the Fayries.'

Medieval French prose romances, such as the 15th-century *Huon of Bordeaux*, mark the first appearance in literature of Oberon, King of the Fairies. He is described in Lord Berners's translation of 1534 as 'of heyght but of iii fote and crokyd shulderyd, but yet he hath an aungelyke vysage …', an early mention both of diminutive stature (although Gervase of Tilbury's *Otia Imperialia*, completed

in 1211, mentions Portunes, the first of the diminutive fairies, only half an inch tall) and of its cause: the ill wishes of an offended fairy at his birth. Oberon's name derives, however, from the French translation of Alberic, the dwarf of Teutonic legend, so he was probably always small.

Shakespeare is known to have used *Huon of Bordeaux* as a source for *A Midsummer Night's Dream*. The *Dream*, Mercutio's Queen Mab speech from *Romeo and Juliet* (both among his earliest works, dating from the mid-1590s) and *The Tempest*, probably his last play, of around 1610, made use of most of the earlier fairy literature and contemporary folkloric beliefs and provided an endless source of inspiration for the writers and artists who followed. Thomas De Quincey wrote of the *Dream* in his 'Essay on Shakespeare' in the seventh edition of *Encyclopaedia Britannica* (1838–9): '… in no other exhibition of this dreamy population of the moonlight forests and forest lawns are the circumstancial proprieties of fairy life so exquisitely imagined, sustained or expressed …'. In 1845 J.O. Halliwell-Phillipps (1820–1889), the literary folklorist, devoted an entire volume to *Illustrations of the Fairy Mythology of 'A Midsummer Night's Dream'*.

Mercutio describes Mab, the fairies' midwife, as small and delicate as an insect, coming by night to inspire human dreams:

> *In shape no bigger than an agate-stone*
> *On the fore-finger of an alderman,*
> *Drawn with a team of little atomies*
> *Athwart mens' noses as they lie asleep …*
> *Her waggon-spokes made of long spinners' legs;*
> *The cover of the wings of grasshoppers …*
> *Her waggoner, a small grey-coated gnat …*
> *Her chariot is an empty hazel-nut*
> *Made by the joiner squirrel or old grub …*

The fairies who appear in the *Dream* are also conceived as tiny airy beings who share Queen Mab's role as a fertility spirit in blessing the marriages that are celebrated during the course of the play. Their minute size is emphasised: '… all their elves for fear / Creep into acorn-cups and hide them there'. It is implied that a snake skin is 'Weed wide enough to wrap a fairy in', and Titania imperiously commands her tiny servants to perform tasks suited to their stature. She instructs some to kill the pests that live in rose buds, to kill bats for their wings 'To make my small elves coats', to light tapers from the hairs on the thighs of bumble-bees, and to pluck the wings from butterflies to use as fans. Similar descriptions of miniature husbandry can be found in the works of Shakespeare's contemporaries such as the anonymous author of *The Wisdome of Doctor Dodypol*, published in 1600, the same year as the *Dream*:

> *'Twas I that led you through the painted meades*
> *Where the light Fairies daunst upon the flowers*
> *Hanging on each leafe an orient pearle*
> *Which strooke together with the silken winde*
> *Of their loose mantels made a silver chime …*

Fairies are famed for their charming sound effects, which recommend them so highly to the theatre. The 'silver chime' puts one in mind of the note recorded in John Aubrey's *Miscellanies* (1696): 'Anno 1670. Not far from Cirencester was an apparition. Being demanded whether a good spirit or a bad, returned no answer, but disappeared with a curious perfume, and a most melodious twang. M.W. Lilly believes it was a fairie.'

The other type of supernatural sprite featured in the *Dream* is Puck, or Robin Goodfellow, a brownie or hobgoblin well known to the country people of Shakespeare's day as a lone spirit who was associated with mischievous pranks and helpful tasks performed in the house. His exploits are recorded in Reginald Scot's *The Discoverie of Witchcraft* (1584). Antiquarians soon linked Puck with Lar, the household god of the Romans. Scot describes such beings as 'jocund and facetious spirits' who are said to '… sport themselves in the night by tumbling and fooling with Servants and shepherds in Country houses, pinching them black and blew …'.

The Tempest is the last of Shakespeare's fairy plays. Prospero alludes to those who make the 'sour green ringlets' (fairy rings) in the grass. Ariel, his attendant spirit, suggests forming such a circle for dancing when he sings:

'Come unto these yellow sands, / And then take hands …'. In Ariel, however, Shakespeare has moved on from the nature sprites of the *Dream* to create a personification of the air itself, a sylph, for which he was almost certainly indebted to the writings of Paracelsus. While held in thrall by Prospero and at his command, Ariel conjures up a violent storm:

> *… Sometimes I'd divide*
> *And burn in many places; on the topmast,*
> *The yards, and the boresprit, would I flame*
> *distinctly ….*

He also has the capacity to move with amazing speed and outdoes even Puck's boast to orbit the earth in forty minutes. In practical terms, such feats as Ariel's flight could only be effected on stage with the technical innovations in stage machinery introduced from Italy by Inigo Jones, creator of elaborate court masques for James I.

King James's *Daemonologie* (1597), written in Scotland, where fairy belief was still strong, was a refutation of Scot's *Discoverie of Witchcraft*. The King wrote, 'The Phairie … was one of the sortes of illusion that was rifest in the time of Papistrie'. Attempts were made to account for fairy beliefs, notably by Francis Bacon and Robert Burton (1577–1640), who devoted a long 'Digression on the nature of Spirits, Bad Angels or Divels' in his *Anatomy of Melancholy* (1621), in which he lists as earth spirits: 'those lares, genii, faunes, satyrs, wood-nymphs, foliots, fayries, Robin Goodfellows, Trulli etc'. He was one of the first to note that other writers have equated such spirits with the gods of Babylon, ancient Egypt, Greece and Rome, a path that future folklorists and anthropologists were to explore in the 19th century.

Among Burton's extensive collection of books and manuscripts, now in the Bodleian Library, were several unique fairy items, such as *The History of Tom Thumb, His Life and Death* (1630), which was to become one of the most popular stories of all time. In the days of King Arthur, the Queen of the Fairies attends the birth of a boy who is no bigger than his father's thumb.

One of the most celebrated fairy poems of the period was Michael Drayton's *Nimphidia, the Court of Fayrie* (1627), a burlesque, loosely based on Arthurian romance and featuring the illicit love of the fairy knight, Pigwiggen, for Oberon's Queen Mab. Pigwiggen's preparations for his battle with Oberon are described:

... A little Cockle-shell his shield ...
And puts him on a Coate of Male,
Which was of a Fishe's scale ...
His Rapier was a Hornet's sting,
It was a very dangerous thing ...
His Helmet was a Beetle's head,
Most horrible and full of dread ...
Himselfe he on an Earewig set ...

Such conceits as Drayton's and the descriptions of miniature beings in *Tom Thumb* were a potent source of inspiration for the artists and illustrators of the 19th century and beyond (see cat.72).

Robert Herrick wrote a series of fairy poems, published in *Hesperides* in 1648, which contain further ingenious elaborations on the miniature. The three linked Oberon poems, however, carry some darker messages. The fairy king proceeds from 'The Fair Temple; or Oberon's Chapel' – a mild satire on Catholic ritual – to consume the feast in 'Oberon's Diet'. Gorged and slightly tipsy he proceeds to join Queen Mab in the bedchamber of 'Oberon's Palace', a magical and erotic evocation. The room is hung with snake skins and the eyes from peacocks' tails and is lit by glow-worms and the reflections from fish-scales. Mab herself lies wrapped in sheets made from a caul, behind a curtain of cobweb hung with tears 'Dropt from the eyes of ravished girls / Or writhing brides ...', for fairyland is the realm of sexual fantasy and secret desires. Margaret Cavendish, Duchess of Newcastle (1624?–1674), though a lesser writer, also touches, in her *Poems and Fancies* (1653), on the psychological aspects of fairy belief:

Who knows, but in the Braine may dwel
Little small Fairies, who can tell? ...
And the place where memory doth lye in
Is the great magazine of Oberon King.

Milton refers to Faery Mab and the fairies of folk tradition in *L'Allegro*, written in the 1630s, and again in *Paradise Lost*, completed in the 1660s, where he likens the fallen angels, as they build Pandaemonium, to 'Faery elves'. It was a popular belief that the fallen angels, ejected from Heaven, had fallen short of Hell and had become the fairy host.

The next significant reference to fairies in literature occurs in *The Rape of the Lock* (1714), one of the best known works by the most rational of the Augustan poets,

Alexander Pope (fig.7). This is the first time that fairies are described as winged beings. They are also drenched in iridescent rainbow colours, long before stage lighting could create such effects. Pope calls them elemental 'sylphs', and certainly they behave like capricious fairies as they attend the toilet of Belinda whose hoop (the supporting structure for her dress) it takes fifty of them to lift (Canto II, 59–67):

Some to the Sun their Insect-Wings unfold,
Waft on the Breeze, or sink in Clouds of Gold ...
Loose to the Wind their airy Garments flew,
Thin glitt'ring Textures of the filmy Dew;
Dipt in the richest Tincture of the Skies,
Where light disports in ever-mingling Dies,
While ev'ry Beam new transient Colours flings,
Colours that change whene'er they wave their Wings.

In the early 18th century, when indigenous fairies were held by many to have fled abroad, Britain was invaded by foreign spirits, some of the earliest of these being French *fées*. Many were the protagonists of sophisticated fairy tales, elegantly retold by members of the French court. *The Arabian Nights* had arrived in France in the late 17th century to take their place alongside the Italian collections, such as Giovan Francesco Straparola's *Le piacevole notti* (1550) and Giambattista Basile's *Pentamerone* (1635) as well as classical mythology and indigenous folk stories. The *Nights* provide characters and plots for some of the best loved of all fairy tales, including *Puss in Boots*, *Cinderella*, *Beauty and the Beast* and *Sleeping Beauty*.

The first of the new collections, *Histoires, ou contes du temps passé, avec des Moralitez*, also known as *Tales of Mother Goose*, was published in 1697 by the scholar and courtier Charles Perrault, but under the name of his son Pierre. It is interesting to note the reluctance of several figures of the establishment to admit their authorship of fairy tales; John Ruskin wrote *The King of the Golden River* in 1841 and only published it, anonymously, ten years later, while W.M. Thackeray and Charles Dodgson both used pseudonyms to publish fairy stories for children. Though disguised as his son, Perrault could not resist making ironic asides, like the disparaging comments on Sleeping Beauty's old-fashioned attire after her century asleep, or noting the intention of an ogress to eat her grandchildren with a 'sauce Robert', and he ends each tale with a trite morality intended to amuse a sophisticated adult audience.

Most of the French fairy-tale compilations, however, were made by noblewomen. The *Contes des fées* of Marie-Catherine, Baronne d'Aulnoy became available in English twenty years before Robert Samber's 1729 translation of Perrault. She was followed by the Comtesse de Murat, Marie-Jeanne L'Héritier, Mme de Villeneuve and Mme Leprince de Beaumont. The last named writer published a standard version of *Beauty and the Beast* in her anthology for young people, the *Magasin des enfants* (1756), while working as a governess in England. French authors were responsible both for introducing the Fairy Godmother into the personae of fairyland and for the moralising tone which was to have such a stifling effect on fairy tales of the early 19th century.

The French Revolution and the rise of Napoleon prompted strong anti-French feeling in Britain. Romanticism, the next great cultural movement, came from Germany. Some of the seeds of the movement were actually sown in England, notably by Bishop Thomas Percy (1729–1811), whose *Reliques of Ancient English Poetry* (1765) gathered together many of the early fairy ballads and who, in 1770, translated from the French Paul Henri Mallet's work *Northern Antiquities: or a Description of the Manners, Customs … of the Ancient Danes*, the treatise which first stirred Europeans to the romance of Norse mythology. Mallet's work inspired Benjamin Thorpe's *Northern Mythology* (1851–2), which Burne-Jones introduced to William Morris at Oxford. Morris's passion for the Icelandic sagas led to expeditions to Iceland and his great translations: *Sigurd the Volsung* was published in 1876, the year that Wagner's first complete production of *The Ring* was presented at Bayreuth, based on the same sources. Most importantly, Percy issued a prophetic challenge in the *Reliques* regarding research into fairy beliefs:

> *It will afford entertainment to a contemplative mind to trace these whimsical opinions up to their origin. Whoever considers how early … they have prevailed in these nations, will not readily assent to the hypothesis of those who fetch them from the East so late as the Croisades. Whereas it is well known that our Saxon ancestors, long before they left the German forests believed the existence of a kind of diminutive Demon, or middle species between men and spirits ….*

Sir Walter Scott, who was deeply influenced by the *Reliques*, reissued the challenge in his notes to *The Lady of the Lake* (1810), proposing that '… a work of great interest might be compiled upon the origin of popular fiction and the transmission of similar tales from age to age, and from century to century'.

A number of 19th-century antiquarian scholars spent their working lives seeking the origins of mythological beliefs worldwide, resulting in such mighty works as Thomas Keightley's *The Fairy Mythology* (1828) and J.G. Frazer's *The Golden Bough* (1890). Such epic quests were fictionalised by George Meredith in *The Ordeal of Richard Feverel* (1857), describing the dyspeptic Hippias Feverel who 'forsook his prospects at the Bar' in order to compile 'his ponderous work on the Fairy Mythology of Europe', and by George Eliot in *Middlemarch* (1872), in Casaubon's unrealised ambition to write a 'Key to all Mythologies'.

In Germany, Christoph Martin Wieland's translations of 22 of Shakespeare's plays, published in the 1760s, gave impetus to the Romantic movement; another translator of Shakespeare, August Wilhelm von Schlegel (1767–1845), was one of its greatest exponents. In his famous lecture series given at the universities of Jena and Vienna, he scorned classicism and the teachings of the Enlightenment and promoted the Arthurian legends, the *Nibelungenlied* and the works of Dante, Boccaccio, Petrarch and Cervantes. Eventually he turned his attention to Oriental languages and was made Professor of Indology at Bonn in 1818. His ideas had a profound influence on Samuel Taylor Coleridge (1772–1834), who studied for a year in Göttingen and frequently wintered in Germany. M.G. Lewis, author of the celebrated Gothick novel *The Monk* (1795), had studied in Weimar and was an early patron of Sir Walter Scott, who forged his own links with German writers: he noted the potential for developing the traditional ballad forms revealed by writers such as Gottfried August Berger, and corresponded fervently with the brothers Grimm.

Coleridge translated Friedrich Schiller's play *Wallenstein* (1798–9), which contains a passage of poignant regret for the passing of the fairies:

> *The old fable-existences are no more*
> *The fascinating race has emigrated …*
> *The fair humanities of old religions*
> *That had their haunt in dale or piny mountain …*
> *Or chasms and watery depths, – all these have vanished*
> *They live no longer in the age of reason …*

Coleridge himself composed a number of early fairy poems: *The Song of the Pixies* (1793) is imbued with the folklore of Devonshire, but early editions of *The Aeolian Harp* (1795), a more substantial work in which the poet attempts to reconcile the imagination with everyday life, contain explicitly fairy lines,

> *Such a soft floating witchery of sound*
> *As twilight Elfins make, when they at eve*
> *Voyage on gentle gales from Fairy-Land …*

which were omitted from later editions in favour of a more abstract evocation. Among Shelley's juvenilia is the poem *Queen Mab* in which the Fairy Queen appears in a vision to Ianthe as an emanation of the ether. Keats, in *La Belle Dame sans Merci*, creates a powerful fairy being cast in the medieval mould.

The true heir to the fairy tradition in Britain, by virtue of his research and scholarship as much as his passion for the Celtic heritage and gifts as a poet, was Sir Walter Scott. He was one of the first to appreciate and collect early fairy stories which had survived in ballad form (because metrical verse is easy to memorise). *Minstrelsy of the Scottish Border*, the fruit of his labours, was published in 1801–2, containing stories of fairy agency such as *True Thomas* (Thomas the Rhymer, who meets the Queen of Elfland and visits that country) and *Young Tam Lin*. It was followed by *The Lay of the Last Minstrel* (1805) and *The Lady of the Lake* (1810), in which the fairy ballad 'Alice Brand', written in a declamatory style, includes a vivid account of a Fairy Rade, or ritual procession, redolent of the Middle Ages and flooded with unearthly light:

> *'Tis merry, 'tis merry in Fairy-land,*
> *When fairy birds are singing,*
> *When the court doth ride by their monarch's side,*
> *With bit and bridle ringing.*
>
> *And gaily shines the Fairy-land –*
> *But all is glistening show,*
> *Like the idle gleam that December's beam*
> *Can dart on ice and snow.*
>
> *And fading, like that varied gleam,*
> *Is our inconstant shape,*
> *Who now like knight and lady seem,*
> *And now like dwarf and ape.*

These publications established Scott's fame and brought the romance of Scottish history and folklore to a wide audience.

Minstrelsy is most important, however, for Scott's extended essay on 'The Fairies of Popular Superstition', later included in his *Letters on Demonology and Witchcraft* (1830; see fig.8). He traces the etymology of fairy names (elves having evolved from the dwarves of the Icelandic sagas, fairies from the Persian *peris*). He quotes from Gervase of Tilbury, from Thomas Heywood's *Hierarchie of the Blessed Angels* (1635), from Richard Bovet's *Pandaemonium, or the Devil's Cloister* (1684), from John Aubrey and from John Brand, whose *Observations on Popular Antiquities* (1777), edited and enlarged by Sir Henry Ellis in 1813, laid the foundations for a science of folklore. He includes many reports of close encounters with the fairies, such as that of the Fairy Boy of Leith who drummed the elves to France or Holland every Thursday night. He also relates the curious tale of Robert Kirk, the Gaelic scholar and minister of Aberfoyle who was abducted by the fairies, recalled in *The Secret Commonwealth of Elves, Fauns and Fairies*, written in 1691 but not published until 1815. He described them thus: '[They] are said to be of a middle nature betwixt man and Angel … intelligent Studious Spirits, and light changeable bodies … somewhat of the nature of a condens'd cloud, and best seen in twilight.'

Scott was generous in his support of others working in the field, notably the Scottish writer James Hogg (1770–1835), known as the Ettrick Shepherd, a gatherer of fairy legends, and also of the Irish antiquary Thomas Crofton Croker (1798–1854), author of *Fairy Legends and Traditions of the South of Ireland* (1825; illustrated edition 1828), whom Scott described, in 1826, as 'little as a dwarf, keen-eyed as a hawk, and of easy, prepossessing manner'. Croker failed to acknowledge contributions from another Irishman, Thomas Keightley (1789–1872), who, though annoyingly brash in manner, was a far greater scholar. In his *Fairy Mythology* (1828, revised and enlarged in 1850), Keightley was the first to take account of the oral tradition, discriminating between genuine legends and composed songs. He claimed to read twenty languages or dialects and he culled tales from throughout Europe and beyond. He proposed that the myths of Persia and India had travelled the trade routes via Syria and Egypt centuries before the *Arabian Nights*, contrary to the beliefs of the brothers Grimm. He included their *Deutsche Mythologie* in later editions, observing, 'The labours of MM Grimm in this

department of philosophy can never be too highly praised'. Scott exchanged enthusiastic letters with Jakob Grimm in 1814–5, thanking him for translating his work and expressing his eagerness to see the brothers' newly published *Kinder- und Hausmärchen* (1812); Jakob Grimm sent him a copy.

Jakob and Wilhelm Grimm's *Kinder- und Hausmärchen*, a selection of which were translated by Edgar Taylor into English in 1823 under the title *German Popular Stories*, with a second series appearing in 1826, are perhaps the most famous product of German Romantic nationalism. The idea of collecting folk tales was suggested to them by the poet Clemens Brentano, a member of Schlegel's circle, who had already published a collection of folk songs, *Des Knaben Wunderhorn* (1806). The Grimms' stories were not gathered from country peasants, as was once believed, but from older women among the Grimms' circle of bourgeois acquaintance in Hesse-Kassel. Old women

are, of course, the traditional story-tellers: 'gossips' and 'old wives' (Chaucer's Wife of Bath, for instance), the 'Mother Bunch' or 'Mother Goose' of Perrault and the French collectors. Goethe's mother was a famous story-teller in her day, and Goethe acknowledged that he inherited from her his love 'of spinning fantasies'.

The Grimms' tales arrived in Britain just in time to counter the moral offensive mounted by Mrs Sarah Trimmer, founder of the magazine *The Guardian of Education*, whose object was to 'preserve' the young and innocent from the dangers … of infantine and juvenile literature'. She took particular exception to Cinderella, less for the absurdities of the supernatural agents than for '… some of the worst passions that can enter the human breast … such as envy, jealousy, a dislike to mothers-in-law and

Fig.8 George Cruikshank, Illustration to Sir Walter Scott's *Letters on Demonology and Witchcraft*, 1830

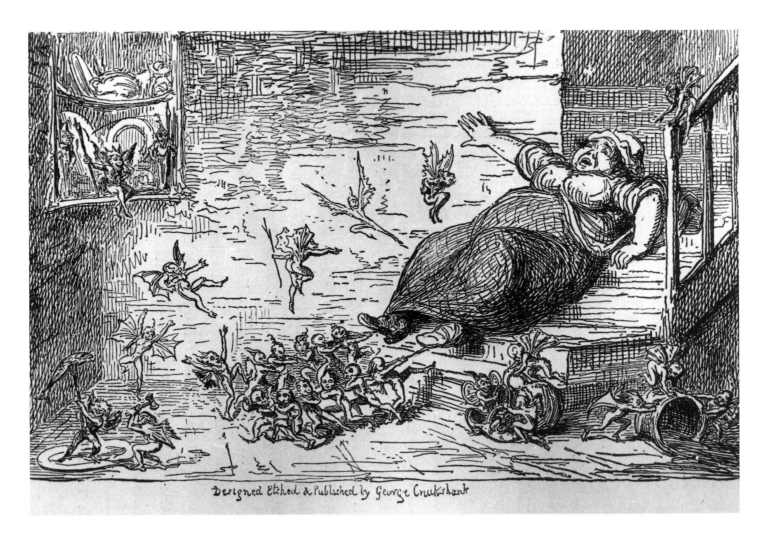

Designed Etched & Published by George Cruikshank

half-sisters, vanity, a love of dress etc., etc.'. She was, of course, responding to the innate subversion of fairy tales. Though long since purged of the worst of their brutality and salaciousness (the rape and impregnation of Sleeping Beauty, or Cinderella's murder of her stepmother, for instance, in their Italian originals) and of their crude vulgarities by their noble French interpreters, their power depends on the human passions they relate and the exciting unpredictability of the supernatural and of fairy interference.

The success of the Grimms' tales in England in 1823 was due in part to the inspired illustrations by George Cruikshank (see fig.25, 26, 27, pp.56–7) which so pleased the brothers that they planned that he should decorate further German editions. Cruikshank went on to illustrate several of the early works of Charles Dickens. By 1847, however, Cruikshank had committed himself to the temperance movement and become a fanatical crusader for total abstinence from liquor. He planned, and began to publish, his *Fairy Library* in 1853, beginning with *Hop-o'-my-Thumb* and *Cinderella* retold as temperance tracts. Dickens believed passionately that fairy stories, particularly the *Arabian Nights*, had saved his soul and nurtured his imagination while he toiled, as a youth, in the blacking warehouse. '[They] kept alive my fancy, and my hope of something beyond that place and time.' He echoed Coleridge's view, expressed in a letter of 1797: '… from my early reading of Faery Tales, & Genii &c&c – my mind had been habituated *to the Vast* … I know no other way of giving the mind a love of "the Great" & "the Whole".' Dickens condemned Cruikshank's endeavours in 'Frauds on the Fairies', the opening article in *Household Words* of 1 October 1853. Having noted '… the intrusion of a Whole Hog of unwieldy dimensions into the fairy flower garden,' he went on to state: 'In a utilitarian age … it is a matter of grave importance that Fairy tales should be respected …. A nation without fancy, without some romance, never did, never can, never will, hold a great place under the sun.'

Much of the power of Dickens's greatest novels derives from their fairy-tale plots, albeit clothed in social realism. Thackeray's daughter Anne Thackeray Ritchie made explicit the fact that the structure of many of the greatest novels depends on the plots of the classic fairy tales in her *Five Old Friends and a Young Prince* (1868), published in the United States as *Fairy Tales for Grown Folks* (n.d.), which includes modern retellings of 'The Sleeping Beauty in the Wood' and 'Beauty and the Beast'. She remarks: 'Fairy stories are everywhere and every day …. All these histories are the histories of human nature which does not seem to change very much in a thousand years'.

Dickens also created the fairy godmother Grandmarina, who rides in with a coach and four (peacocks) at the finale of *The Magic Fishbone* to reward the resourceful Princess Alicia for her fortitude, and *The Chimes, A Goblin Story of Some Bells …*, a Christmas book of 1845, in which the bells are personified and allegorised as a swarm of tiny elves who ring in the New Year.

By this time, Ruskin had written *The King of the Golden River … a Legend of Stiria*, a Germanic tale of virtue rewarded; the eponymous hero, a golden dwarf about a foot and a half high, is eventually transformed into a rainbow. Thackeray's tongue-in-cheek fairy story, *The Rose and the Ring*, published as a Christmas book in 1855, introduces the world-weary Fairy Blackstick who has tired of bestowing the usual fairy gifts and instead awards her godchildren 'a little misfortune', over which they eventually triumph.

In 1863 Charles Kingsley published *The Water-Babies*, in which Tom, the chimney-sweep, escapes the horrors of real life to join the underwater fairies in their marine world. Kingsley, in common with his fellow writers and contemporaries Lewis Carroll and George MacDonald, was a clergyman who struggled with religious doubt; he was also keenly interested in natural history and an enthusiastic subscriber to Darwin's theory of evolution. In telling Tom's story, Kingsley was almost certainly trying to come to terms with the death of his brother Herbert, who had drowned as a child. He denies that Tom had died after falling into the stream but suggests: 'The fairies had washed him, you see, in the swift river, so thoroughly, that not only his dirt, but his whole husk and shell had been washed quite off him, and the pretty little real Tom was washed out of the inside of it and swam away …'.

This poignant motif is not new: Scott records a verse from Thomas Fletcher's *Faithful Shepherdess* which records how the fairies often dipped their 'stolen children' in a particular stream or fountain '… so to make them free, / From dying flesh and dull mortality'. It is also the theme of W.B. Yeats's haunting poem *The Stolen Child* (1886), with its authentic note of fairy seduction:

Fig.10 Karl Friedrich Schinkel, design for E.T.A. Hoffmann's *Undine*,
final scene of Act I of the original production at the Königliche Schauspielhaus, Berlin, first performed 3 August 1816,
gouache, 33.2 × 56.4 cm, Kupferstichkabinett, Staatliche Museen zu Berlin, 22c.173

JOHN WARRACK

FAIRY MUSIC

ON 11 January 1798, the audience in Vienna's Leopoldstadt Theatre saw a new piece about a Danube water sprite entitled *Das Donauweibchen*. The author was the theatre's director, Karl Friedrich Hensler; the music was by Ferdinand Kauer, a busy composer who was to turn out some 200 works for Vienna stages in melodious, untroubling succession. Five weeks later, a second part was performed; and in 1803 popular demand led to a sequel, *Die Nymphe der Donau*. By then, the piece had begun to spawn imitations, rewritings, further sequels, translations, parodies, all the apparatus of instant theatrical success. It was seized upon by the humblest stages looking for a quick financial return, it scaled the heights of Goethe's Weimar theatre (as *Die Saalnixe*), it crossed Europe in all directions and rooted itself in St Petersburg in a new setting on the banks of the Dnieper, with a new text and new music in yet more different versions and sequels. The piece inspired a dramatic poem by Pushkin, and thence Alexander Sergeyerich Dargomyzhsky's opera *Rusalka* (1856), helping to keep alive a myth that was still potent by the time of Dvořák's *Rusalka* of 1901.

Yet the original Singspiel, no more than a well crafted musical tale, scarcely seems to justify all this activity. Albrecht, with the comic Viennese Käsperle in attendance, is intercepted on his way to his wedding to Bertha by the Danube nixie Hulda, upon whom he once fathered a daughter, Lilli. Mother and daughter try to regain his love, with all manner of entertaining disguises and apparitions and with farcical humiliations for Käsperle. But Albrecht goes through with the marriage, even rejecting Hulda's plea for just three nights of love a year. She has the last word, using her magic to carry him off. A final tableau shows him at her feet in her watery realm.

Nowhere was the music responsible for this European popularity. Kauer was hardly more than a workmanlike composer who could turn out an effective song; in two of the Russian versions, Stepan Davydov and Catterino Cavos were skilled enough to add some pieces giving the Danube nixie touches of local colour; and this is worked more thoroughly in Davydov's recomposition *Lesta, ili Dneprovskaya Rusalka* (1805), in which a new libretto establishes her firmly on the Russian territory where she had always had a home in legend. Prince Vidostan has abandoned Lesta for Princess Miloslava; tiring of his bride, he seeks Lesta again, and though they reaffirm their love, she is obliged to renounce him. Whether seductive southern Slav *rusalka* or vengeful northern Slav *rusalka*, beguiling *Donauweibchen* or betrayed Undine, the water sprite had an appeal across national styles and transcended musical and theatrical conventions. The wild, instinctive creature and the rational, calculating man are drawn irresistibly together, yet are unable to find a true marriage. Each is liable to forfeit life and soul in the attempt. The tale spoke deep: Nature and Reason, too far sundered in the Enlightenment, are, post-Rousseau, vainly seeking a new union.

This emergent Romantic idea found its most resonant voice in Friedrich de la Motte Fouqué's *Undine* (1811). His *Novelle* was quickly seized upon by E.T.A.Hoffmann, who had staged Kauer's Singspiel at his Bamberg theatre and now persuaded Fouqué to act as librettist for his own opera (1816; fig.10). As Hoffmann well knew, Fouqué's tale is one that accords with the view of the Romantics' prized philosopher Schelling and his idea of Nature and Mind striving to become one and so to restore the lost harmony of the world. Undine is now a water spirit who must find union with a mortal if she is to acquire a soul. She is a fisher

couple's foster daughter, replacing their supposedly drowned child, and for her sake Huldbrand abandons Berthalda. The old water spirit Kühleborn warns her of man's perfidy and of the danger of her destruction if she is betrayed. Huldbrand becomes uneasy at Undine's spirit nature, and abandons her in turn when she reveals that Berthalda is the missing orphan. At the wedding feast of Huldbrand and Berthalda, a well is opened and Undine appears. She gives Huldbrand her kiss of death, and they are united in what is described as a *Liebestod*.

Fig.11 Playbill for the first performance of Carl Maria von Weber's *Oberon*, Theatre Royal, Covent Garden, London, 12 April 1826

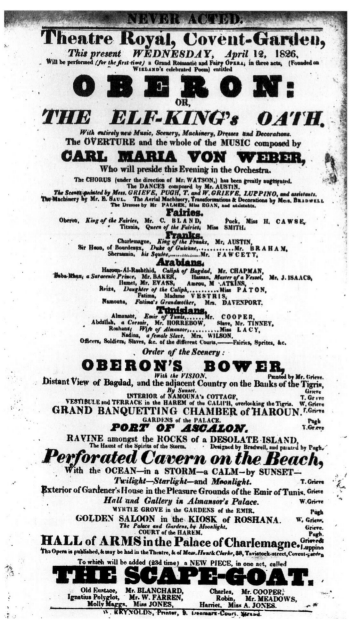

With his belief in music as a mysterious realm of experience – as he describes in his stories *Don Juan* and *Ritter Gluck* – Hoffmann sought through the medium of opera to confer a new depth on this tale of the natural and the supernatural seeking one another. Even if his musical gifts did not match his literary genius, he produced a strange and affecting work, one in which he strove for a new artistic unity. His achievement was immediately acknowledged by Carl Maria von Weber, who, in a long essay after the first performance, praised Hoffmann's realisation of 'the German ideal, namely a self-sufficient work of art in which every feature and every contribution by the related arts are moulded together in a certain way, and dissolve to form a new world'.

No composer was better placed than Weber himself to explore worlds in which the human and the supernatural touched. Like most of his contemporaries, he was fascinated by such tales, and with the Wolf's Glen scene in *Der Freischütz* (1821) he gave musical voice to the diabolical horror that may lurk beneath a sunny village normality; but he also took pleasure in a lighter fairy world. In Weimar, he made friends with Christoph Martin Wieland, whose Shakespeare translations of the 1760s had come as a revelation to Germany. The only verse translation among these was *A Midsummer Night's Dream*, a play which so haunted Wieland's imagination that he re-entered its world in the last major work of his long life, *Oberon* (1780). Here he combined Shakespeare's fairy realm with an old *chanson de geste* to make a tale in which a pair of lovers must prove their fidelity under severe trials before the fairy king and queen can be reconciled. It was quickly seized upon for several operas, most successfully by Paul Wranitzky, whose *Oberon* (1789) held the stage until Weber's own *Oberon* (1826; fig.11).

Reluctantly composed as he was dying, to a Covent Garden commission he hoped would provide for his family, Weber's *Oberon* is a sorry mess. English 'opera' of the day, as interpreted for him by his librettist James Robinson Planché, permitted little else. Yet in *Oberon* Weber created some of the most ravishing fairy music ever composed. Part of his genius as a composer was to make the timbre of instruments essential to the musical invention, rather than a colouring of it. As the curtain rises on the fairies guarding the sleeping Oberon, he uses his orchestra primarily as delicate texture. He pits muted strings against a solo viola and the magic horn of the troubled fairy king, around

whose head flutes and clarinets flutter while a bee hums in the violins. He has the full orchestra as a resource, but he chooses a few instruments at a time from it, as if this were chamber music. When Puck summons his spirits to whip up a magic storm, they cluster about him in a cloud of instruments of which the swiftly circling figures and transparent scoring create the sense of a myriad creatures hovering; the storm passed, mermaids rock in gently lapping waves of horn and strings.

The score of *Oberon* reached Germany a few months later, and may have reached the ears of the boy genius who five years earlier had marvelled at *Der Freischütz*, Felix Mendelssohn. *A Midsummer Night's Dream* was his family's favourite play, translated in part by his philosopher grandfather Moses Mendelssohn, and often staged by them domestically with Felix and his sister Fanny taking turns in different roles. 'We were really brought up on *A Midsummer Night's Dream*', Fanny was later to write, and it scarcely needed the arrival in this cultured Berlin household of the new Schlegel and Tieck translation that year for Felix's mind to be set racing. In time found between his university lectures, he drafted the concert overture which distils much of the play's essence: the four mysterious woodwind chords disclosing the magic wood, the dancing, flickering fairy violins, the lyrical figure for the lovers, the heehawing of poor translated Bottom.

The overture seems not to have come easily to him, probably because he could not find a musically satisfying form in which to contain his ideas; at any rate, when seventeen years later he was commissioned to write a full set of incidental music, he allowed the overture's invention to colour much of it. If it is the fairy element which is the most vivid – and the composer of some of the fleetest scherzos in all music was in his own element here – this arises from his understanding of the play. Though he provides for necessary incidents, with the Bergomask and with the most famous of all Wedding Marches, it is the fairies who predominate, Mendelssohn seeing his music as providing the dimension of magic in which the drama lives. So there is no music after the overture until the first act is over, when the banished lovers find themselves in the wood near Athens and, with a Scherzo, Mendelssohn can advance the fairy world to the centre of the drama. It remains a dazzling orchestral *tour de force*, especially for the speeding flute, creating a sense of pace but also a glint of danger that brings us face to face with Puck as the

curtain rises on Act II. There is a thread of menace in Titania's call for 'a roundel and a fairy song', answered by the fairies' 'You spotted snakes', as Mendelssohn's darting, sinuous figures depict the creatures exorcised in protection of the Queen's sleep. In the depths of the magic, the lovers, too, sleep, sheltered in the Nocturne whose woodland horns surround them with their lulling melody.

Only Berlioz, who deeply admired Mendelssohn and especially the *Midsummer Night's Dream* overture, could rival this fairy delicacy, but he instantly regretted his casual remark, dropped when they were out riding together near Rome in 1831, that 'no-one had ever thought of writing a scherzo on Shakespeare's glittering little poem "Queen Mab".... Happily for me he thought no more about it.' He included two settings in his choral symphony *Romeo and Juliet* (1839), the first a dancing little vocal Scherzetto. But, throughout the symphony, it is when his imagination is released in a purely orchestral movement that it burns brightest. His 'Queen Mab' is a dizzying nocturnal Scherzo, swift, unnerving, charged with graphic touches as the fairies' midwife courses through men's dreams, with lovers sighing and serenading, the soldier's bassoon snoring in his nightmare of breaches and ambuscadoes, fantasies suddenly broken off at daybreak.

This was not Berlioz's first encounter with the fairy world. An overture to *The Tempest* was inspired in 1830 by his 'délicieux Ariel', the beautiful and seductive pianist Camille Moke. 'When she frolics upon her piano', he wrote, enraptured, 'it is like an army of fairies dancing on the keys.' The piece found its eventual home in the odd entertainment which he appended to the *Symphonie fantastique* in 1832, *Lélio*. Here it has become a *Fantaisie sur la tempête de Shakespeare*, as a chorus of spirits of the air softly call 'Miranda!' through rippling flutes and clarinets, muted strings and little trills and flourishes from the piano. The orchestration – gentle timbres, airy textures, instruments in their lightest registers deftly alternating as if hovering motionless – set a new standard for fairy music. In fact Berlioz had tried his hand with it once before, for, next only to Shakespeare and Virgil, Goethe claimed his devotion, and his first reading of *Faust* in 1828 had set his mind in a ferment. Without quite knowing their destination, he began composing eight scenes from the poem, the third of them a Concert de Sylphes. Rewritten, they found their ultimate home in *La Damnation de Faust* of 1846. This *légende dramatique*, a concert work appealing

to the listener's dramatic imagination, turns Goethe's ever striving Faust into a doomed Romantic, each of life's consolations stripped from him by Mephistopheles until he is in the Romantic hell of numbness from all sensation, even from that of Marguerite's love. His first vision of her is conjured up as he lies dreaming by the banks of the Elbe. Mephistopheles's soothing melody turns subtly into that of the *Chœur de Gnomes et de Sylphes*, scored in 1846 with even greater delicacy and airiness than before as orchestra and chorus create a luminous haze around the murmur of these alluring creatures of the devil's imagining; and by yet another diabolical twist, the theme turns into a pretty waltz for the sylphs, with flutes, violins and harps, all these

enchantments weaving Faust into his dream until, spellbound, he calls her name, and is lost.

Fairy operas continued to tempt composers in all traditions and all manners, from the farcical to the most ambitious. *Kaspar der Fagottist* (1791) was one of the first, and the most enduringly successful, of Wenzel Müller's operas. It finds comedy in the encounter between the fairy world and a plain Viennese citizen, a vein still yielding richly (and still with Müller's music) to Ferdinand Raimund in the 1820s. Wagner's first completed opera, *Die Feen*, written in 1834 but never produced during his lifetime, is rather a heavy-handed attempt at conquering the genre of German Romantic opera with a tale of divided fairy and human worlds (fig.12). He may have known Auber's *Le Lac des fées* (1839), a Parisian Grand Opera in which a student falls in love with a lake fairy: at any rate, he seems to have remembered her companions' undulating melody when he came to compose his own Rhine maidens.

Fig.12 The final tableau of *Die Feen*, Wagner's first completed opera, first performed on 29 June 1888 at the Munich Court Theatre, five years after the composer's death, from the *Illustrierte Zeitung*, Leipzig, 28 December 1889. Recent developments in stage technology ensured that the production was spectacular, using electricity to illuminate stars and flowers.

Undine returned in various guises, for example in one of Lortzing's light operas (1845) and in an operatic project which Tchaikovsky never completed, though he saved some of the music for *Swan Lake* and for Ostrovsky's play *The Snow Maiden*. Dozens of minor figures tried their hand at a genre in which popular interest was assured. In the wake of Weber's *Oberon* there was a flurry of attempts in England, where the fairy operas of Edward Loder, Henry Bishop and many more, especially John Barnett's *The Mountain Sylph* (1834), stimulated Gilbert and Sullivan to satire in *Iolanthe* (1882). Yet Sullivan shows more affection than mockery towards the tradition, and indeed by being of such superior quality to the targets of its parody, *Iolanthe* actually contributes to it.

Music for the ballet lagged behind. When Taglioni's Sylphide floated on to the Paris stage on points in 1832, her fairy seduction of the hapless young human hero was to negligible music by one Jean-Madeleine Schneitzhoeffer. Despite the example of Adolphe Adam and Léo Delibes, music was long regarded as the least important ingredient of the Romantic ballet, and this attitude transferred itself to Russia with the succession of French ballet masters who were summoned to St Petersburg – Charles Didelot, Jules Perrot, Arthur Saint-Léon and Marius Petipa, all of whom found the Russian admiration for French manners fertile ground for their talents. Under them grew and flourished the great Russian tradition of dance virtuosity serving stage spectacle as aristocratic entertainment in *divertissement* and *ballet-féerie*. The composers were conductors or hack theatre musicians, men such as Cesare Pugni, Yuly Gerber and Ludwig Minkus, cordially despised by Russian composers ambitious for the emancipation of their country's music.

It was not until discussions about the Romantic ballet among a group of artists and intellectuals led to the commission for Tchaikovsky to write *Swan Lake* (1877) that any real musical quality entered the genre. A lover of ballet, he had never seen dance as incompatible with music of quality. His score for *Swan Lake* was promptly derided as 'too symphonic', since he conferred a strong musical structure on this new version of the doomed attempt of a human to find union with a supernatural being. This he did with a carefully designed key system, by some use of motive, and by moving between substantial musical movements for the main action, graceful dances that were functional to the plot, and some colourful *divertissements*

that lay outside it. He developed the method with even greater richness and virtuosity in *The Sleeping Beauty* (1890), finding some of his most ravishing music for the Lilac Fairy who rescues the lovers from the curse of the wicked fairy Carabosse. However, in the fairytale context of the plot, neither the Lilac Fairy nor Carabosse are very different from the Princess to whose christening they are invited; it is as heroine and villainness that they are depicted, careful as Tchaikovsky is to keep them within the bounds of fairy ballet convention rather than allow them the human characterisations of his operas. His most celebrated fairy portrait was reserved for the *divertissement* finale of his third and last ballet, *The Nutcracker* (1892). Lamenting 'the absolute impossibility of depicting the Sugar Plum Fairy in music', he chanced upon a Paris instrument maker's new invention, the Celesta, and promptly had one dispatched to St Petersburg, secretly so that no rival should get to hear it first. The instrument's succulent chimes, combined with the creamy murmur of the bass clarinet, could not be more apposite for the Sugar Plum Fairy, who guides Clara through the Kingdom of Sweets.

It is with Shakespeare, and the illusion of an illusion, that the fairy century closes in opera. Tricked into Windsor Forest as punishment by the Merry Wives of Windsor, Verdi's superstitious Falstaff is alarmed to be encompassed by all manner of apparitions, as elves, imps and fairies surround him with their pinching and pricking, their stinging and stabbing. The music is in the fairy convention of Mendelssohn or of Berlioz's 'Queen Mab', but crackles with light malice and with a suppressed laughter. It is the laughter which wins through when Falstaff spots what is being done to him, and sees that the ghosts and ghouls are the Merry Wives and their menfolk, his little fairy tormentors the children of Windsor. But also, in the darkness and its charades, the lovers have had their union truly blessed in defiance of the same parents who have set themselves to humiliate Falstaff, and so he draws them all into a circle of forgiveness in a fugue that picks up voice after voice until they are all singing the same music. It is the aged Verdi's farewell to the stage, on a fairy trick reasserting human companionship. '*Tutto nel mondo è burla*' – 'All the world's a jest', Falstaff reminds them and, as the fugue ends at curtain-fall, off they go to supper together.

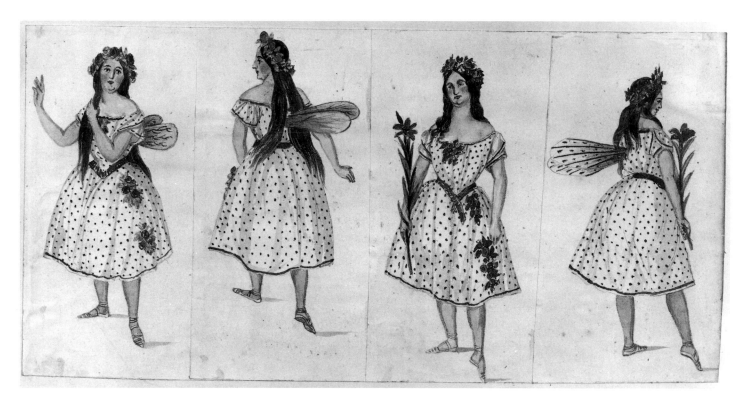

Fig.13 Fairies from Charles Kean's production of *A Midsummer Night's Dream*,
Princess's Theatre, London, 1856, watercolour, Folger Shakespeare Library, Washington

RUSSELL JACKSON

SHAKESPEARE'S FAIRIES
IN VICTORIAN CRITICISM AND PERFORMANCE

IN THE 19th century *A Midsummer Night's Dream* and *The Tempest* were considered fundamental to the understanding of Shakespeare's poetic imagination. Together with the 'Queen Mab' speech in *Romeo and Juliet*, these were the principal sources of information about Shakespeare's fairy lore, regarded as a significant aspect of his claim to transcendent genius. The Rev. T. F. Thistleton Dyer opened his *Folk-lore of Shakespeare* (1883) with the observation that 'the wealth of Shakespeare's luxuriant imagination and glowing language seems to have been poured forth in the graphic accounts he has given us of the fairy tribe'.[1] August Wilhelm von Schlegel had identified Shakespeare's treatment of the spirit world as a sign of his inspired status, an indication of his Romantic poetic mind, evincing 'a profound view of the inward life of nature and her mysterious springs, which … can never be altogether unknown to the genuine poet, as poetry is altogether incompatible with mechanical physics …'.[2]

In undertaking to 'realise' the 'ideal' creatures of these two plays, Victorian and Edwardian theatre managers exposed some intriguing contradictions in contemporary understanding and uses of fairy lore. Like the scholars, critics and graphic artists with whose interpretations they challenged comparison, theatre managers sought to establish conventions that would adequately represent the fairies and spirits. Artists, designers and actors wavered between two archetypes, the womanly and the childlike. The spirits and fairies of *The Tempest* and the *Dream* provoked intense discussion on the relationship between poetry and its theatrical 'realisation' – or was it debasement? – and hence on the standing of the theatre itself. Shakespeare (as a national talisman of artistic probity) had to be protected from the taint of such lower entertainments as pantomime, ballet and extravaganza.

(The Romantic ballet was full of spirits, but in Britain at least it did not enjoy the high cultural status of Shakespearean drama.) Between the 1830s and the early 1900s, productions of *The Tempest* and *A Midsummer Night's Dream* typically combined music, dance, scenic display and spoken drama, and taxed and displayed to the full the resources of any theatre: unfortunately, the same might be said of Christmas pantomime.[3]

Reviewers of the *Dream* frequently cited William Hazlitt's dismissal of a production at Covent Garden in 1816. With its three acts of abbreviated text, added spectacle and 24 vocal pieces, this was a culmination of the tradition of 'operatic' revisions of the play. Hazlitt asserted that the play, 'when acted, is converted from a delightful fiction into a dull pantomime' and complained, 'That which was merely an airy space, a dream, a passing thought, immediately becomes an unmanageable reality'. For many decades his magisterial conclusion defied the scenographer and stage-manager: 'The boards of a theatre and the regions of fancy are not the same thing'.[4]

At the same time, there was no lack of commentators and theatre practitioners prepared to speak up for the stageworthiness of the plays and the fitness of the modern stage to represent them. *The Tempest* was staged by the influential actor–manager William Charles Macready (1793–1873) in 1838 in a text more or less free of the alterations and interpolations of earlier acting versions, and the popular singer and comic actress Elizabeth Vestris (1797–1856) achieved a comparable 'restoration' in her 1840 staging of the *Dream*. Both productions established traditions of staging and interpretation that subsequent managers felt bound to imitate or to surpass.[5] Justice might yet be done to the regions of fancy. The theatre had a threefold task: to provide appropriate fantastic environ-

ments for the plays; to devise acceptable embodiments of the various supernatural figures; and to find suitable devices to execute convincingly their magical feats.

In the production of *The Tempest*, Prospero's island usually included exotic elements, vivid colouring, tropical vegetation and, for the shipwreck, yellow sands and a rocky coast. Mechanical effects for the opening tempest were often so elaborate as to preclude any of the dialogue being heard distinctly (a fault still common), but it was the island's ability to change in character from scene to scene that was most taxing to the designer's ingenuity. Here Macready's 1838 production was judged to have succeeded brilliantly: 'At one moment a rich fairyland starts into shape before us – then the fantastic and varying tints of enchantment vanish, and on a bare and rocky strand, amongst strange volcanic vestiges, we can see "not a twig", no, not one …'. John Forster, Dickens's biographer and a close friend of the actor–manager, noted that the masque was given 'as Shakespeare wrote it; with beautiful landscapes, brown and blue, such as Titian would have beheld with pleasure'.[6] (As it happened, Macready re-used some scenery from an unsuccessful pantomime of the previous season, *Sinbad the Sailor*!) A review in *The Times* (15 October 1838) waxed lyrical in almost Wordsworthian terms: '… while nature is delineated, we seem aware of some indistinct supernatural presence, as if the spiritual agency had operated on inanimate objects'. It quoted Shelley: '… the limits of the sphere of dream / The bounds of true and false are past'. Forster summed up the effect simply as 'a daydream realised for all eyes and hearts'.

At the Princess's Theatre in 1857, in the sumptuous revival of *The Tempest* by Charles Kean (1811–1868), the scenery was unequivocally exotic, and the promptbook's notes for the mechanics of the scene changes suggest a dangerous affinity with the shifting and dissolving scenes of pantomime. The banquet offered to the courtiers by the spirits is an example. Kean's admiring biographer, anxious to assert that 'the powers of the modern stage mechanism are almost as marvellous as the gift ascribed to the magic wand and book of Prospero', described the effect:[7]

A long perspective of desolation gradually changes from barrenness to tropical luxuriance; trees rise from the earth, fountains and waterfalls gush from the rocks; while naiads, wood-nymphs, and satyrs enter, bearing fruit and flowers.

Kean announced that the costumes and the ship were copied from 13th-century designs, and that various Greek mythological sources had been used at other points. For the masque, he provided a 'View of Elusis and its Temple, dedicated to the Goddess Ceres' and had Juno attended in her descent by the Graces, the Seasons and Hymen ('with other spirits').[8] Patrons were informed that the stage effects in *The Tempest* were achieved with 'the aid of above one hundred and forty operatives nightly', all of them unseen by the audience. He was duly rewarded with such notices as one in *The Athenaeum* that applauded the 'most elaborate specimen of stage appliances ever witnessed in this country'.[9]

In a 1904 production that represented, for better or worse, the ultimate in the theatre of illusion's treatment of *The Tempest*, Sir Herbert Beerbohm Tree went as far as he could to 'realise' the sea-nymphs dancing on the yellow sands. The stage-direction in his souvenir edition of the play describes the effect at the conclusion of Ariel's song:[10]

At Ariel's disappearance there is a roll of thunder, and the Scene darkens. In the darkness is faintly heard the singing of sea-nymphs, and through the mists we discern them dancing on the yellow sands and on the waves of the sea. The light is mystical – 'the light that never was on sea or land'.

This was one of Tree's less obtrusive embellishments; several reviewers took exception to the production's ornateness. *Blackwood's Magazine* echoed Hazlitt, declaring that 'Imagination and fancy cannot be expressed by the stage carpenter'. Stung to issue a 'Personal Explanation', Tree maintained that his stage effects were all warranted by the text of the play and insisted that he had striven successfully 'to emphasise the fantasy and the poetry of the text'.[11] As depicted in Charles A. Buchel's vivid illustrations in Tree's souvenir edition of the play, the various locales of the setting seem a cross between a tropical island and a recognisably British landscape of the kind later seen on Great Western Railway travel posters.

The settings required by the *Dream* were at once more specific and less problematic. After Vestris's 1840 production it had become customary to provide a classical Athenian cityscape and palace for the opening and closing acts and for the country scenes a woodland more or less exotic but less clearly identifiable as Greek (let alone classical). The scenic artists and costumiers courted

comparison with the popular pictorial representations: reviewers of the *Dream* frequently referred to Paton and Landseer. Like mid-century painters, theatrical managers valued and vaunted the historical accuracy of costumes, properties and settings. The souvenir acting edition for Charles Kean's 1856 revival at the Princess's Theatre (see fig.13; cat.10) gave sources for the 'archaeology', down to the furniture and tools in Quince's workshop, 'copied from discoveries at Herculaneum'.[12] It is clear, however, that his woodland scenes owed little to scholarship or even botany. The German novelist Theodor Fontane, reporting on English Shakespeare productions for German readers, described the maypole dance in the third act of Charles Kean's *Dream*:[13]

> *A gigantic lichen, not unlike an agave, with fleshy leaves that hang down to the ground, stands in the middle of the forest glade. Suddenly it grows into a tree, forming a high shaft that stands in the centre of the stage, and from the top of it countless chains of white and red roses fall down. Each fairy grasps one of these, and a fantastic dance around the tree now begins.*

The danger with such effects was that they crossed an important boundary between the achievement of an illusion and the self-conscious display of ingenuity, so that (in Victorian terms) the merely theatrical usurped the legitimately poetic. A notable discrimination between acceptable and unacceptable devices is provided by Henry Morley. Reviewing Kean's *Dream*, he admired the 'dream-like moving of the wood, beautifully managed' in Act II, but thought it 'spoilt in effect by a trifling mistake easily corrected':[14]

> *Oberon stands before the scene waving his wand, as if he were exhibitor of the diorama, or a fairy conjurer causing the rocks and trees to move. Nobody, I believe, ever attributed to fairies any power of that sort. Oberon should either be off the stage or on it still as death, and it should be left for the spectators to feel the dreamy influence of wood and water slipping by their eyes unhindered and undistracted.*

This goes to the heart of the Victorian Shakespeare aesthetic, indicating the contamination that might result from any self-conscious theatricality in a performance.

In a contrasting earlier review Morley had praised the greater tact of Samuel Phelps's 1853 production at Sadler's Wells. For the 'fairy' scenes Phelps's designer, Frederick Fenton, had hung a coloured gauze directly behind the proscenium arch, so that 'it subdue[d] the flesh and blood of the actors into something more nearly resembling dream-figures, and incorporate[d] more completely the actors with the scenes, throwing the same green fairy tinge, and the same mist over all'. The costumes, 'especially in the case of the fairies', had been designed accordingly, and 'a harmony between the scenery and the poem' was achieved.[15] Douglas Jerrold, in *Lloyd's Weekly News*, suggested, 'The best way to enjoy it, is to half-close your eyes, and to resign yourself completely to the influence of the scene'.[16]

Promptbooks and published acting texts reflect the attempts of managers to achieve such a dream-like state of mind. Actors could be made to appear and disappear with the use of traps, sliding platforms and gauzes (painted so that they could be lit from behind or in front to produce an opaque or transparent effect), and flying machinery of various kinds was copiously employed. In the staging of the concluding scene, with squadrons of fairies occupying the palace of Theseus, the precedent had been set by Vestris. Stage directions in a published acting edition of 1840 indicate what was expected. On Puck's 'I am sent, with broom before, / To sweep the dust behind the door',

> *Scene glides away, part of it ascending, other parts descending, and going off Right and Left – the stage form [sic] a flight of steps – large flights of steps Right and Left – Platform and gallery from Right to left – Fairies all discovered with torches of various coloured fires – stairs and gallery crowded with them – Oberon, Titania, First and Second Fairies centre.*[17]

In 1840 the final air, 'If we shadows …', was a solo for Oberon, played by Vestris herself, and the custom persisted in Kean's and other versions. More sophisticated scenic tricks might be employed (illuminating the pillars of the palace from within, for example) but the effect of the finale was usually similar.

The fairy population of *A Midsummer Night's Dream* was habitually described by literary critics in terms that replicate, with variations, Schlegel's account of them, as resembling 'those elegant pieces of arabesque, where little genii with butterfly wings rise, half embodied, above the flower-cups …'.[18] Conventionally balletic stage costume could have quite the wrong effect. Henry Morley

complained that Charles Kean's fairies were 'not airy beings of the colour of the greenwood, or the sky, or robed in misty white, but glittering in their most brilliant dresses, with a crust of golden bullion about their legs'.[19] Costume designs (fig.13, p.38) show that his fairies were indeed bodiced, skirted and shod like the peris, sylphs or wilis of the Romantic ballet, with no concession to the more adventurous (but for the stage, hopelessly underclothed) fairies of such paintings as Paton's. In this department, graphic artists had the upper hand.

In the course of the century, research into English folklore provided a specifically patriotic view, exemplified in an anonymous article in *The Edinburgh Review* in 1848. Shakespeare's fairies were an example of the 'combined purity and beauty' so important 'in a national mythology', and English readers were fortunate: 'our imagination has conversed with a more delicate creation than the sensuous divinities of Greece, or the vulgar spectres of the Walpurgis-Nacht'.[20]

Fig.14 Ellen Terry as Puck in Charles Kean's production of *A Midsummer Night's Dream*, 1856, photograph by Adolphe Beau

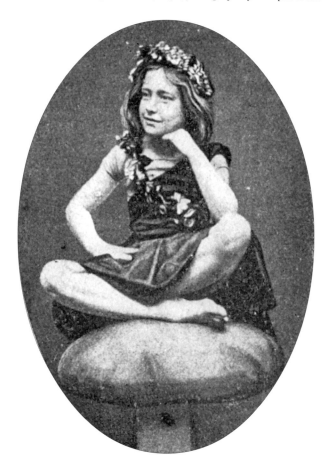

The study of folklore tended to support an interpretation of Puck as 'of the earth, a gross, merry spirit, of material form, and fond of mixing with mankind, and playing rough practical jokes upon them'.[21] In the theatre this was somewhat softened. Male children and adolescents were habitually played by young women, but when Charles Kean cast a much younger actress – the eight-year-old Ellen Terry – as Puck he was breaking with custom and establishing a precedent (fig.14). Theodor Fontane noted the effect:[22]

There is a lot to be said for this in itself, and it corresponds to the usual English representations of 'Robin Goodfellow'. The costume is well chosen: a dark reddish brown gown, decorated with blood-red moss and lichens, with a wreath of the same in the long, fair, somewhat tangled hair …. The impression of her mere appearance was so considerable, that I could no longer contemplate a Puck with a full bosom and plump arms.

By the end of the century the childish, frolicsome Puck played by a young woman was familiar, but archness and the spirits of the pantomime and (even worse) music-hall always threatened to obtrude. After seeing – and hearing – Puck performed in Tree's 1900 production by Miss Louie Freear, Mabel Terry Gielgud wrote that, instead of 'a certain subtle whimsicality and the thoughtful characterisation' she anticipated, the performance was 'wholly dominated by her hideously cockney and unmusical voice'.[23]

In the case of Oberon the theory was that a female was by nature more likely to be convincingly ethereal than a male. Vestris in 1840 (fig.15) was undoubtedly exotic:[24]

[She wore] a translucent, star-flecked dress of yellow and gold descending only to the knee, tightly belted at the waist, and pinned at the shoulders, exposing arms and neck. Her large eyes were framed by a plumed Grecian helmet with moth-like wings appended, and she carried a gold spear topped with a butterfly.

Vestris, however, notorious for her love life and her erotic allure, could never be perceived as an ungendered being, whatever her disguise – and she never failed to display her much-admired legs.[25] Theatrical display of the female leg threatened associations of pantomime, extravaganza and burlesque, and was less easily transformed into aesthetic appropriateness than the blatant eroticism of Noël Paton's shapely and (only just) androgynous Oberon.

Like Puck and Oberon, Ariel was almost invariably played by a woman, and the trick effects associated with the roles were very similar. In approaching Ariel, however, the distinction between masculine and feminine might seem more important. Ariel may be male, but he has attributes not conventionally regarded in the 19th century as masculine (he is 'delicate' and 'tricksy') and is capable of assuming the form of a nymph of the sea. Moreover his relationship with Prospero is more complex than Puck's with Oberon. Although in some respects very similar (wrote one critic), 'Ariel differs from Puck in having a fellow-feeling in the interests of those he is employed about'.[26] Ariel also is the mouthpiece for a moral sense (evident when he appears 'like a harpy' and harangues the courtiers) and has only a few scenes in which to play Puckish practical jokes. This would seem to predicate a more solemn approach to Ariel. For some Victorian readers, however, childishness was still close enough to godliness. In his *Shakespeare-Characters* (1863) Charles Cowden-Clarke described Ariel as 'the etherial personification of will and accomplishment', and added, 'Shakespeare has contrived to secure our interests in and sympathies with this exquisite being, by imbuing it with the frolicsome and wayward fancies of a petted child'.[27]

Macready's Ariel in 1838 was Priscilla Horton (1818–1895), whose idealised figure appears in the fine painting by Daniel Maclise (cat.16). In a review his friend John Forster hailed Macready's achievement in 'restoring the Enchanted Island of Shakespeare to the innocence and golden purity of its first creation'. Forster clearly appreciated the gender of the performer, and thought Horton central to a celebration of the 'scene of fairy life' that the play presented 'from first to last'.[28] He concludes his review with more on this 'perfectly charming' Ariel, played by an actress who 'seems fairly inspired by its pretty wilfulness and submissive animal spirits', and considers the moment in Act IV, Scene I, when Ariel, about to leave the stage, turns and asks Prospero, 'Do you love me, master? – No'. This, he writes, 'could not have been better given, with a more pretty, winning contradiction of its own doubt – had the clever little actress never studied it at all, but acted only from the womanly impulse of the moment'.[29]

In 1857 Charles Kean adapted many of Macready's ideas, but his Ariel was played by the thirteen-year-old Kate Terry, whose 'habitual aspect [was] that of a semi-celestial being with wings of the angelic kind'.[30] Kean's biographer commented, 'There have been Ariels in profusion, who could act and sing beyond the reach of critical censure, but they were full-grown voluptuous-looking females: no-one could beguile himself into the delusion that they were anything less material and substantial.' Kean 'has given us, and for the first time, the dainty spirit, the etherial essence that could be compressed within a rifted pine'.[31]

Kean had certainly done as much as he could to make Ariel magical. Hans Christian Andersen, house guest of Charles Dickens, attended the first performance and described Ariel's entrance in the second scene:[32]

As Prospero called him forth, a shooting star fell from heaven and touched the turf; it shone in blue and green flame, in which one suddenly saw Ariel's beautiful, angelic form. All in white he stood, with wings from his shoulders to the ground. It was as though, in an instant, he had swung through space on a stellar meteor.

Fig.15 Madame Vestris as Oberon in *A Midsummer Night's Dream*, 1840, Covent Garden, London, engraving

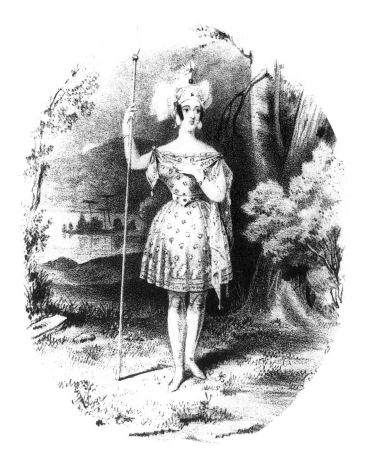

The prompter recorded this in practical terms: 'Red flag signal above for stream of light perpend[icular] from above. Bush opens – after which, pull below to send up Ariel on small trap Left. Lime light … Same time.'[33]

As for Ariel's subordinate spirits, Kean announced that 'to preserve the mythological tone throughout' the 'principal demons and goblins' that harrass Caliban and his fellow conspirators had been 'copied from Furies depicted on Etruscan vases'.[34] In his 1891 production, F.R. Benson – later famous for his Shakespearean touring company – had Ferdinand on his first entrance 'drawn by a silver thread, held by two tiny Cupids whose costumes [were] chiefly wings' – which seems to reflect a change in taste owing more to the contemporary illustrations of Walter Crane than to the classical dictionary.[35]

According to *The Times* of 6 July 1857, Kean's final picture in the play was 'perhaps, one of the most poetical ideas ever embodied by means of stage contrivance' (fig.16). The souvenir edition describes it in full. After Prospero has released Ariel, 'Night descends. The Spirits, released by Prospero, take their flight from the island, into the air. Chorus of Spirits. "Where the bee sucks," etc., etc. Morning breaks, and shows a Ship in a Calm, prepared to convey the King and his Companions back to Naples'. Prospero then speaks the epilogue from the deck of the vessel, which 'gradually sails off'. Finally, 'the island recedes from sight, and Ariel remains alone in mid-air, watching the departure of his late master. Distant chorus of Spirits'.[36]

Fig.16 *Shakespeare's Play of "The Tempest": Scene the Last*, 1857, the Princess's Theatre, engraving from *The Illustrated London News*, 18 July 1857

SHAKESPEARE'S PLAY OF " THE TEMPEST," AT THE PRINCESS' THEATRE : SCENE THE LAST—SEE NEXT PAGE.

Some such business became customary. Departing from tradition, Tree, in 1904, removed the epilogue and used 'Ye elves …' in its place, and the final, wordless picture of his production focused firmly on the figure of Caliban – played by the manager himself. Ariel's voice is heard, climbing higher and higher, and 'gradually is transformed into a lark'. Then 'Caliban, who has been watching the departing ship, hearing the voice of the Lark, points in the direction from which the sound is coming, thus forming picture at which the curtain descends'.[37]

The stage traditions accumulated by the two plays did not come to a sudden end with the new century, still less with the demise of Queen Victoria in 1901. However, the solidly realised trees and troupes of gauze-draped balletic fairies gradually disappeared from the *Dream*, victims of an increasing interest in the theatricality of Shakespeare's own time, accompanied by a drive towards various kinds of stylised, rather than 'realistic', stagecraft. They survived only in such affectionate pastiches as Tyrone Guthrie's 'Twopence Coloured' production (Old Vic, 1937) and the various stagings of Frederick Ashton's ballet *The Dream* (1964).

One London production, by Harley Granville Barker at the Savoy Theatre in 1914, was particularly influential. with its swift, fluid staging – with painted curtains to represent the woodland – and frank enjoyment of the play's self-conscious theatricality. The fairies were dressed in exotic, oriental costumes of red and gold, distinguished from mortals by their stiff, deliberate movements rather than any attempted illusion of weightlessness, still less an ability to fly. Invisibility was achieved not with gauzes and trick scenery but, as on Shakespeare's stage, simply by declaring 'I am invisible' and behaving appropriately. Puck, played by a male actor, was a mischievous baggy-trousered imp with a shock of red hair. (Not every critic was enchanted by this revolutionary figure: for at least one he was a 'crude, deliberate patch of ugliness in a fairy play'.)[38]

By the 1930s *The Tempest* had also undergone a sea-change. J.C. Trewin contrasts a programme from Viola Tree's old-style 1921 production, and its dozen scene-changes ('Another part of the island'), with that for Harcourt Williams's Old Vic revival of 1933: 'The play will be given in two parts, with an interval of twelve minutes'. Ariel, in the interpretations of Elsa Lanchester (Old Vic, 1934) or Leslie French – 'wistful or mercurial'

and recognised as the Ariel of his generation – was now a stylised (indeed, streamlined) personification of speed and enchantment in the manner of Art Deco or modern dance rather than the Romantic ballet.[39]

The Victorian way with Shakespeare's fairies and spirits fell from favour for complex cultural and social reasons: one of the most important was a redefinition of the theatre, amounting to a new respect for non-naturalistic conventions, and a revaluation of theatrical self-consciousness.

The 'day-dream' that Victorian commentators hoped for when they approached Shakespeare had been replaced by something less indistinct and more vividly coloured. A reviewer described Barker's 1914 production as an 'original and very wide-awake Dream'. As a recent historian has noted, it was designed to 'awaken the audience, to disturb old notions',[40] but it was also indicative of a new definition of the dream itself.

1 Rev. T.F. Thistleton Dyer, *Folk-lore of Shakespeare*, London, 1883, pp.1, 2

2 August Wilhelm von Schlegel, *Lectures on Dramatic Poetry*, translated by John Black, London (Bohn edition), 1846, p.396

3 On the musical tradition in stagings of the play, see Gary Jay Williams, '"The Concord of this Discord". Music in the Stage History of "A Midsummer Night's Dream"', *Yale / Theatre* 4/3, 1973, pp.40–68

4 William Hazlitt, *Characters of Shakespeare's Plays*, 1817, Oxford (World's Classics edition), 1966, p.103

5 On the stage history of *A Midsummer Night's Dream*, see Trevor R. Griffiths, ed., *A Midsummer Night's Dream* (in the *Shakespeare in Production* series, Cambridge, 1996) and Jay Halio, *Shakespeare in Performance: 'A Midsummer Night's Dream'*, Manchester, 1994. On *The Tempest*, see Stephen Orgel's introduction to his edition for The Oxford Shakespeare, Oxford, 1978, especially pages 64–87; Alden T. Vaughan and Virginia Mason Vaughan, *Shakespeare's Caliban: A Cultural History*, Cambridge, 1991; and Mary M. Nilan, '"The Tempest" at the Turn of the Century: Cross-currents in Production', *Shakespeare Survey*, 25, Cambridge, 1972, pp.113–23

6 *The Examiner*, 21 October 1838, quoted by Alan S. Downer, *The Eminent Tragedian. William Charles Macready*, Cambridge MA, 1966, p.178; John Forster, review from *The Examiner*, in John Forster and George Henry Lewes, *Dramatic Essays*, ed. William Archer and Robert W. Lowe, London, 1896, p.69

7 J.W. Cole, *The Life and Theatrical Times of Charles Kean, F.S.A. ...* 2 vols, 1859, II, p.220

8 *Shakespeare's Play of The Tempest, Arranged for Representation at the Princess's Theatre ... by Charles Kean, F.S.A*, London, 1857, pp.ix, 54, 55. Production notes enclosed with a draft promptbook (Folger Shakespeare Library, Prompt Temp.11) list the personnel for the vision: '12 Naiades, 24 Dryades, 2 lords, 12 satyrs, 4 satyr boys'

9 Kean, *Play of The Tempest*, p.ix. *The Athenaeum* notice (4 July 1857) is quoted by Frederick J. Marker, 'The First night of Charles Kean's *The Tempest* – from the Notebook of Hans Christian Andersen', *Theatre Notebook*, 25/1, 1970, pp.20–23

10 *Shakespeare's Comedy of 'The Tempest' as Arranged for the Stage by Herbert Beerbohm-Tree*, London 1904, p.11

11 *Ibid.*, p.x

12 *Shakespeare's Play of 'A Midsummer Night's Dream', arranged for Representation at the Princess's Theatre, with Historical and explanatory notes by Charles Kean ...*, London, 1856, p.12 (scene heading for Act I, Scene II)

13 Theodor Fontane, 'Die Londoner Theater', 1857, in *Nymphenburger Fontane Ausgabe, 17/3: Causerien über Theater*, Munich, 1967, p.64 (my translation)

14 Henry Morley, *Journal of a London Playgoer, 1851–1866* (2nd edition, 1891), reprinted with an introduction by Michael R. Booth, Leicester, 1974, pp.133–4

15 Morley, p.57

16 Quoted in W. May Phelps and Johnston Forbes-Robertson, *The Life and Life-Work of Samuel Phelps*, London, 1886, p.132. See Richard Foulkes, 'Samuel Phelps's *A Midsummer Night's Dream*. Sadler's Wells – October 8th, 1853', *Theatre Notebook* 23/2, 1968–9, pp.55–60

17 J. S. Pattie's edition, *A Midsummer Night's Dream as revived at the Theatre Royal Covent Garden. November 16th 1840*, London, 1840

18 Schlegel, p.393

19 Morley, p.134

20 Horace Howard Furness, ed., New Variorum edition of *A Midsummer Night's Dream*, Philadelphia, 1895, p.307

21 Thistleton Dyer, p.1

22 Fontane, pp.61–2

23 Mabel Terry Gielgud, *A Victorian Playgoer ...*, ed. Muriel St Clare Byrne, London, 1980, p.89

24 Gary Jay Williams, 'Madame Vestris's *A Midsummer Night's Dream* and the web of Victorian tradition', *Theater Survey*, XVIII, 2 November 1977, pp.1–22, at p.7

25 On Vestris's reputation and career, see Clifford John Williams, *Madame Vestris. A Theatrical Biography*, London, 1973, and William W. Appleton, *Madame Vestris and the London Stage*, New York, 1974

26 Anonymous, 'Portraits of Players. No.IX Shakespere's [*sic*] "Tempest" (concluded)', in *The Sunbeam. A Weekly Journal devoted to Polite Literature and Music*, London, vol.1, no.44, 1 December 1838, pp.341–2

27 Charles Cowden-Clarke, *Shakespeare-Characters*, London, 1863, p.280

28 Forster, pp.66, 68

29 *Ibid.*, p.71

30 *The Times*, 6 July 1857

31 Cole, pp.217, 220

32 Marker, p.22 (translation by Marker)

33 Folger Shakespeare Library, Prompt. Temp.11

34 Kean, *Play of The Tempest*, p.vii

35 On Benson's production see Nilan, p.115 (quoting Lady Benson's memoirs)

36 Kean, *Play of The Tempest*, pp.72–3

37 Concluding picture of Tree's *Tempest*: Folger Shakespeare Library, Prompt. Temp. 15

38 Quoted by Christine Dymkowski, *Harley Granville Barker. A Preface to Modern Shakespeare*, Washington, London and Toronto, 1986, p.66. See also Dennis Kennedy, *Granville Barker and the Dream of Theatre*, Cambridge, 1985, pp.158–69

39 J.C. Trewin, *Shakespeare on the English Stage, 1900–1964*, London, 1964, p.141

40 Kennedy, *Granville Barker and the Dream of Theatre*, 1985, p.169

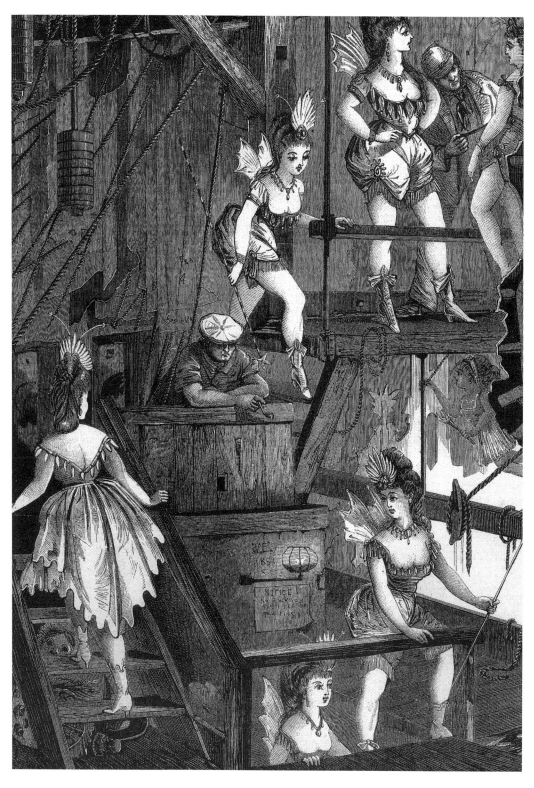

Fig.17 *Behind the Scenes – up in the Flies – Gauzy Nymphs going up to the Gridiron to Descend to Earth,*
steel engraving reproduced in *The Day's Doings,* 31 December 1871

LIONEL LAMBOURNE

FAIRIES AND THE STAGE

Oh the fairies, whoa the fairies, Nothing but splendour and feminine gender
Oh the fairies, whoa the fairies! Oh for the wings of a fairy Queen!

THE rousing chorus of this mid-Victorian song vividly captures the frisson of sensuality which for centuries has been created by fairies in the theatre, beings deeply associated with both 'splendour' and 'feminine gender'. Dealing with such subjects in these days of political correctness we tread on dangerous ground, as already Thackeray realised when in 1855 he wrote in *The Rose and the Ring*: 'Fairy roses, fairy rings, / Turn out sometimes troublesome things'. The politics of fairyland are never correct.

Of all Shakespeare's plays *A Midsummer Night's Dream*, written in 1594, has contributed most to the concept of fairyland and has never lessened its appeal to the public. We do not know much about the original staging or scenery, but Shakespeare's play was endlessly revived and adapted over the centuries, with many variations on fairy themes. It was not, however, the only dramatic fairy work of its time. On 1 January 1611 a masque, *Oberon, the Fairy Prince*, was staged at the Banqueting Hall, Whitehall. It was written by Ben Jonson to honour Henry, Prince of Wales. The lavish scenery and costumes designed by Inigo Jones cost £2000 for the single performance. We gain an idea of the spectacle from the stage directions: 'The whole palace opened, and the nation of fays [fairy knights] were discovered, some with instruments, some bearing lights, others singing …. Oberon, in a carriage … to a loud triumphant music began to move forward, drawn by two white bears … guarded by three sylvans' (fig.18).

Even during the Commonwealth, when the Puritans closed the theatres, the *Dream* continued to weave its strange magic spell. A play derived from it, called *The Merry Conceited Humours of Bottom the Weaver*, was performed illegally during the period 1649–60. But when in 1662 the *Dream* was staged again in its entirety at the King's Theatre, Samuel Pepys pronounced crossly in his diary that it was 'the most insipid ridiculous play that ever I saw in my life', although he also confessed he saw 'some good dancing and some handsome women, which was all to my pleasure'.

In April 1692, in London at the Dorset Gardens Theatre, an operatic masque in three acts was performed. Entitled *The Fairy Queen*, it was based in part on the *Dream*. The music by Henry Purcell was one of the composer's most ambitious works and included some glorious melodies, a synthesis of Italian operatic and English instrumental styles. It required complicated scenic apparatus to facilitate the elaborate scene changes and was divided into a succession of musical interludes made up of various songs, duets, choruses and dances. Descriptive passages such as 'The Monkey's Dance' or 'Hark! the Echoing Air' achieve strangely modern effects. The close and fruitful interchange between fairy themes and the British stage which had begun with the alchemy of Shakespeare's words had taken a new direction, combining the theatrical arts of illusionism with music, song and dance.

Throughout the 18th century the theatre saw the introduction of an increasing number of choral and balletic interludes during the performance of plays. This was due in large part to the monopoly held by Covent Garden and Drury Lane. Under the provisions of the Licensing Act of 1737 only these two great theatres were allowed to stage plays, other, more minor, theatres being excluded. Persons acting for 'hire, gain or reward' without licence from the Lord Chamberlain were deemed to be rogues and vagabonds. It was, however, legal to charge for entry to a 'Concert of Music' and give the play, free of charge, during the interval. This led to performers becoming extremely versatile. It should also be remembered that the 18th-

century stage was dominated by the Italian opera and by the work of George Frederick Handel, both of which utilised plots from Tasso and Ariosto that contained enchantresses akin to fairies.

In 1755 the great English actor David Garrick, constantly alert for novelties to attract the public, helped to devise an 'opera' entitled *The Fairies*. It contained several dances and 27 songs with lyrics drawn from Dryden, Milton's *L'Allegro* and Shakespeare's *The Tempest, Much Ado about Nothing* and the *Dream*, especially the fairy

Fig.18 Inigo Jones, design for the costume of Oberon for the masque *Oberon, The Fairy Prince* by Ben Jonson, staged at the Banqueting Hall, Whitehall, January 1611, Devonshire Collection, Chatsworth

scenes. A few years later, on 16 April 1767 at Worcester, Roger Kemble produced Dryden's and Davenant's curious and complicated re-writing of *The Tempest* (an adaptation already nearly a century old); his eleven-year-old daughter Sarah (later Mrs Siddons) played Ariel.

Fairies were to feature prominently in the great pictorial celebration of the theatre, the Shakespeare Gallery, established by John Boydell (1719–1804). Boydell, an entrepreneur of great vision, was a successful engraver and print publisher, becoming an Alderman of the City of London and Lord Mayor in 1790, the year after his Shakespeare Gallery opened in Pall Mall. From 1786 Boydell commissioned works from such major artists as Reynolds, Romney and Fuseli (fig.2, p.12), resulting in a total production of 162 oil paintings. Boydell idealistically hoped by this venture to encourage the rise of 'a great national school of History Painting' and pragmatically to make a profit on the sale of engravings after the paintings.

Later artists continued to make paintings inspired by performances of Shakespeare in the theatre. Daniel Maclise depicted Priscilla Horton playing the role in William Macready's revival of *The Tempest* on 13 October 1838 at Covent Garden. It is representative of many paintings and sculptures of Ariel, of both sexes or none, which featured in Royal Academy exhibitions in the 1850s. Maclise may well have been influenced by contemporary ballet prints in his portrayal of the charms of Miss Horton and her fairy wand. She had spent the previous month learning to fly on wires, and her song, 'Where the Bee Sucks', performed while suspended in mid-air, delighted the audience. The next day, Macready wrote in his diary, 'Could not recover myself from the excitement of last night. The scenes of the storm, the flights of Ariel, and the enthusiasm of the house were constantly recurring to me.'

Two years later, in 1840, again at Covent Garden, Madame Vestris, the supreme mistress of 'breeches roles', appeared as Oberon in her revival of the *Dream*. The stage effects were also most remarkable, notably the gliding panoramic scenery and the powerful effect produced in the last scene by a stageful of fairies 'clad in virgin white and immaculate silk stockings who at Oberon's command flitted and danced through the house carrying twinkling coloured lights'.

At the Princess's Theatre in the 1850s, Charles Kean staged some of the most lavish of all Victorian productions of Shakespeare. Kean's production of the *Dream* in 1856

was the great success of the series and ran for 250 perform-ances (cat.10). It was notable for the performance of the eight-year-old Ellen Terry as Puck (see fig.14, p.42). On one night she caught her foot in a trap door hurting her toe badly. In the wings, the manager's wife, Mrs Kean, offered her double pay if she finished the performance. She did so, earning thirty shillings for the dramatic demonstration of the old adage that 'the show must go on'. Kean's revival of *The Tempest* in 1857 again had remarkable stage effects, the powers of Victorian stage mechanism proving almost as marvellous as the gifts ascribed to the magic wand and book of Prospero. A contemporary critic described Ariel, played by Kate Terry: '... at one moment descending in a ball of fire; at another, rising gently from a tuft of flowers; again, sailing on the smooth waters on the back of a dolphin; then gliding nervously over the sands, as a water nymph; and ever and anon, perched on the summit of a rock, riding on a bat, or cleaving mid-air with the velocity of lightning'.

The plays of Shakespeare not only influenced fairy painting, they also, via the superb translations of August Wilhelm von Schlegel, contributed to the dawn of the Romantic movement in Germany. The tales of Shakespeare fused with the German folk stories collected by the brothers Grimm to create a never-never land, an area which, as Théophile Gautier observed to Heinrich Heine, might be said to resemble 'one of the Bohemian sea-ports that Shakespeare loved: it suffices for it to be on the other side of the Rhine, in some mysterious corner of Germany'. From this fertile source were to spring the new sensual fairy themes which emerged in the Romantic ballets of the 1830s. Some of the most memorable of these roles were interpreted by the great ballerina Marie Taglioni, whose first appearance on 10 June 1822 in Vienna had, appropriately, been in her father's *divertissement*, *La Réception d'une jeune nymphe à la cour de Terpsichore*. During the next 30 years the Romantic ballet became widely popular throughout Europe, from London and Paris in the west to Moscow in the east.

Dancing on points was not actually introduced by Taglioni; the innovation is traditionally credited to the dancer Amalia Brugnoli, who was certainly the first dancer portrayed on points as a fairy – in a lithograph of the ballet *Die Fee und der Ritter*, with music possibly by Albert Gyrowetz, performed first in Vienna in 1823 and subse-quently in London in 1833 as *The Fairy and the Knight*.

But it was Taglioni who brought the technique to effortless perfection, creating an image of aerial weightlessness which is reflected in the work of artists such as Alfred Edouard Chalon and John Brandard (see cat.3). Like delicate butterflies, the naiads, wilis, sylphs and faeries of the Romantic ballet are captured in their lithographs, works which are echoed in the fairies dancing in the decorative borders and watercolours of Richard Doyle (cat.54).

A ballet is a composite work, the fusion of music, painting, mime and dancing; when there is a plot, as in *Giselle*, the most famous of all Romantic ballets, the author of the synopsis also makes a vital contribution. Théophile Gautier, who devised the theme of Giselle, was inspired by a poem by Heine. He recorded how the ballet came into being in a notice of the first night on 28 June 1841 in a letter to the poet:

My Dear Heinrich Heine, when reviewing ... your fine book De l'Allemagne *I came across ... the place where you speak of elves in white dresses, whose hems are always damp; ... of snow-coloured Wilis who waltz pitilessly; and of those delicious apparitions you have encountered in the Harz mountains ... in a mist softened by German moonlight; and I involuntarily said to myself: "Wouldn't this make a pretty ballet"?*

Taglioni made her first appearance in London on 3 June 1830 in Charles Didelot's ballet *Flore et Zéphyr*, with music composed by Cesare Bossi. Her performance in the main role provoked an amusing caricature from Thackeray (fig.19), and led Chalon to depict her wearing a costume with small delicate wings, anticipating her dress two years later in *La Sylphide*, her most sensational success (cat.3). The ballet *La Sylphide*, with music composed by Jean-Madeleine Schneitzhoeffer, is a neo-Gothic dream of elf-haunted Scotland. It was first seen in London on 26 July 1832. It blends the Romanticism of Sir Walter Scott with a fairy story of a mortal man torn between his human love for his betrothed, Effie, and that of a fairy. Her unearthly beauty gives him the hope of transcendent, superhuman love. In this role, Taglioni inspired gushes of poetic prose from critics: 'To describe Marie Taglioni one would have to dip a humming bird quill into the colours of the rainbow and inscribe it on the gauze wings of a butterfly'. Gautier described how she 'flies like a spirit in the midst of the transparent clouds of muslin with which she loves to

surround herself, she resembles a happy angel who scarcely bends the petals of celestial flowers with the tips of her pink toes'. Other famous Romantic ballets with fairy themes include Jules Perrot's first major choreographic work, *Ondine*, danced by Fanny Cerrito in 1843. With music by Cesare Pugni and sets designed by William Grieve, the ballet was a great success, and Perrot was eulogised as 'the Flaxman of the ballet'. It was based on la Motte Fouqué's *Undine*, the classic Romantic tale which first appeared in 1811, and which also inspired Daniel Maclise's painting (fig.38, p.66).

Perrot's next fairy ballet was *Eoline, ou la Dryade*

Fig.19 William Makepeace Thackeray, frontispiece to *Flore et Zéphyr*, illustrated by the author under the pseudonym Théophile Wagstaff, lithographed by Savile Morton and printed in Paris, 1836 (*The Works of William Makepeace Thackeray, Centenary Biographical Edition*, V, London, 1911)

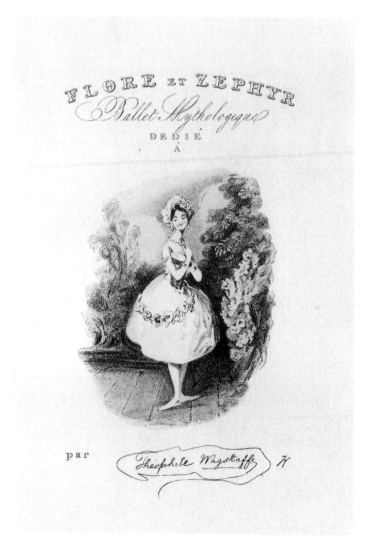

(1845), a tragic tale in which Eoline, half-dryad, half-human, danced by Lucile Grahn, dies on her wedding-day at the hand of the jealous Rubezahl, prince of the gnomes. Tchaikovsky's later celebrations of fairies of all hues in *The Sleeping Beauty* (1890) and of the Sugar Plum Fairy in *The Nutcracker* (1892) only appeared on the British stage under the aegis of Diaghilev in the 1920s.

Another important element in the British perception of fairies was their annual appearance each December in that most British of institutions, the pantomime, an art form which fascinated Charles Dickens. In 'Gaslight Fairies' published in *Household Words* on 10 February 1855, he recorded the experience of hearing a producer give a stage manager an order for 'five and thirty more fairies tomorrow morning – and take care they are good ones …. I saw them next day. They ranged from an anxious woman of ten, learned in the prices of victual and fuel, up to a conceited young lady of five times that age, who always persisted in standing on one leg longer than was necessary, with the determination (as I was informed) "to make a part of it".' Dickens described them at work:

> … they have a way of sliding out of the clouds … like barrels of beer delivering at a public house … and you resign yourself to what must infallibly take place when you see them armed with garlands. You know all you have to expect of them by moonlight …. You are acquainted with all these peculiarities of the gaslight fairies, and you know by heart everything that they will do with their arms and legs, and when they will do it.

The scenic artist William Beverley was a master of the transformation scene. He began his career at the Theatre Royal, Manchester, before going on to work first at the Lyceum, and then for 30 years at Drury Lane. Beverley virtually invented 'the transformation scene in which gauzes lifted slowly one by one' to reveal what Sir Arthur Quiller-Couch described as 'a new and unimagined world, stretching deeper and still deeper as the scenes were lifted; a world in which solid walls crumbled and forests melted, and loveliness broke through the ruins, unfolding like a rose'. One of Beverley's triumphs, on 26 December 1849, was the creation of the scenery for the fairy extravaganza *The Island of Jewels*, written by the dramatist J.R. Planché, who recorded with delight: 'The novel and yet exceedingly simple falling of the leaves of a palm tree which discovered six fairies supporting a coronet of jewels, produced such an

effect as I scarcely remember having witnessed on any similar occasion up to the present time.'

Another striking stage effect guaranteed to produce a chorus of wonder from the audience is depicted in an illustration *Behind the Scenes – up in the Flies – Gauzy Nymphs going up to the Gridiron to Descend to Earth* (fig.17, p.46), which shows 'fairies' ascending to the fly floor (5 metres above the stage) to be attached to their flying harness, controlled by counterweights, which, from the gridiron 10 metres higher than the stage level, will fly them into view from the audience. Another illustration, *Below the Stage … The Slider away and the Trap Ready* (fig.20), shows an intrepid fairy about to be propelled up on to the stage via a trap door of the type which injured Ellen Terry.

James Robinson Planché (1796–1880) deserves wider fame for his entertaining theatrical memoirs, for his books on costume and armour, and for writing the libretto for Weber's fairy opera *Oberon: or the Elf-King's Oath*, first performed at Covent Garden on 12 April 1826. But today he is best remembered for the excruciating puns and rhymes of his pantomimes, still often revived at the Players' Theatre in London. In such pantomimes fairies appear notably in the finales – scenes with sonorous titles such as *The Coral Queen's Court under the Sea*, *The Language of the Fan*, *Palace of Pearl* or *The Fairy's Bower*. Elves leap-frogged, and winged petite girls 'flew' round the stage suspended by wires, while the Good Fairy rose from below as the scenes 'transformed' or 'dissolved', originating the fantastic fairy transformation scenes which still conclude traditional pantomimes.

While it was fun to play the good fairy, it was even more exciting to play a bad fairy role. In 1857 Ellen Terry's blond hair made her 'a natural' for the role of the good fairy Golden Star, although she longed for the less tedious role of Dragonetta. Ellen's partner, Sir Henry Irving, also began his career in pantomime, appearing at the Theatre Royal, Edinburgh, in a transvestite role he was to forget as soon as possible, that of the wicked fairy Venoma in *The Sleeping Beauty in the Wood*.

Commercial plugs and advertising jingles have always had their place in pantomime. At the Theatre Royal, Liverpool, in 1862, the pantomime's transformation scene gave the audience olfactory as well as visual sensations in a scene entitled *The Fuchsia Bower of the Fairies in the Gardens of Never Fading Bloom*. The programme described how 'During this scene the perfume of Flowers will be diffused throughout the Theatre by means of Rimmel's Perfume Vaporiser …. It diffuses the perfume of any flower in all its freshness and purity, emitting the balmy fragrance of a blooming parterre on a fine spring morning'.

Noteworthy events of the day have also frequently made an impact on the insubstantial world of fairyland. On 27 December 1852, at the Theatre Royal, Drury Lane, the curtain rose on the first pantomime devised by Edward Leman Blanchard, who for the next forty years was to gain the accolade of 'King of the Pantomime Writers'. Earlier in the year the Crystal Palace had been moved from its central London site in Hyde Park to the top of Sydenham Hill.

Fig.20 *Below the Stage – The Cellar – The Slider away and the Trap Ready – Angels in the Lower Depths preparing to Ascend*, steel engraving in *The Day's Doings*, 31 December 1871. When the bell (shown above the amorous fiddler) rings the trap door is slid away and the fairy ascends to the stage.

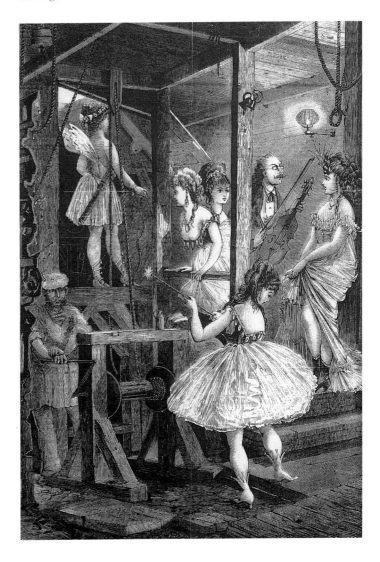

This move was emulated on the pantomime stage, the 'Abode of Antiquity' giving place to 'The New Crystal Palace and Gardens at Sydenham'. A tableau of fairies appeared at the entrance, representative of Art, Science, Concord, Progress, Peace, Invention, Wealth, Health, Success, Happiness, Industry and Plenty. An imp then delivered what even by the standards of Victorian pantomime is a stupendously awful pun: 'Behold my treasures here, there's naught forbid' in 'em, / And all will be revealed though now *it's hid in 'em* [Sydenham]'.

Puns also came readily to the pen of W.S. Gilbert, who shared the contemporary fascination with fairies, for him synonymous with the pretty young dancers of the panto-mime stage. His libretto for the operetta *Iolanthe; or the Peer and the Peri*, first produced on 25 November 1882 at the Savoy, was significantly described as 'An Entirely New and Original Fairy Opera' (fig.21). In it Gilbert's fertile satiric imagination linked the radical threat to the House of Lords and the first manifestations of female politics:

> *We are dainty little fairies,*
> *Ever singing, ever dancing;*
> *We indulge in our vagaries*
> *In a fashion most entrancing.*
> *If you ask the special function*
> *Of our never-ceasing motion,*
> *We reply, without compunction,*
> *That we haven't any notion.*

It has been suggested that Iolanthe, the Fairy Queen, was intended by Gilbert to represent Queen Victoria. The Lord Chancellor was Gladstone, her Prime Minister, and Private Willis, the guardsman who attracts the Fairy Queen's

Fig.21 Scenes from the first production of Gilbert and Sullivan's *Iolanthe*, the Savoy Theatre, from *The Graphic*, November 1882

Fig.22 Walter Crane, *Elves: Fairy Painters*, designs for the costumes of *The Snowman* performed at the Lyceum Theatre, 1899, watercolour, 45.7 × 35.6 cm, Victoria and Albert Museum, London, D162

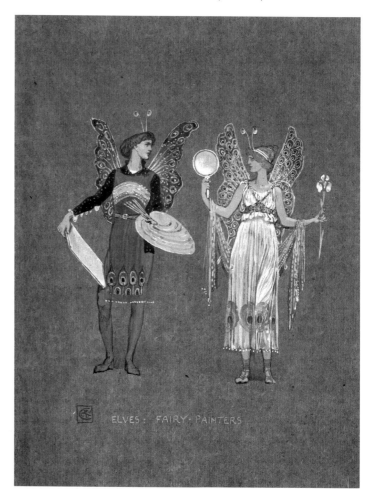

attention, was John Brown, Queen Victoria's faithful Highland servant. While this argument may be valid, the costume of Iolanthe has more than a suggestion of that of Wagner's Brünnhilde completed in 1874.

Even after the break-up of his partnership with Sullivan, Gilbert remained a committed fairy fancier. In December 1909 Gilbert's last operatic venture at the Savoy Theatre, in partnership with the composer Edward German, was *Fallen Fairies; or, The Wicked World*. But tastes had changed, and although the piece abounded with Gilbertian 'patter songs' it soon folded.

In June 1899 the Art Worker's Guild staged the elaborate spectacle *Beauty's Awakening: A Masque of Winter and Spring* at the Guildhall, London, with contributions from virtually every major figure of the Arts and Crafts movement from C.R. Ashbee to Henry Wilson. Walter Crane (who played Nuremburg in the Fair Cities Procession) designed costumes for 'The Dance of the Five Senses'. The event's success led to the creation of several later Arts and Crafts masques, an art form well suited to the antiquarian and revivalist spirit of the movement, recalling the elaborate court masques of the Jacobean age. More immediately it led the aesthetic impresario J. Comyns Carr to persuade Walter Crane to design the costumes for *The Snowman*, a Christmas entertainment at the Lyceum Theatre, thus procuring a higher cultural profile than usual for the pantomime. The transformation scene in the finale was a remarkable reprise of 'aesthetic' interests in the decorative arts. Fairy architects and builders jostled with fairy painters, weavers, potters, carpenters and jewellers (fig.22). The play was performed from 21 December 1899 to 31 January 1900. Crane's costumes form an interesting comparison with the work of the most prolific of all costume designers for pantomimes, Charles Wilhelm.

Later in 1900 a spectacular production of the *Dream* was presented by the great actor-manager Sir Herbert Beerbohm Tree. In it the fairies revelled in a wood populated with singing birds, live rabbits and real glow-worms, all controlled by the dignified figure of Miss Julia Neilson as Oberon, dressed in golden, flowing robes and with an electric coronet and breastplate. Throughout the 20th century the play has continued to wield its spell in adaptations varying from Benjamin Britten's opera of 1960, Frederick Ashton's ballet of 1964, and Peter Brook's highly imaginative production of 1970, which incorporated circus skills and audience participation.

Queen Victoria (privately dubbed 'the Faery' by her favourite Prime Minister, Disraeli, in an ironic romantic allusion to Spenser's *Faerie Queene*) died in 1901. Fairies lived on; and the most important new theatrical fairy work for many years was created in the new reign of Edward VII. In *Peter Pan, or, The Boy Who Wouldn't Grow Up*, J.M. Barrie combined fairyland with fantasies of crocodiles, piracy, Red Indians and adoption. The play was first produced in London at the Duke of York's Theatre on 27 December 1904. The exciting novelty of electricity was used in creating the fairy Tinker Bell, a being 'not wholly heartless ... [but so] ... small that she has only room for one feeling at a time'. In the theatre Tinker Bell is created by means of a small wandering light spot, and a bell, for the tinkle of bells is 'the fairy language'. As a theatrical device it is simple yet amazingly effective, culminating in Peter's famous appeal, 'Do you believe in fairies? Say quick that you believe! If you believe clap your hands!'

Fig.23 *Seven Fairies ready to ascend when the Counterweight is Dropped*, steel engraving from *The Day's Doings*, 31 December 1871

Fig.24 George Cruikshank, Frontispiece to Thomas Keightley,
The Fairy Mythology, London, 1850

PAMELA WHITE TRIMPE

VICTORIAN FAIRY BOOK ILLUSTRATION

WHEN George Cruikshank created the illustrations for Grimms' *German Popular Stories* in 1823 he was already a caricaturist of note, but these established his reputation as an illustrator of fairyland – a romantic realm of castles and strange creatures. Whereas his earlier work had centred on contemporary London low life and on satire, his fairy illustrations evoked a coherent other-world, where distortions, particularly of size and distance, were natural rather than ironic.

Cruikshank's illustrations emphasised the oral origin of these folk tales. In the frontispiece to each volume he depicted a storyteller (in the first, a man, and in the second, a woman) seated in front of a large fireplace surrounded by a crowd of children and adults (fig.25, 26). Through details of costume and setting, both historical and imaginative, his frontispieces create a sense of timelessness and community, a safe haven from the cares of the world. Cruikshank's illustrations adroitly advance the Grimms' narrative to the climactic moment in the story, often by portraying the main character in action. His masterpiece is his illustration to 'The Elves and the Shoemaker'. The shoemaker and his wife hide behind a curtain in the shop while two elves put on their new clothes and dance. We are shown the cottage's thatched roof, stone floor and sparse furniture. While miniature in stature, the elves are fully evolved as characters (fig.27). Ruskin recognised Cruikshank's 'manly simplicity of execution', that the fancy was 'easy, unencumbered' and stated that his etchings 'were unrivalled in masterfulness of touch since Rembrandt'.

Cruikshank collaborated closely with the printers in executing his designs. After working on the etched copper plate, he would review trial proofs and often made modifications to the original designs, incorporating suggestions gleaned from his publisher's close reading of the text. This working method allowed him to build upon his most effective skill – selective use of descriptive details.

In 1853 Cruikshank returned to the fairy genre when he published the first volume of his *Fairy Library*. He rewrote and illustrated traditional fairy stories, transforming them rather implausibly into temperance tracts. By this time he had become an ardent teetotaller and thought that fairy tales in their original form were too violent. Not surprisingly, his illustrations for these revamped fairy tales were less successful than his earlier images, lacking the energetic forms that characterised the first exuberant drawings. Both the illustrations and the stories themselves are sterile in their depiction of fairyland.

Contemporary with the English translation of Grimms' tales was T. Crofton Croker's *Fairy Legends and Traditions of the South of Ireland*, published in 1825 and again in 1828, when illustrated by Daniel Maclise, establishing his reputation as a fairy illustrator (fig.28). Also published in 1828 was Thomas Keightley's *Fairy Mythology*, illustrated by William Henry Brooke, who had engraved Maclise's illustrations for Crofton Croker. Another compilation of British folk tales, Samuel Carter Hall's *The Book of British Ballads*, was published in two volumes in 1842 and 1844; Richard Dadd illustrated the ballad 'Robin Goodfellow', and Noël Paton, Richard Redgrave, W.B. Scott and E.M. Ward, among others, contributed (cat.25).

By the mid-19th century, many established authors had written original fairy tales, almost always accompanied by illustrations. Although officially said to be written for the amusement of children, the enormous popularity of the fairy theme suggests that adults also read the stories. Charles Dickens, for example, created his Christmas books between 1843 and 1848 and intended them to be read aloud by the entire family. William Makepeace Thackeray wrote

55

and illustrated *The Rose and the Ring* (1855); John Ruskin's *The King of the Golden River* was published in 1851 with illustrations by Richard Doyle. Always a supporter of fairyland, Ruskin reasserted his belief in the importance of fairy tales in 1868 when he wrote an introduction for a new edition of the collected stories of the brothers Grimm.

Between 1854 and 1856, Edward Coley Burne-Jones made numerous drawings to illustrate *The Fairy Family*, written by Archibald Maclaren. In the event only three were used, and later Burne-Jones chose to deny his authorship of these inventive and meticulous designs, declaring that his artistic career began only in 1856 when he met Rossetti. Burne-Jones's frontispiece (cat.64) to the

book is a masterpiece of drawing, showing the influence of Cruikshank's work for the brothers Grimm and for the second edition of Keightley's *Fairy Mythology* (1850; fig.24), of Keightley's earlier illustrator, William Henry Brooke, and of Richard Doyle.

In 1855 the Pre-Raphaelite artists John Everett Millais, Dante Gabriel Rossetti and Arthur Hughes were commissioned to illustrate William Allingham's collection of poems entitled *The Music Master* (cat.63). Rossetti and Millais contributed one plate each, while Hughes provided seven. One of the images was to have lasting importance for later fairy illustration: 'The Maids of Elfen-Mere' by Rossetti unites medieval revivalism and poetic symbolism, highlighting the otherworldliness of the three spinning

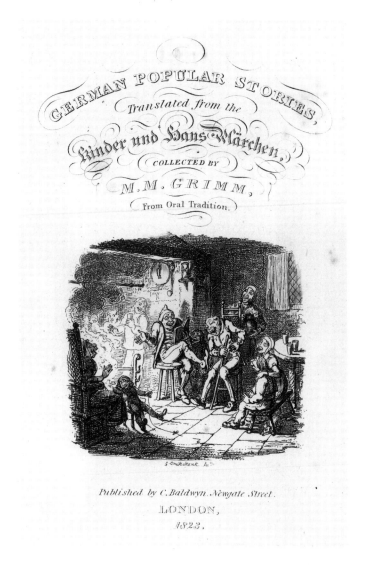

Fig.25 George Cruikshank, title-page to the brothers Grimm, *German Popular Stories*, first series, C. Baldwyn, London, 1823

Fig.26 George Cruikshank, title-page to the brothers Grimm, *German Popular Stories*, second series, James Robins & Co., London and Dublin, 1826

damsels (fig.29). The engravers experienced acute diffi-culties with Rossetti, but the work, when it did appear, had an immediate appeal. The attenuated grace of the figures, which overflow the picture frame, create a sense of claustrophobia that enhances the story's ghostly atmosphere. Hughes's illustration (see cat.63) for the most famous poem in *The Music Master*, 'The Fairies', is different in emotional tone from Rossetti's. The small vignette displays six 'trooping fairies' dancing in the full moon. Their diminutive size is emphasised by the flowers and grasses that frame them, and their wild dance is reflected in a pool of water below. Ignoring the more frightening aspects of Allingham's text, Hughes chose instead to depict the light-hearted dancing of 'wee folk, good folk / trooping all together'.

In 1862 Rossetti provided two illustrations for his sister Christina's *Goblin Market and Other Poems*, showing the two young girls tempted by the goblins' fruit; his lush illustrations added to the suggestiveness of the text, which is often interpreted as a tale of sexual awakening. Hughes illustrated George MacDonald's *Dealings with the Faeries* in 1867 and his *At the Back of the North Wind* in 1869. A friend of Lewis Carroll's, MacDonald also worked as an editor of the popular magazine *Good Words*, which often serialised contemporary fairy stories before they were published in book form.

One of the best known illustrators in the mid-19th century was Richard 'Dicky' Doyle, who began his artistic career illustrating *Punch* magazine in 1843. The son of John Doyle, a leading caricaturist, Dicky was an artistic prodigy (see cat.51): in 1840 he published *Dick Doyle's Journal*, a record of youthful imaginings, and Charles Dickens chose the young Doyle to illustrate his Christmas books from 1844 to 1847; in 1846, Doyle's first fairy book, *The Fairy Ring*, was published; in 1849 he created a famous cover for *Punch*, which includes many fairies. He resigned from the staff of *Punch* the following year and

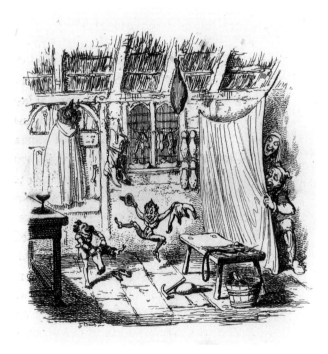

Fig.27 George Cruikshank, 'The Elves and the Shoemaker', from the brothers Grimm, *German Popular Stories*, first series, C. Baldwyn, London, 1823

Fig.28 Daniel Maclise, title-page to T. Crofton Croker, *Fairy Legends and Traditions of the South of Ireland*, new edition, London, 1828

thereafter worked on a freelance basis; in 1851 he illustrated John Ruskin's *The King of the Golden River* to great critical acclaim.

In Fairyland, Dicky Doyle's most famous work, was published for Christmas 1869 (cat.54). The artist's 36 illustrations of fairyland were commissioned by Longman's, with William Allingham writing the accompanying verses only after the watercolours were finished, as had Bulwer Lytton for his *The Pilgrims of the Rhine* (1834; see cat.14). The images were enhanced by an innovative colour printing process employed by the printer Edmund Evans; that and the book's large format made *In Fairyland* a masterpiece of Victorian book production. Doyle created compelling images of his secret fairy world: the fairies, elves and gnomes are shown in grassy surrounds riding snails, conversing with birds and jumping off toadstools. When Doyle died in 1883, Austin Dobson, the poet and man of letters, wrote that 'In Oberon's court he would at once have been appointed sergeant-painter'.

Dicky Doyle's younger brother, Charles Altamont Doyle, was also an artist and illustrator of consequence. His fairyland scenes possess a directness and have a fresh, childlike quality that suits his subject-matter and is distinct from other artists' work in the genre. Their simplicity does not preclude witty visual comments. After he was committed to an asylum in the late 1870s for alcoholism and epilepsy, Doyle spent the rest of his life in and out of institutions, and yet continued to pursue his art. His self-portrait, *Meditation* (cat.62), painted in hospital, is intensely introspective, with supernatural beings populating the shadows of the murky room. Except for the few works that were exhibited at the Royal Scottish Academy, Charles Doyle's art was unknown to the public until 1924, when his son Arthur Conan Doyle mounted an exhibition of his father's work in London.

The Water-Babies (1863) by Charles Kingsley was illustrated by Joseph Noël Paton, famous for his paintings of Shakespearean fairies, and by Percival Skelton (fig.30).

Fig.29 Dante Gabriel Rossetti, Illustration to 'The Maids of Elfen-Mere', in William Allingham's *The Music Master* (see cat.63)

Fig.30 Percival Skelton, 'Mother Carey's Peace Pool', Illustration to *The Water-Babies* by Charles Kingsley, Macmillan, London, 1879, pl.310

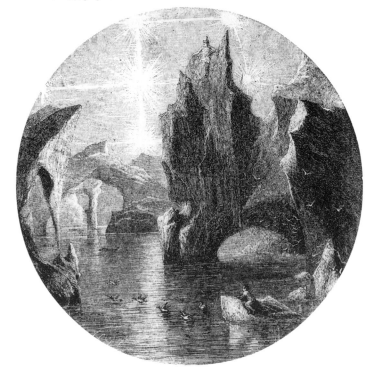

In 1865 Charles Lutwidge Dodgson, a fellow and lecturer in mathematics at Christ Church, Oxford, wrote *Alice's Adventures in Wonderland* under the pseudonym of Lewis Carroll. Its sequel, *Through the Looking Glass and What Alice Found There*, appeared in 1872. Carroll had wished to illustrate the works himself, but judged that his artistic talent was insufficient. John Tenniel was enlisted to create the images for the books, which no doubt contributed in great measure to their appeal. Carroll had been fascinated with Paton's fairy painting *The Quarrel of Oberon and Titania* of 1849 (cat.33): he counted the fairies and was amazed to find 165. In 1872 he asked Paton to illustrate a new edition of *Through the Looking Glass*; Paton refused and suggested that Tenniel was still the best choice.

Walter Crane belongs to a slightly younger generation of fairy illustrators. As a child of twelve he saved up to buy the 1857 Moxon edition of Tennyson's poems illustrated by Rossetti, Millais and William Holman Hunt. These exquisite black-and-white illustrations had a strong impact on Crane, who was apprenticed to W.J. Linton, a leading wood-engraver of the day. In 1862 he met Edmund Evans, one of the innovators in colour printing, a process which had developed rapidly in the 1850s. Although Evans was not the only publisher in the lucrative children's market, it was with the advent of his toy-books, eight-page colour booklets with wood-engravings for small children, that colour-printed works entered the popular market. Sold for sixpence, these books were an example of the cheap books printed in editions of ten thousand copies to make them commercially viable.

Other artists also drew illustrations for Evans, but he increasingly relied on Crane to design his books and even on occasion to write the text, as for *A Song of Sixpence* and *Mrs Mundi at Home*. The most successful, however, were those with very simple texts, such as alphabets or multiplication tables. Fairy tales had to be abridged, and often the most coherent narrative could be followed not in the words but in Crane's designs. The artist's innovative style incorporated the medieval-inspired decorative devices gleaned from Pre-Raphaelite illustrations and coupled them with his own emerging awareness of the Japanese woodblock masters. Crane wrote that certain aspects of the Japanese print, such as strong black outlines and flat areas of brilliant colour, provided him with an artistic model. His sophisticated designs for simple children's books (fig.31) were appreciated by a number of

artists, architects and designers, including Whistler, who used Crane's books as examples for his clients to demonstrate the effect of avant-garde design.

In 1881 Crane drew 52 illustrations for *The First of May, A Fairy Masque*. Dedicated to Charles Darwin, it was a dramatic May Day fantasy variation on *A Midsummer Night's Dream* written by Crane's old friend and supporter J.R. Wise. Crane illustrated Oscar Wilde's book of fairy tales, *The Happy Prince*, in 1888, and in 1894 an elaborate edition of Spenser's *The Faerie Queene*. He was also involved in designing tableaux and masque sets, including the fairy costumes for *The Snowman* by Arthur Sturgess, staged at the Lyceum Theatre in London in 1899 (see fig.22, p.52).

Although Kate Greenaway did not make fairy illustrations, her idyllic scenes of childhood, steeped in nostalgia, inspired a later generation of illustrators. Such artists as Margaret Tarrant, Cecily Mary Barker, the illustrator of *Flower Fairies*, and Mabel Lucie Attwell were active after the turn of the century, and drew on Greenaway's idyllic world, avoiding the disturbing elements present in the tales of the brothers Grimm and Hans Christian Andersen.

Fig.31 Walter Crane, *Lionel and Beatrice Crane*, from *The Baby's Bouquet: a Fresh Bunch of Old Rhymes and Tunes*, 1878, courtesy Anthony Crane

The fairy theme was revived by the success of Andrew Lang's series of fairy books, beginning with *The Blue Fairy Book* of 1889 and concluding in 1910 after twelve volumes with *The Lilac Fairy Book*. A Scottish classical scholar, poet and folklorist, Lang was helped by his wife, Leonora. He also wrote some of the fairy stories himself; 'The Princess Nobody' was written in 1884 to accompany Richard Doyle's previously published drawings from *In Fairyland*,` superseding the unsuccessful poem by Allingham.

Fig.32 H.J. Ford, 'The Enchantment', Illustration to 'The Story of Ciccu', from *The Pink Fairy Book*, edited by Andrew Lang, Longman, Green & Co., London, 1897

Henry Justice Ford illustrated most of Lang's fairy books (fig.32). He provided both black-and-white illustrations and three or four colour plates surrounded by a decorative border in each book. Ford's art fluently adapted to the variety of stories, incorporating his training as a painter of landscapes and historical themes; he also designed the covers. His work was highly influential and served as the inspiration for Daisy Makeig-Jones, who translated many of Ford's drawings into designs for her Wedgwood Fairyland Lustreware in 1915.

Eleanor Vere Boyle, known as E.V.B., made her first illustrations to accompany nursery rhymes in 1852. John Ruskin praised them saying, 'I never saw anything in modern art to approach them – except the finest work of Millais and Hunt'. Her illustrations show sweet-faced realistic children rather than otherworldly fairies. Her colour illustrations for *The Story Without End* (1870), the 1873 edition of Andersen's *Danish Fairy Legends* and *Beauty and the Beast* (1875) were important in that they utilised the relatively new technique of chromolithography.

Of the many noteworthy illustrators in the 1890s, the Birmingham School artists occupy a unique position, many of them working both for large commercial printers and for private presses run by artists. William Morris visited the Birmingham School of Art, whose work he admired; the Birmingham School artists in turn were greatly influenced by Morris's Kelmscott Press. One of the Birmingham School, Arthur Gaskin, made illustrations for Andersen's *Stories and Fairytales* in 1893 and a new edition of the brothers Grimm's *Household Tales* in 1899, though these remained unpublished. Gaskin was able to reproduce the fine detail and freshness of Morris's medievalism for mass-produced books. The illustration became as dominant as the narrative theme it was to convey. Andersen's tales were also illustrated by Arthur Rackham (1932) and Henry Justice Ford.

Although Arthur Rackham began his career as an illustrator in 1893, his most important commissions belong to the 20th century. His first exhibited fairy painting, shown in 1903 at the Society for Oil Painters, was an enlarged version of his earlier illustration for 'Rumpelstiltskin' in an edition of Grimms' *Fairy Tales* (1900). His skilful and intricate linear style shows the influence of George Cruikshank and Richard Doyle, combined with the more fantastic contemporary work of Aubrey Beardsley. Although Rackham was never himself

an etcher, a contemporary critic for *The Birmingham Post* praised his work thus: 'Rackham reminds me of Cruikshank but he is a far more accomplished draughtsman, owing much, no doubt, to the study of Dürer's etchings, and the engravings of the Little Masters of the German Renaissance'.

In 1905 Rackham was commissioned to illustrate Washington Irving's *Rip Van Winkle* and, in 1906, J.M. Barrie's book *Peter Pan in Kensington Gardens*. Rackham's initial sketches for *Peter Pan* were made in Kensington Gardens, as recorded by his nephew Walter Starkie:

We would sally forth early on a sunny morning and my uncle, loaded with all his paraphernalia of paints, paint-brushes and easel, reminded me of one of the kobolds I had read about in Andrew Lang's Blue Fairy Book; but when we were in Kensington Gardens and the painter had armed himself with his palette and paint-brush, he became in my eyes a wizard who with one touch of his magic wand would people my imagination with elves, gnomes and leprechauns. He would make me gaze fixedly at one of the majestic trees with massive trunk and tell me about Grimm's fairy tales ... and about the little men who blew their horns in elfland. He would say that under the roots of that tree the little men had their dinner and churned the butter they extracted from the sap of the tree. He would also make me see queer animals and birds in the branches of the tree and a little magic door below the trunk, which was the entrance to Fairyland.

Barrie was pleased with Rackham's images, but Rackham was disappointed that Barrie's play *Peter Pan* (1904) was more famous than the book set in Kensington Gardens: 'I think Never-Never Lands are poor prosy substitutes for Kaatskills and Kensingtons, with their stupendous powers of imagination. What power localising a myth has. The Rhine. The Atlas Mountains. Olympia.' In *Peter Pan in Kensington Gardens*, a sense of place is firmly established because actual places in Kensington Gardens are recorded: The Broad Walk, St Govor's Well, the Round Pond and the Serpentine (cat.70). This strange mix of reality and fantasy gives Rackham's illustrations an evocative power, unusual even among such contemporaries as Edmund Dulac, Jessie M. King, Charles Robinson and William Heath Robinson.

In 1906, the same year he completed *Peter Pan*, Rackham illustrated Rudyard Kipling's *Puck of Pook's Hill*, a collection of stories narrated by the character Puck. 'The Dymchurch Flit' (cat.69), like many of Puck's tales, is much more than a fairy story – a necessity of invention that Kipling understood. In this story, the 'pharisees' (as fairies are called in all the Puck stories) have decided to leave England for France to avoid the persecution they expect to endure during the Reformation. They must obtain a boat to carry them across the Channel and thus contact the Widow Whitgift, a mortal who could see and speak to the fairies. They ask her for her boat and the aid of her two sons, one blind and one deaf, to help them on their journey. By relating stories in which the fairies' power was undermined by the realities of the outside world, and then reaffirmed, Kipling was attempting to rekindle interest in fairy literature.

Rackham, who lived until 1939, also continued his work in the fairy genre with two versions of *A Midsummer Night's Dream* (1906 and 1928). After World War I, however, he found that interest in fairies had all but disappeared: the horror of war had destroyed too many fantasies. The Leicester Galleries, which had regularly shown his work, now supported rising British artists such as Wyndham Lewis, Vanessa Bell and Duncan Grant. The demand for illustrated books was also modified to meet significant changes in taste among both the art world and the general public. Black-and-white images acquired an appeal of their own, while artists preferred to use private presses that allowed more control in the entire process of production. They were no longer interested in the controlling flow of the narrative.

Rackham, like his fairies, had to find support for his art away from England during the latter part of his career. He had always had an appreciative audience in America, and increasingly he exhibited and worked on book illustration commissions there. His family is convinced that Walt Disney consulted Rackham before he made his first animated film, *Snow White*, but Rackham never went to Hollywood, unlike his contemporary and fellow illustrator Kay Nielsen, who worked on the Mussorgsky sequence in *Fantasia*. The sense of wonder and magic encompassed in 19th-century fairy illustration was relegated to the nursery shelves, while a new and often much less credible fairy kingdom was constructed.

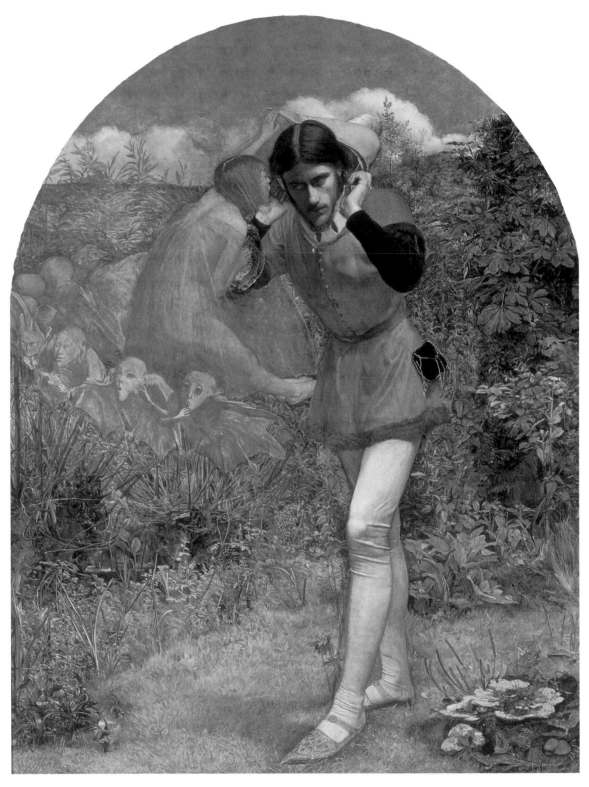

Fig.33 John Everett Millais, *Ferdinand Lured by Ariel*, 1849–50,
oil on panel, 64.8 × 50.8 cm, Private Collection

CHARLOTTE GERE

In Fairyland

Charlotte was sadly out of spirits ... she had been gently but firmly informed that no such things as fairies ever really existed. 'Do you mean to say it's all lies?' asked Charlotte bluntly. Miss Smedley deprecated the use of any such unladylike words in any connexion at all. 'These stories had their origin, my dear,' she explained, 'in a mistaken anthropomorphism in the interpretation of nature. But though we are now too well-informed to fall into similar errors, there are still many beautiful lessons to be learned from these myths.'
(Kenneth Grahame, *The Golden Age*, 1908)

As MODERN industrial progress engulfed the English countryside, the Victorians embraced belief in fairies as a reaction to the disenchantment of the world; by 1908 when Edwardian optimism had overcome the need for it, Charlotte's governess was able to dismiss it with enviable certainty. Fairy painting is the visual evidence of a spectrum of mid-19th-century preoccupations: nationalism, antiquarianism, exploration, anthropology, the dismantling of religious belief and, crucially, the emergence of spiritualism. Its colourful brilliance reflects the influence of the theatre, and its haunting quality is reminiscent of music, an artistic avenue to be explored by Whistler. Later in the century fairy reality would be threatened by studies in the psychology of visual perception and the development of photography and moving pictures. Disdaining the duties imposed on artists – and so prized by Victorian critics – to edify and draw moral conclusions, fairy painters present a world in great contrast to the conventional idea of the Victorian middle class as pious, complaisant, self-satisfied and assured.

In about 1785 William Blake had the notion of equipping his fairies with diaphanous butterfly wings (fig.34), probably derived from depictions of winged putti or of Psyche – personification of the soul – in ancient Greek vase-paintings, on Greek and Roman engraved gems and cameos or on the newly revealed wall-paintings at Pompeii. Blake's aerial nymphs are part of the vocabulary of Neo-classicism, to which the early phase of fairy art belongs (fig.35). The adolescent Psyche figure remained the ideal of fairy femininity, even when surrounded by Gothic grotesques from northern myth. At the outset fairy painters were visionaries. Blake believed in fairies and reported that he had seen a fairy funeral in his back garden. Henry Fuseli

so valued the inspiration of dreams that he went to extraordinary lengths to procure them, for example eating raw meat before he went to sleep. In his paintings of *A Midsummer Night's Dream* he invented a fairy world that was to inspire and influence his pupils and successors. His position as Professor of Painting at the Royal Academy from 1790 until his death was sufficient guarantee that his ideas would be pervasive among the second generation of fairy artists, but it is interesting to find J.A. Fitzgerald utilising Fuseli's goblins as late as 1857 in his *Artist's Dream* (cat.36). The greatest visionary painter of the time, John Martin, was an important influence on the later fairy artists. It does not take much special pleading to include his *Satan on the Burning Lake* (1827, for an illustrated edition of Milton's *Paradise Lost*) among the fairy paintings. The ancient belief that fairies were fallen angels fits well with the Oberon-like figures cast upon the shores of the burning lake.

Images that might have inspired the visions of fairyland in the early 19th century were found in shows of natural curiosities and spectacles of history and travel. In about 1800 painted panoramas and dioramas of exotic locations were first shown to an enthusiastic public. The Colosseum in Regent's Park, a rotunda for the display of panoramas and other scenic installations, was designed by Decimus Burton in 1824–7; it was demolished in 1875. Faithful and detailed landscapes and townscapes, romantically lit, some of them designed to move past the audience on rollers or on metal tracks, gave the illusion of travelling abroad. Volcanic eruptions or fires could be simulated and moonlight effects were popular. Such displays provided suitable topographical material for Prospero's enchanted island in *The Tempest* and for other imaginary fairy realms.

Fig.34 William Blake, *Oberon, Titania and Puck with Fairies Dancing*, *c*.1785, pencil and watercolour, 47.6 × 67.3 cm, Tate Gallery, London

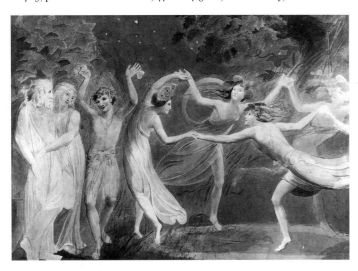

The painted panoramas were the work of theatrical scenery specialists, among them Thomas Grieve and William Telbin, who were responsible for Charles Kean's sensationally illusionistic *A Midsummer Night's Dream* in 1856 (see cat.10).

Also shown at the Colosseum and at the Egyptian Hall in Piccadilly were tropical birds and strange beasts, along with freaks and sports of nature, more material for the realisation of fairyland. General Tom Thumb (Charles Stratton), P.T. Barnum's celebrated 25-inch-high midget, drew enormous crowds to the Egyptian Hall. A medal was issued in 1844 to commemorate the sight of his tiny carriage

Fig.35 John Gibson, *Cupid Pursuing Psyche*, marble relief, 60.9 × 91.4 cm, 1844, made for Queen Victoria, Royal Academy, London

with coachman and postillion and four miniature ponies parading the streets of London. Complete with full court dress, worn for three command appearances before Queen Victoria and the royal family at Buckingham Palace, his perfectly proportioned diminutive stature opened a door to fairy reality. When Tom Thumb married a fellow midget Barnum had the clever notion of exhibiting the doll-sized wedding dress and tiara in a New York store. When the giant waterlily *Victoria regia* was successfully cultivated in the glasshouse at Chatsworth, a child (daughter of its architect Sir Joseph Paxton, later creator of the Crystal Palace) was depicted standing on one of the leaves for *The Illustrated London News* (17 November 1849); dwarfed by the vast leaves she looks like a Doyle fairy (fig.37).

The word 'magic' was frequently invoked in connection with these shows, notably in the case of the Colosseum's 'Gallery of Natural Magic', which featured 'the World of Spirits' and 'Phantoms of a Witches' Sabbath' in 1839. Fairy scenes were enacted as *tableaux vivants* (fig.36) and provided for toy theatres (cat.76), and as optical toys, or phantasmagoria, hugely popular home entertainments in which terror was mixed with fascination. Many devices simulated movement – for example the Zoetrope, an early motion-picture machine – and there was no difficulty in suggesting flight. The barrier between illusion and reality was constantly eroded by these devices and the certainties of a rational society were shaken. At the Great Exhibition in London in 1851, Queen Victoria surveyed the vista of fluttering banners and exhibits from the balcony of Paxton's magical Crystal Palace – of which the rib-like structure was inspired by the underside of the great waterlily leaf – and exclaimed that it 'had quite the effect of fairyland', acknowledgement of the part that lights, rainbow reflections from crystal panes and iridescent colours played in the creation of fairy realms.

Fairy mythology fitted well into the Romantic medievalist's concept of uncorrupted, pre-industrial innocence, since its living beliefs and traditions best survived in remote rural communities where the modern world had still made very little impact – in the Scottish Highlands, in Wales, in Ireland, in Devon and Cornwall and in East Anglia. In the 1840s medievalism was presented as an attractive contrast to the degeneracy of modern society, a theme that was to be developed in John Ruskin's writings. Chivalry was important to the Victorian concept of the Middle Ages, and it forms a key element in

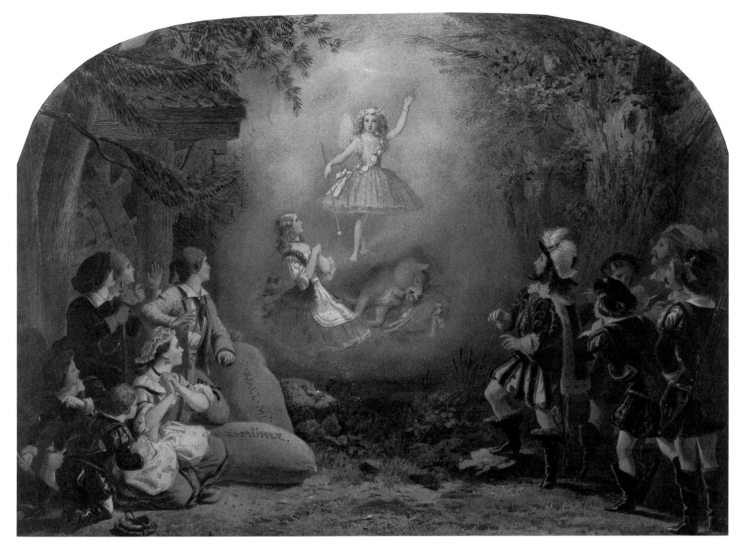

Fig.37 The *Victoria regia* lily in bloom for the first time at Chatsworth, supporting Paxton's daughter, from *The Illustrated London News*, 17 November 1849

Fig.36 Edward H. Corbould, *A Fairy Scene, Rothkappchen*, 1855, showing Queen Victoria's children perfoming *Little Red Riding Hood*, watercolour, 36.5 × 53 cm, The Royal Collection © Her Majesty The Queen

fairy literature and art. In *Fors Clavigera* (1870–74), Ruskin claims a large role for chivalry in shaping an ideal society: 'All that hitherto has been achieved of best – all that has been in noble preparation instituted, – is begun in the period, and rooted in the conception, of Chivalry.' Fairy tales involve rescue of the weak by the strong and noble, and fairy mythology is full of acts performed in secrecy to reclaim the fortunes of the poor.

It may have been the chivalric aspect of Maclise's most celebrated fairy painting, *Undine* (1843; fig.38), as much as its fairy side, that attracted Queen Victoria, who purchased it as a present for Prince Albert. Obviously the German origin of the subject – from la Motte Fouqué's romance – would have seemed to the Queen, herself of predominantly

Philadelphia, its title curiously reflecting that of Cooke's earlier book. It is hardly coincidental that this marks the end of an era in fairy painting, with disturbing visions giving way to dreamy woodland scenes.

The literature and other accounts of fairyland that provided notions of scale and details of costume and habitat in fairy painting ultimately were supposedly derived from literal experiences of finding fairyland or sightings of fairies visiting the human world. Antiquaries and rural historians have collected stories of fairy appearances from country people up to the present day. Cecil Torr, who was born in 1857, reported the fairy phenomena in his Devonshire village in *Small Talk at Wreyland*, first published in 1970. Torr was recording not only tales told him by his grandfather, who had lived at Wreyland since 1837, but his own experiences. 'There is said to be a goblin about a quarter of a mile from here I have never seen the goblin; but I have good evidence that men have been scared by something at night, and that horses have refused to pass there in the day.' He writes also of the box-edged beds by old houses, known as Pixey Gardens, 'As pixies are twelve inches high, these little paths are pretty much the same to them as Devonshire lanes to human beings. I was taught that one could always tell a pixey from a fairy, as fairies wear clothes and pixies go without ...'.

In the early years of the twentieth century there were fairy manifestations in the family circle of Edith Somerville, co-author of the popular books about the hunting experiences of an Irish resident magistrate. Among tales of men of low stature with arms that hung below their knees – the 'ancient tribe' theory given eye-witness authenticity – and of hearing fairy music, there is a circumstantial account of finding a fairy shoe. In the 1920s Dr Somerville took it on an American tour. Examination under a microscope at Harvard University revealed tiny hand-stitches and that the material was mouseskin. (This is reported in articles first published in *Country Life*, 1973, reprinted in *An Ulster Childhood*, 1987.)

The fairies that caused the greatest stir were seen, so it was claimed, in July 1917 by Elsie Wright, aged fifteen, and her cousin Frances Griffiths, aged eleven, at Cottingley in Yorkshire, and they faked photographs of them to support their story. Their cause was taken up by Sir Arthur Conan Doyle, nephew of Richard Doyle and son of Charles, then in the grip of spiritualistic fervour, and he described the incident in *The Coming of the Fairies* (1921). At the end of her life Elsie admitted that the images were faked, saying it was the only way that their sighting of the fairies would be believed.

The diarist James Lees-Milne, in *Ancestral Voices* (1975) recorded a conversation on the subject which he had with the old Duke of Argyll in 1943. 'At tea the Duke talked of fairies in whom he implicitly believes, as do all people here. He described them as the spirits of a race of men who ages ago lived in earth mounds, which are what they frequent. They are usually little green things that peer at you from behind trees, as squirrels do, and disappear into the earth. The Duke has visited numerous fairy haunts in Argyll.'

The focus on folklore had some curious offshoots, as in the lore and language of flowers and plants. Transmitting messages with flowers was suggested in the 1770s by Lady Mary Wortley Montagu in her account of this practice in Turkish harems. By the early 19th century a spurious flower language, derived from Mme de la Tour's *Le Language des Fleurs*, was circulating in bowdlerised form through publications such as Mrs Burke's *Language of Flowers*, published in 1826. These notions were enormously popular, as can be deduced from the greetings cards employing flower imagery with hidden messages.

Ancient beliefs connected with flowers and plants were collected by folklorists. It was said that hawthorn provides the fairies with a hiding place (cat.40), that elder protects witches, and that holly protects against witches. Apparently random customs were explained; for example on his *Rural Rides* William Cobbett (1762–1835) remarked on the holly to be found in Suffolk hedges, without understanding its significance in deterring witches. Orange blossom, traditionally used for the wreaths and bridal bouquets, protects against infertility in marriage. In Dadd's painting *The Fairy Feller's Master Stroke* (cat.27) the rocky hillside is studded with daisies, perhaps a reference to the belief that a decoction of daisy roots could produce diminutive stature. Amelia Jane Murray (1800–1896) connected flower symbolism with fairies in *A Regency Lady's Faery Bower*, which she wrote and illustrated herself, as did Eleanor Vere Boyle in her illustrations to *A Story Without End* by Sara Austin (1868). Flower symbolism taken from Shakespeare, folklore and the language of flowers was employed both by Fitzgerald and Simmons. While Fitzgerald does not flaunt the flower lore in his pictures, it may be that his use of the narcotic

purple convolvulus, signifying 'night' or 'death', is to underline the sinister message of his fairy scenes. Victorian paintings were 'read' by a public well versed in ancient and modern literature, moral precept and flower lore.

The Rev. Hilderic Friend's massive two-volume *Flower Lore* of 1884 may have been behind the Edwardian fascination with flower fairies. Kate Greenaway made an illustrated flower alphabet in 1884 and Walter Crane began his series of 'Flower Books' as early as 1888. The best of the flower fairy artists, for example Eleanor Fortescue-Brickdale (cat.71), Cecily Mary Barker (1895–1973), Florence Mary Anderson (active 1914–30) and Ida Rintoul Outhwaite (1888–1960), are inseparable from memories of childhood. Their works were reproduced in colour by the Medici Society and postcard publishers and used in advertising; examples of these are eagerly collected today.

The lore of precious stones and amuletic and magical jewellery is less evident in fairy painting than flower symbolism, although Simmons seems to use it. Markings on the butterfly wings of his fairies resemble opal and agate, and it is surely no coincidence that opals were considered unlucky. Since the Middle Ages crystals had been used in the Highlands to cure sickness in cattle and even humans. 'Elf-shot' flints (Stone Age flint arrow heads) were mounted in silver and worn as amulets. These beliefs originated in the misuse of holy relics that the medieval Church had been at such pains to eradicate, threatening excommunication to witches and sorcerers and damnation for faith in spells and amulets. Elves were particularly condemned as being conjured up by the Devil to lead people astray.

Fairy artefacts and the mysterious 'lucks' that survive in a number of British ancestral homes were another aspect of folklore. Their history is often hard to establish and proof of their magical reputation can barely be traced before the 18th century. The most celebrated is the enamelled glass beaker known as the 'Luck of Edenhall' – in fact of 13th-century Syrian manufacture – which may conceivably have been brought back by a Crusader, reflecting the idea that the Crusaders had discovered fairyland in the Orient. The fortunes of the Musgrave family at Edenhall in Cumberland were said to depend on their ownership of the beaker, and it was only surrendered in 1926. Also of apparently Near-Eastern or Coptic origin, and dating between the 4th and 7th century AD, is the magical Faerie Flag of the Macleod family, still kept at Dunvegan Castle on the Isle of Skye. Examples of its magic powers in protecting the Macleods are given for two occasions, at the battle of Glendale in 1490 and at the battle of Waternish in 1580. Some fairy artefacts have found their way into museums: the 'Fair Maid of Gatacre', an Elizabethan pendant set with a Roman cameo, as well as the 'Luck of Edenhall' are in the Victoria and Albert Museum, London; a fairy mirror and fairy trow (sword) in the Royal Scottish Museum, Edinburgh, and flint arrow heads – 'elf-shot' – in Brighton Museum.

Fairy imagery is also found in the decorative arts and interior decoration. Sir John Soane commissioned paintings of *A Midsummer Night's Dream* from Henry Howard for his house in Lincoln's Inn Fields. The use that Boydell envisaged for his 'Shakespeare Gallery' can be appreciated in a surviving print room at Stratfield Saye in Hampshire. There Fuseli's fairy paintings from *A Midsummer Night's Dream* take their place in the Shakespearean context for which they were designed. In the 1790s the prints were inset into a golden background almost completely covering the walls of the room, where they remain to this day. When the great Duke of Wellington came into possession of the house he was so taken with this effect that he made a second print room for the house with his own hands.

Fairy – or fairy-tale – schemes were a speciality of William Morris. Apart from Morris's own Red House with its Chaucerian decoration of about 1859, the earliest of these was The Hill at Witley in Surrey (started in 1864), rural retreat of the artist Myles Birket Foster, with its panels of hand-painted tiles illustrating Cinderella and Sleeping Beauty. Mary Howitt, translator of Hans Andersen's fairy tales, had similar tiles: 'I have vastly enjoyed Mr Morris's poems,' she wrote in 1869, 'and thus it is a pleasure to me to think of him in his blue blouse and with his earnest face at "The Firm", and to feel that he is a great poet. I am glad that we had the fairy tale tiles for the fireplace from Morris & Co., their connection with the modern Chaucer gives them a new value and interest'. George Howard's house in Palace Green in London, designed by Philip Webb and decorated by Morris, had a morning-room frieze by Burne-Jones illustrating the legend of Cupid and Psyche. Burne-Jones's masterpiece of fairy-tale decoration, the four paintings of the 'Briar Rose' series completed in 1890 for Alexander Henderson, survives at Buscott Park in Berkshire.

The Gothic revival had encouraged the taste for fairytale castles, both new and restored from neglected ruins. Cardiff Castle and Castel Coch belonged to the millionaire Marquis of Bute, and their rehabilitation was the work of William Burges. Cardiff Castle was haunted, which may have added to its attractions. The first part to be completed in the 1870s and 1880s was the turreted Clock Tower, housing the Bachelor's Bedroom and the Winter and Summer Smoking-Rooms. Here religious imagery, history, Norse legend, Greek myth and Arabian Nights interweave in a rich evocation of an enchanted palace. Fitzgerald was a friend of Burges and collaborated in his decorative schemes, and Burges owned at least two of his paintings. The specific nature of the smoking in Burges's own home is apparent from the painted wardrobe with poppy motif in his bedroom, which had an inconspicuous compartment on the side nearest his bed for bottles of opium.

Throughout the last two decades of the 19th century fairies appeared on Coalbrookdale cast-iron hallstands and garden seats inset with fairy roundels, tiles from Minton & Co. and Wedgwood, and ceramics, textiles and wallpaper designed by Walter Crane. Many fancy-dresses were designed for fairies and fairy princes; the patterns were issued by department stores and the costumes could be ordered from them. The quintessential fairy sculpture, Sir George Frampton's *Peter Pan Memorial* in Kensington Gardens, dates from 1911 (fig.40).

The Glasgow artists, led by Charles Rennie Mackintosh, with his wife and sister-in-law, Margaret and Frances Macdonald, and their colleague, the illustrator Jessie M. King, designed fairies with a spectral quality. Many of them do not have wings and their habitat is no longer realistically drawn. They are part of Continental Symbolism, and belong to the world of myths and legends, not of fairyland. The main thread of fairyland inspiration survived in books and the theatre.

Fig.40 George Frampton, *The Peter Pan Memorial*, bronze, 1908, Kensington Gardens, London

HENRY SINGLETON

BORN LONDON, 1766; DIED LONDON, 1839

Genre, mythological and allegorical painter, also an illustrator
and graphic artist. He was brought up by his uncle William
Singleton, a miniaturist. He exhibited from the age of fourteen,
and entered the Royal Academy Schools, winning both silver
and gold medals (1784 and 1788).

He exhibited 285 works at the Royal Academy and 157
works at the British Institution. His early works were usually
scenes from history, the Bible or Shakespeare, many conceived
on a large scale, several of which were engraved. He also
painted a number of portraits including a group portrait of
Royal Academicians commissioned in 1793. Later he
concentrated on smaller-scale compositions and illustrations
for books, completing a series of Shakespearean illustrations
shortly before his death.

1 Henry Singleton

ARIEL ON A BAT'S BACK

1819 · Oil on canvas, 100.3 × 125.7 cm

TATE GALLERY, LONDON
Bequeathed by the artist, 1840

Singleton was a prolific and facile painter. It was said that if a
subject was suggested to him it would be on the canvas within
five or six hours. In fifty years of exhibiting at the Royal
Academy he regularly included scenes from Shakespeare
among the portraits and history paintings that were the staples
of his professional career. The Shakespearean paintings were
considered to be more successful, since they were usually small,
imaginative and pleasantly coloured. Singleton was a
contemporary of Henry Howard, a reputed fairy painter, and
like him carried on the style of Shakespearean imagery
established by Fuseli and Blake. Singleton's career was nearing
its end before the revolution in theatre production that saw a
new emphasis on authenticity in text, costume and staging, and
before the introduction of sophisticated lighting and
mechanical devices such as high wires for flying.

EXHIBITION: Royal Academy Summer Exhibition, 1819, no.64

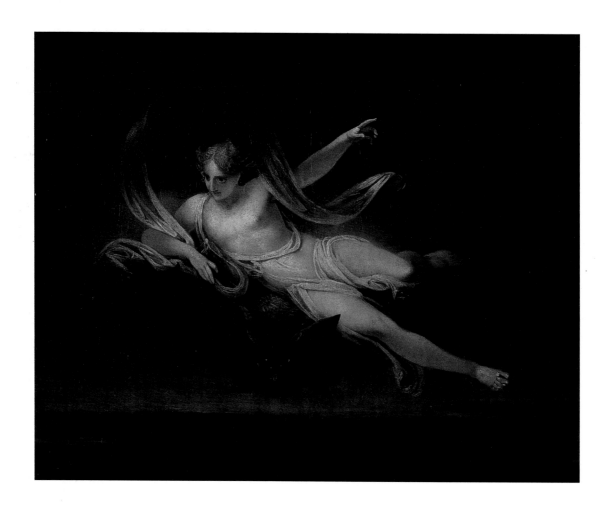

JOSEPH MALLORD WILLIAM TURNER RA

BORN LONDON, 1775; DIED LONDON, 1851

The son of a Covent Garden barber and printseller, he was admitted to the Royal Academy Schools in 1789, and exhibited his first picture there at the age of fifteen. Soon he had begun the first of many sketching tours and became a frequent visitor to Scotland, Wales, the Lake District and most of the counties of England. He painted over 10,000 watercolours during his working life. By 1796 he had also turned to oil painting. He was elected RA in 1802. His first trip to France and Switzerland followed. Appointed Professor of Perspective at the Royal Academy in 1807, he published the first volume of his *Liber Studiorum* the same year. This series of engravings of landscape continued to appear until 1819. In 1843 John Ruskin published his celebrated defence of Turner in the first volume

of *Modern Painters*. During this decade his style became increasingly abstract. His last exhibited landscape was *Rain, Steam and Speed* in 1844, pre-dating both *Queen Mab's Cave* (cat.2) and *Undine* (Tate Gallery) by two years.

2 J.M.W. Turner

QUEEN MAB'S CAVE

1846 · Oil on canvas, 92 × 122.5 cm

TATE GALLERY, LONDON
Bequeathed by the artist, 1856

There is some ambiguity about the subject of Turner's painting since quotations from two different sources accompanied the title in the British Institution's 1846 catalogue. A line from *A Midsummer Night's Dream*, 'Frisk it, frisk it, by the Moonlight beam', is followed by 'Thy Orgies, Mab, are manifold' from *The Tempest*. In a sense the exact location of Queen Mab's cave

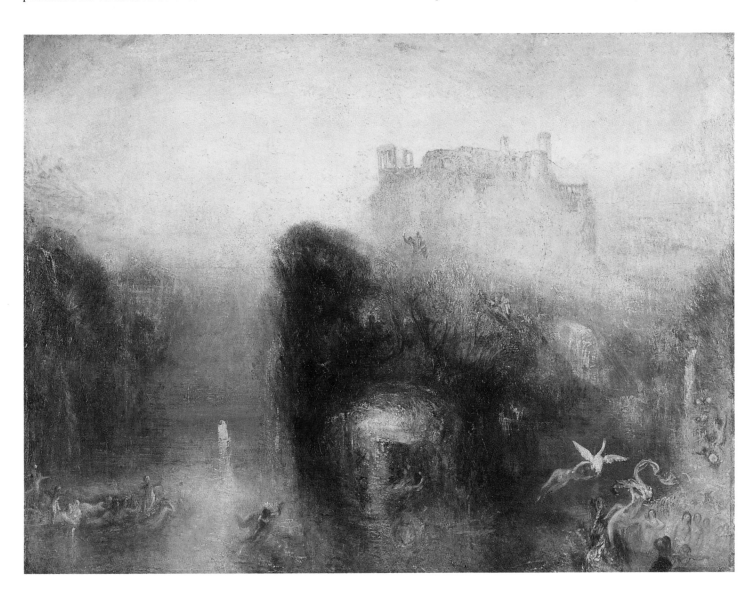

is unimportant; Turner is playing with subject-matter within his own 'vague, illusive, and fanciful' vision (to quote *The Art Union*'s response to the picture). The same critic continued: 'and full advantage is taken by the artist to play with the means he commands to produce a daylight dream in all the wantonness of gorgeous, bright and positive colour, not painted but apparently flung upon the canvas in kaleidoscopic confusion'. Ruskin sorrowfully concluded that the painting was a failure. It has been suggested that *Queen Mab* was painted in response to Danby's fairy subject of 1824, *An Enchanted Island* (private collection).

PROVENANCE: Turner Bequest, 1856; transferred to the Tate Gallery, 1954

EXHIBITIONS: British Institution, 1846, no.57; *Berlioz,* Victoria and Albert Museum, London, 1969, no.111 (illus.); *J.M.W. Turner*, Royal Academy, London, 1974, no.B42

REFERENCES: *The Art Union*, March 1846, p.76; Ruskin, 1906–12, IV, p.342; Martin Butlin and Evelyn Joll, *The Paintings of J.M.W. Turner*, New Haven and London, 1977, pp.239–40; London, 1988, no.21

ALFRED EDWARD CHALON RA

BORN GENEVA, 1780; DIED LONDON, 1860

Huguenots born in Geneva, Chalon and his brother settled in London. After studying at the Royal Academy Schools from 1797 Alfred became a successful portrait painter, watercolourist and miniaturist. He was a founder member of the Sketching Society, and was appointed Painter in Water Colours to Queen Victoria – his portrait of the young Queen appeared on some early colonial stamps. He also painted numerous portraits as miniatures on ivory.

In 1832 the Italian dancer Maria Taglioni had been swept to fame with her romantic creation *La Sylphide* (see cat.3); the same year Chalon exhibited her portrait as 'La Bayadère' at the Royal Academy. Between 1801 and 1860 he exhibited 396 works at the Royal Academy, including contemporary and historical genre subjects, some in oils. He was elected RA in 1816. Some of his portraits of opera singers and actresses are in the National Portrait Gallery, London.

3 Alfred Edward Chalon

LA SYLPHIDE: *SOUVENIR D'ADIEU*

Six scenes of Marie Taglioni in the title role of the ballet

1845 · Watercolours on paper heightened with white, each: 40.6 × 27.9 cm
Signed and dated in gold *AEC R.A. &c,&c. 1845.*, and numbered 1–6

PRIVATE COLLECTION, LONDON

1. La Sylphide hovers beside the seated sleeping James (Act I)

2. Standing on the window ledge, La Sylphide mourns James's betrothal to his childhood sweetheart, Effie (Act I)

3. La Sylphide, the ethereal creature, dances for James (Act I)

4. James, having deserted Effie, presents La Sylphide with a

nest of a sister creature of the air. Alarmed, she flies to the tree tops to replace it (Act II)

5. Despairing of her fleeting visits, James captures La Sylphide with a scarf bearing some witches' evil curse. Struck by a fatal blow, her wings fall to the ground (Act II)

6. Marie Taglioni as La Sylphide takes her curtain call with a posy of flowers

Marie Taglioni (1804–1884) first appeared in the two-act version of *La Sylphide* at the Paris Opéra (Académie Royale de Musique) on 12 March 1832; it transferred to the Theatre Royal, Covent Garden, on 26 July 1832. Of the critics *The Times* proclaimed that her dancing had become 'an art worthy to rank with poetry and painting' while *The Athenaeum* (28 July 1832) found that 'the terms of praise are almost exhausted on this perfect – this preter-perfect – this preter-pluperfect creature'. Subsequently performed throughout Europe, *La Sylphide* became the triumph of Romanticism in ballet, and Taglioni's reputation in the role remained unsurpassed.

In the original 1832 production, music was by Jean Schneitzhoeffer, scenery by Pierre-Luc-Charles Ciceri, costumes by Eugène Lami and choreography by Filippo Taglioni, Marie's father. The most authentic revival of this ballet today can be seen at the Royal Danish Ballet, where a version first created in 1836 is still in the repertoire. As Ivor Guest has noted in his *Romantic Ballet in Paris*, 'after La Sylphide … the Opéra was given over to gnomes, ondines, salamanders, elves, nixes, wilis, peris, to all those strange, mysterious folk who lend themselves so wonderfully to the fantasies of the Maître de Ballet'.

These six watercolours were executed by Chalon almost certainly from Jules Perrot's specially shortened one-act production of *La Sylphide* in 1845. They were probably ordered from Chalon by the print publisher John Mitchell, as all six watercolours are identical to the six lithographs of Taglioni, entitled the 'Souvenir d'Adieu', published by Mitchell from his premises at 33 Old Bond Street, London, on 15 September 1845 to mark the forty-year-old ballerina's first farewell performance in London (Taglioni finally retired in 1847). The lithographs, by R.J. Lane, J.S. Templeton, Edward Morton, J.H. Lynch and T.H. Maguire, were also published in Paris.

PROVENANCE: Sold Christie's, 24 February 1866, lot 63; sold John Mitchell, Christie's, 22 July 1875, lots 27–32; bought Thomas Miller McLean, Belsize Park, London; by descent Malcolm P.M. McLean, West Reynham, Norfolk, until 1949; sold Christie's, 20 January 1970, Miss Helen M. McLean, Hastings, lot 46; Fine Art Society, London; Private Collection, London

EXHIBITIONS: Musée Rath, Geneva, *Deux Artistes Genèvois en Angleterre*, 1971, nos.7–12; Victoria and Albert Museum, London, *The Chalon Brothers*, 1981

REFERENCES: Ivor Guest, *The Romantic Ballet in England*, London, 1954, repr. 1972, pp.57–8; *idem, The Romantic Ballet in Paris*, London, 1966, pp.9–10, 112–17

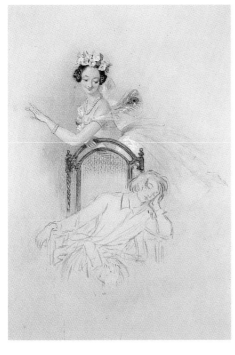

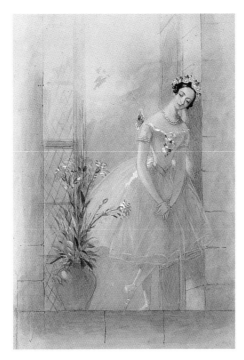

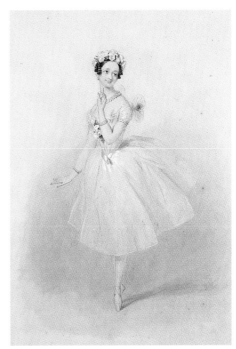

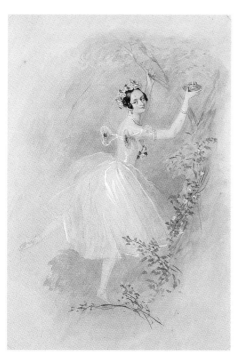

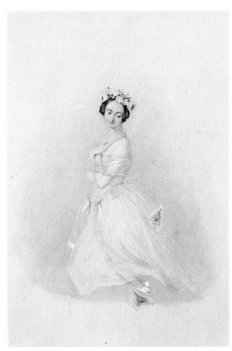

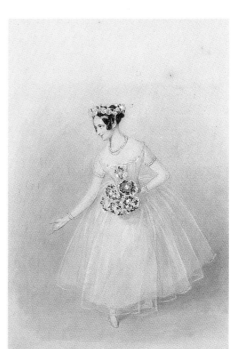

WILLIAM B. ESSEX

BORN c.1784; DIED BRIGHTON, 1869

Enamel painter to King William IV and Queen Adelaide, and to Queen Victoria and Prince Albert. He specialised in the reproduction in enamel miniature of famous paintings and portraits. Although he rarely initiated original subjects, like his contemporary Henry Bone he was regarded as an artist and remunerated accordingly. He had a flourishing studio with pupils in Regent's Park and exhibited at the Royal Academy from 1818 to 1864.

4 William B. Essex

PUCK (after Sir Joshua Reynolds)

1847 · Enamel on copper, 45 × 42 cm

THE BOARD OF TRUSTEES OF THE VICTORIA AND ALBERT MUSEUM, LONDON

Essex made a faithful reproduction of Sir Joshua Reynolds's painting of *Puck* (private collection, England). Reynolds introduced the impish child who would play this role in various media throughout the 19th century. The picture was created in 1789 for Boydell's Shakespeare Gallery at a cost of 100 guineas and was the most successful of Reynolds's Shakespearean subjects. Acquired by the poet Samuel Rogers at the Boydell sale in 1805 for over £200, it 'excited such admiration that there was a general clapping of hands'. At Rogers's sale in 1856 Earl Fitzwilliam acquired it for 980 guineas, evidence of the continuing high regard in which it was held. It was shown at the Manchester Art Treasures Exhibition in 1857.

EXHIBITION: Royal Academy Summer Exhibition, 1847, no.682

GEORGE CRUIKSHANK

BORN LONDON, 1792; DIED LONDON, 1878

Illustrator. His parents were Scottish, and he was largely self-taught. He dedicated his long life to creating a caricaturist's record of the political events and social customs of the era; his illustrations carried an underlying moral purpose. From c.1819 he concentrated increasingly on book illustrations, in which fairies, elves or devils frequently appeared; most notable in this genre are his illustrations to Grimm's *German Popular Stories* (1823, 1826; fig.25, 26, p.56). By 1836 he had begun to illustrate the novels of Charles Dickens and Harrison Ainsworth. His publication of *The Bottle* in 1847 marked the beginning of what was to become a near-fanatical obsession with teetotalism; even fairy stories were used as temperance tracts. Better known for his etchings and watercolours, Cruikshank on occasions would paint in oils. He exhibited at the Royal Academy and the British Institution.

5 George Cruikshank

A FANTASY, THE FAIRY RING

c.1850 · Watercolour over graphite with touches of bodycolour, 37.1 × 50 cm
Signed: *Geo. Cruikshank*

THE BRITISH MUSEUM, LONDON (CRUIKSHANK COLLECTION)

The Fairy Queen sits in the centre of a ring of dancing figures, surrounded by a fairy band with trumpeters. A goblin with points of light at his fingers and head rides on a bat silhouetted in front of a crescent moon. The dark shapes of foxgloves, or 'fairy gloves', nod their heads at the side. Marginal sketches of grotesque figures and a large frog surround the central scene. Cruikshank's illustrations to the first English translation of the brothers Grimm in 1823 made his reputation as a fairy artist. There is evidence in his work of a knowledge of folklore and fairy myth and legend: this watercolour conveys the mysterious atmosphere of fairy sightings, dusk and distance making the scene indistinct and emphasising the fairy luminescence. The suggested date of 1850 reflects the relationship of the watercolour with Cruikshank's frontispiece for the revised and enlarged edition of Thomas Keightley's *Fairy Mythology* (1850), which shows the same fairy ring and tall foxgloves, but with the addition of a giant and of subterranean fairy realms (fig.24, p.54).

PROVENANCE: Bequeathed to the Museum by Mrs Eliza Cruikshank, widow of the artist, 1886

EXHIBITIONS: London, Victoria & Albert, 1974, no.382; Rhode Island, 1979, no.61

FRANCIS DANBY ARA

BORN COMMON, NEAR WEXFORD, 1793; DIED EXMOUTH, 1861

Landscape artist. Danby studied at the Royal Dublin Society and from 1812 with James O'Connor. The following year Danby and O'Connor travelled to London and Bristol. Finding himself without sufficient funds for the return journey Danby settled in Bristol until 1824. Many of Danby's subjects were drawn from imaginative or historical sources. His poetical painting, *An Enchanted Isle* (1824), also included figures of nymphs and fairies. He was elected ARA in 1825, and two years later was contemplating a large oil to be entitled *Fairie Land*. Having lost to Constable in election to full membership of the Academy and with his reputation shaken by a matrimonial scandal, Danby eloped to the Continent in 1829. His fairy scenes (cat.6, 7) were painted apparently as a result of commissions. Like many of his landscapes they rely on moonlight for illumination.

Danby returned to London in 1841, and over the next years painted both scenes from Shakespeare (*The Tempest*, 1846) and other enchanted scenes including *The Wood Nymph's Hymn to the Rising Sun* (1845), which was purchased by Lord Northwick. Danby, always interested in boat building, moved to Exmouth in Devon in 1847.

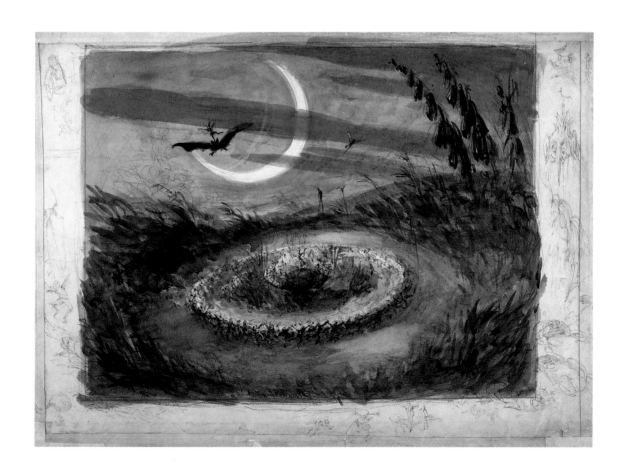

84

The Palace of Theseus (Act V, Scene II)
Watercolour and bodycolour, 25.1 × 35.8 cm

Thomas Grieve's watercolour records the typically lavish set designed by Frederick Lloyds. The souvenir booklet sold at this production of the *Dream* boasted, in words that were less a dream than a monument to Athenian culture, that 'The Acropolis, on its rocky eminence, surrounded by marble temples, has been restored, together with the Theatre of Bacchus, wherein multitudes once thronged to listen to the majestic poetry of Aeschylus, Sophocles, and Euripides …'. Write-ups of this type led to the criticism that Kean's productions consisted of a succession of magnificent pictures periodically interrupted by recitations of Shakespeare.

The first night, attended by Queen Victoria and Prince Albert, marked the début in the role of Puck of the great actress Ellen Terry (1847–1928), aged nine. She is represented by the small figure in the front row.

The Palace of Theseus with the Dance of the Fairies
(Act V, Scene II)
Watercolour and bodycolour, 25.1 × 35.8 cm

Ellen Terry in her role as Puck is seated cross-legged on the left, in the same pose as she is portrayed in a photograph by Adolphe Beau seated upon a mechanical mushroom (see fig.14, p.42). In this scene Puck enters: '… sent with broom before / To sweep the dust behind the door', and, after Oberon and Titania and the fairies have danced, draws the play to a conclusion by begging the audience's pardon with the lines:

> *If we shadows have offended,*
> *Think but this, and all is mended*
> *That you have but slumber'd here*
> *While these visions did appear ….*

Woodland Scenery
Watercolour and bodycolour, 17.2 × 53 cm
Inscribed on the back: *Moving Diorama*

'Moving dioramas' consisted of tall canvases of enormous length wound round a concealed spool which were unwound horizontally across the proscenium on to a second spool. The earliest seems to have been a series of views 'of the most magnificent buildings in London' which was displayed in Drury Lane's Christmas pantomime *Harlequin Amulet* in 1800. 'Moving panoramas', or 'dioramas', became a regular feature of such entertainments, frequently painted by such distinguished artists as Clarkson Stanfield or David Roberts. The famous clown Grimaldi often performed in front of a moving background, as in 1824, when he mimed a balloon trip from London to Paris before a panorama.

In this design the Grieve team modified the idea in this relatively small 'moving diorama'. The effect of fairies flying one way against a slowly moving woodland scene moving the other way must have been magical.

RICHARD JAMES LANE ARA

BORN ?HEREFORD, 1800; DIED LONDON, 1872

Engraver, lithographer, sculptor and draughtsman. Lane was great-nephew to Thomas Gainsborough and the foremost English practitioner of lithographic portraits. At the age of sixteen he was apprenticed to the engraver Charles Heath, but turned to lithography. He exhibited between 1824 and 1872 and was much admired by the young Princess Victoria, who made him her Lithographer in Ordinary in September 1837, only three months after she became Queen. His first portrait of the Princess dates from 1829 when she was ten, and he worked for her until 1859. She made admiring references to him in her *Journal* – 'He draws beautifully … he is the best lithographer in this country. He is besides a very modest, gentle, pleasing, clever and nice-looking young man' – and she much enjoyed his company as he 'talked agreeably about the painters and professional people he knows' (Delia Millar, *The Victorian Watercolours and Drawings in the Collection of Her Majesty The Queen,* London, 1995, I, p.530). Lane was a friend of Charles Macready, and indeed his speciality was theatrical portraits: he reproduced two of Chalon's portraits of Marie Taglioni (cat.3).

11 R.J. Lane

'MERRILY, MERRILY SHALL I LIVE NOW', PRISCILLA HORTON AS ARIEL IN *THE TEMPEST*

1838 · Lithograph with touches of colour, 29 × 22.5 cm
Inscribed: *Priscilla Horton*; *Lane*

THE BOARD OF TRUSTEES OF THE VICTORIA AND ALBERT MUSEUM, LONDON (THEATRE MUSEUM)

The delicate medium of lithography only lightly touched with colour probably gives a better idea of the impression created by Priscilla Horton's performance than the solid being portrayed by Maclise (cat.16). The print bears the date of the first night of Macready's production. Also in the audience was the young George Scharf, known for his topographical drawings of London, who was busy sketching the appearance of Ariel flying from the wings high above the stage. Scharf's etchings of scenes from all the plays in this memorable season at the Theatre Royal were collected in a book, of which only a very few copies were issued; they convey, better than any other report, the magic of these occasions.

EXHIBITION: Brighton, 1980, no.C2b

SIR EDWIN HENRY LANDSEER RA

BORN LONDON, 1802; DIED LONDON, 1873

Painter and designer. The son of an engraver, he studied with Benjamin Haydon and entered the Royal Academy Schools at the age of fourteen. He exhibited his first pictures at the Royal Academy when only twelve years old, and went on to show a further 177 during his lifetime. He was elected to the Academy before he was thirty and received many commissions from Queen Victoria. Many of his works were engraved, increasing his popularity still further. Among his most famous images are *The Old Shepherd's Chief Mourner*, *Dignity and Impudence*, *The Monarch of the Glen* and *The Stag at Bay*.

He was knighted in 1850, but towards the end of his life suffered from depression and refused the Presidency of the Royal Academy in 1865. His famous bronze lions in Trafalgar Square were erected in 1868.

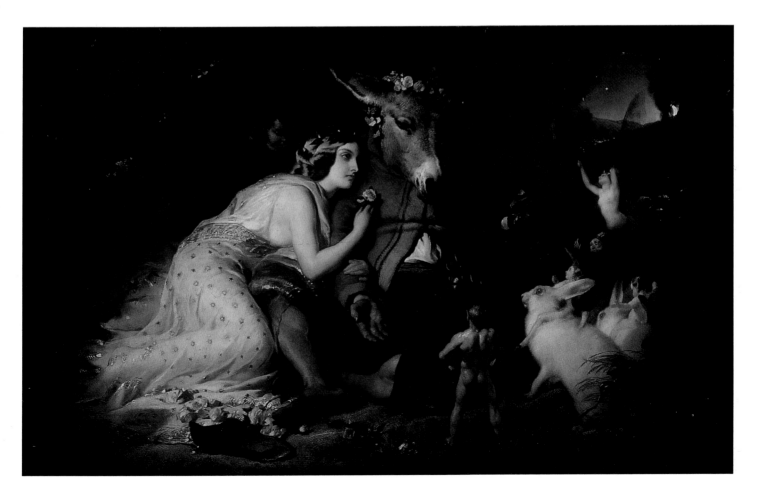

Michael Sadleir, observed that the text was written around existing paintings, rather than *vice versa*. Among them were Maclise's *Faun and the Fairies* (cat.15) and E.T. Parris's *The Visit at Moonlight* (cat.8). The book provided considerable exposure for the fairy imagery at a time when fairy painters were looking beyond Shakespeare for subject-matter.

PROVENANCE: From the Library of Sir Edward Bulwer Lytton, Knebworth House

REFERENCE: Michael Sadleir, *Bulwer and his Wife, a Panorama, 1803–1836*, London, 1931, p.305

15 Daniel Maclise
THE FAUN AND THE FAIRIES

Before 1834 · Oil on board, 43.2 × 37.5 cm

MR AND MRS A. ESSEX

The malevolent faun, half Pan and half Green Man, playing his pipes, with his hair transformed into fruiting vines, presides over a cave in which three grotesque goblin figures crouch. A full moon above his head is partly obscured by an owl. The framing of the scene with fairies and goblins was a common device for Maclise at this date; the outer border is formed by a double rainbow, probably magically significant. Maclise's painting was made for Edward Bulwer Lytton (later Lord Lytton) and was originally called *Pan and the Dancing Fairies*; it was not exhibited. In 1834 it was engraved by Frederick Bacon and used as an illustration to Lytton's *Pilgrims of the Rhine* (cat.14), accompanying an episode entitled 'The Complaint of the last Faun', in which the faun has been persuaded to play for the fairies and goblins to dance; the descriptive text follows closely the details of the composition.

EXHIBITION: Brighton, 1980, no.D60

REFERENCES: James Dafforne, *Pictures by Daniel Maclise R.A.*, London, [1873], p.51; Phillpotts, 1978, pl.8

16 Daniel Maclise
PRISCILLA HORTON AS ARIEL

c.1838–9 · Oil on panel, 68 × 54 cm

FROM THE RSC COLLECTION WITH THE PERMISSION OF THE GOVERNORS OF THE ROYAL SHAKESPEARE THEATRE, STRATFORD-UPON-AVON

William Macready's production of *The Tempest*, which opened at the Theatre Royal, Covent Garden, on 13 October 1838, caused great excitement and was almost universally acclaimed. It was remarkable for the magnificence and attention to detail in the staging, but its chief claim to fame was that Macready had restored the text to its original form after more than a century of adaptation and emasculation. Priscilla Horton stole the show with her 'gentle' Ariel. She had learned the art of flying on wires, and sang 'Merrily, Merrily Shall I Live Now' while suspended high above the stage.

EXHIBITIONS: National Portrait Gallery, London, 1972; Brighton, 1980, no.C2a

17 Daniel Maclise
MOORE'S IRISH MELODIES

by Thomas Moore, Longman, Brown, Green & Longman's, London, 1846
Rebound, 280 pp., closed 27 × 19 cm; numerous full-page plates, borders
and ornaments by Maclise
Open to show the illustration to 'The Time I Have Lost in Wooing',
pp.120–21, engraved by F.P. Becker

ROYAL ACADEMY OF ARTS, LONDON

Moore's *Irish Melodies* were set to music by Sir John Stevenson
(1807–1834); the songs, including 'The Minstrel Boy', 'Believe
Me, if all those Endearing Young Charms' and 'The Harp that
Once Through Tara's Halls', proved exceedingly popular in an
age when singing to piano accompaniment was a desirable
amateur accomplishment. Publications such as this, in gift book
format, were destined for the Victorian drawing room, and
provided a valuable source of work for illustrators. Maclise had
made his reputation working for *Fraser's Magazine*, but the
flowing naturalistic borders and teaming company of
imaginary figures decorating these pages far surpass anything
that he had previously attempted. The inspiration derives
ultimately from German sources, in particular from the work of
F.A.M. Retzsch (1779–1857), as a correspondent commented in
reviewing Maclise's work for *The Athenaeum*. Maclise
borrowed from Retzsch's *Outlines to Shakespeare* for his own
Shakespearean compositions.

DAVID SCOTT

BORN EDINBURGH, 1806; DIED EDINBURGH, 1849

He was the fifth son of Robert Scott, an Edinburgh engraver, architect and stern Calvinist; his younger brother was the artist and writer William Bell Scott (*q.v.*). He studied at the Trustees Academy, Edinburgh, from the age of fourteen, and exhibited at the Royal Scottish Academy from 1828, being elected an Academician the following year. In 1832–4 he studied in Rome and Paris, returning to Edinburgh where he hoped to revive a tradition of grand historical painting. His large and ambitious pictures, usually of biblical and mythological subjects, show an intense and imaginative spirit. Shakespeare was another source of inspiration, with *Ariel and Caliban* (cat.18) and *Puck Fleeing before the Dawn* (cat.19) both being painted in 1837. The same year his 25 line illustrations to Coleridge's *Ancient Mariner* were published. In 1842–3 he worked on his entry for the competition to decorate the new Houses of Parliament, but his work attracted no attention.

Scott had admirers, including the Pre-Raphaelites, who later praised his bold use of colour, but during his lifetime his work met with little public approval. Among his last works were illustrations to *The Pilgrim's Progress*, engraved after his death. Highly sensitive, and racked not only by ill health but by religious doubt and profound disappointment, he died aged 43. William Bell Scott produced a *Memoir* of his brother the following year.

18 David Scott *overleaf above*
ARIEL AND CALIBAN
1837 · Oil on canvas, 116.8 × 97.8 cm
NATIONAL GALLERY OF SCOTLAND, EDINBURGH

This and *Puck Fleeing before the Dawn* (cat.19), also dating from 1837, were exhibited at the Royal Scottish Academy in 1838, together with two paintings by Scott of classical subjects. The artist attempted to invest his Shakespearean pictures with grandeur, taking them well beyond the merely illustrative. His critics were baffled by his strange vision – one saying that he had 'the imagination of madness' – but more recently he has been compared to Blake in the originality of his artistic ideas. In the *Memoir* of his brother, William Bell Scott wrote that *Ariel and Caliban* was 'the most truly poetic production of the painter'. He believed that his brother intended the figures to represent 'the two poles of human nature; the ascending and descending forces of mind and matter'.

PROVENANCE: In the artist's studio at the time of his death, 1849
EXHIBITIONS: Royal Scottish Academy, 1838; Bonnar and Carfrae, Edinburgh, 1849; Brighton, 1980, no.D78
REFERENCE: William Bell Scott, *Memoir of David Scott, R.S.A.*, Edinburgh, 1850, pp.206–9, 349

19 David Scott *overleaf below*
PUCK FLEEING BEFORE THE DAWN
1837 · Oil on canvas, 95.3 × 146.1 cm
NATIONAL GALLERY OF SCOTLAND, EDINBURGH

The two paintings exhibited here are Scott's most ambitious essays in the Shakespearean fairy genre. He has broken away from the compelling model created in 1789 by Reynolds (see cat.4) with a most original vision of Puck, curled up holding his knees, like a ball shot from a cannon, as he catapults himself through the night sky.

EXHIBITIONS: Royal Scottish Academy, 1838; Brighton, 1980, no.D79; *David Scott, 1806–1849*, ed. M. Campbell, National Galleries of Scotland, Edinburgh, 1990, p.22 (illus.)
REFERENCE: William Bell Scott, *Memoir of David Scott, R.S.A.*, Edinburgh, 1850, p.206

THEODORE VON HOLST

BORN LONDON, 1810; DIED LONDON, 1844

Painter and draughtsman. His family came from Mecklenburg but had settled in Riga (Latvia) before moving to London. He studied at the Royal Academy Schools from the age of ten, where he became a favourite pupil of Henry Fuseli. Fuseli's style greatly influenced Von Holst, who became a noted draughtsman with a fine, often theatrical, style and colour sense; on occasions he included sprites and other supernatural creatures in his pictures. He first exhibited at the Royal Academy in 1829 and continued to exhibit both there and at the British Institution throughout his life.

Many of his subjects were taken from literature – Dante, Scott, Byron, Shakespeare and Goethe – while some were of his own romantic, and sometimes eccentric, invention. In 1831 he illustrated an edition of Mary Shelley's *Frankenstein*, and ten years later was awarded a prize of 50 guineas by the British Institution for *The Raising of Jairus's Daughter*. Rossetti, and other Pre-Raphaelites, greatly admired his work.

21 William Bell Scott

COCKCROW

1856 · Oil on canvas, 55.8 × 71.4 cm
Signed: *William B. Scott*; signed and dated on reverse: *William B. Scott 1856*

RHODE ISLAND SCHOOL OF ART AND DESIGN

The subject is taken from the poem 'A Fairy Tale' by Thomas Parnell (1679–1718). The title, the poet's name and the relevant lines (slightly altered) are inscribed on the painting's stretcher. 'Here ended all the phantom show/ They smelt the fresh approach of day/ And heard a cock to crow'. There are echoes of this scene in Fitzgerald's picture of fairies looking through a

Gothic arch (cat.47). The minute naturalism of the grass-grown churchyard is a legacy of Scott's association with the Pre-Raphaelites. In 1862 he presented the picture, which retains its original frame, to his companion and patron, Alice Boyd, to commemorate the third anniversary of their meeting.

PROVENANCE: Miss Alice Boyd, 1862; by family descent; sold to Stone Gallery, Newcastle; Maas Gallery, London; bought by the Rhode Island School in 1978 (Helen M. Danforth Fund)

EXHIBITIONS: *Victorian Fairy Paintings, Drawings and Watercolours*, Maas Gallery, London, 1978, no.53; Rhode Island, 1979, no.201

REFERENCE: Beatrice Phillpotts, 'Victorian Fairy Painting', *The Antique Collector*, 49, no.7, July 1978, p.80

RICHARD DADD

BORN CHATHAM, 1817; DIED BROADMOOR, BERKSHIRE, 1886

Painter. Dadd's early paintings were of landscape, marine and animal subjects. He entered the Royal Academy Schools in 1837 and became a founder member of a group of artists known as 'The Clique'. Paintings such as *Titania Sleeping* (cat.23) anticipate the extraordinary compositions of later years.

In 1842 Dadd travelled to the Middle East with his patron, Sir Thomas Phillips. The exhilaration of the journey was such that Dadd already doubted his own sanity on his return to London. He entered the competition for the decoration of the Houses of Parliament, but after his design was rejected his mental health deteriorated, resulting in the murder of his father in August 1843. Dadd fled to France but was arrested and admitted to Bethlem Hospital (Bedlam). His schizophrenia was recognised and he was allowed materials to continue his painting in both oils and watercolours. His *Contradiction: Oberon and Titania* (cat.26) and *The Fairy Feller's Master Stroke* (1855–64; cat.27) both date from this period and were worked on with the intensity of a man possessed. Two of his fairy paintings made before his incarceration were shown at the Manchester Art Treasures exhibition in 1857. He spent the last 22 years of his life at Broadmoor Hospital, where he died.

22 Richard Dadd
THE HAUNT OF THE FAIRIES

*c.*1841 · Oil on canvas, oval: 56 × 47.3 cm

THE FORBES MAGAZINE COLLECTION, NEW YORK

This forms part of a group of fairy subjects, including '*Come unto These Yellow Sands*' (fig.6, p.20), *Titania Sleeping* (cat.23) and the circular *Puck* (private collection), all dating from the early 1840s before Dadd's madness declared itself in 1843. He made a less than half-size repetition of this subject at about the same date, entitled *Evening*.

PROVENANCE: Thomas Agnew, 1854 and 1856; sold Christie's, 18 February 1884, no.439; 1978, Fine Art Society, London, 1978
REFERENCE: London, 1974, no.60; Brighton, 1980, no.D23

23 Richard Dadd *overleaf*
TITANIA SLEEPING

*c.*1841 · Oil on canvas, 64.8 × 77.5 cm

MUSÉE DU LOUVRE, PARIS

Dadd was an admired fairy painter before his confinement in the Bethlem lunatic asylum, having received good critical reactions for '*Come unto These Yellow Sands*' from *The Tempest*, this picture of *Titania Sleeping* and its companion *Puck*. Since his Bethlem works, arguably now the two most famous 19th-century fairy subjects, *Contradiction: Oberon and Titania* and *The Fairy Feller's Master Stroke*, were unknown during his lifetime, it was through these fairy pictures of the early 1840s that he was judged by his contemporaries. *Titania* and *Puck* were the only representatives of the fairy genre to be shown in the exhibition *Art Treasures of the United Kingdom* at Manchester in 1857.

This scene from *A Midsummer Night's Dream* shows Titania being lulled to sleep by her attendants in her bower of wild thyme, oxlips, violets and woodbine. The picture was exhibited at the Royal Academy with the quotation from Oberon's speech at the end of Act II, Scene II: 'There sleeps Titania sometime of the night / Lull'd in the flowers with dances and delight'. Dadd has borrowed a device from Maclise's *Undine* (fig.38, p.66) and *The Faun and the Fairies* (cat.15), encircling the brilliantly lighted central group with flowers and flying fairies, a borrowing that was noticed by the reviewer in the *Literary Gazette*: 'A small production and near the ground, but one that promises greater efforts to the clever young artist. The conception of the fairy circle boasts of originality, even after the hundreds of times it has been painted ...'. Other borrowings, from Giorgione's *Adoration of the Shepherds* (*c.*1505, Kunsthistorisches Museum, Vienna) and from Poussin's *Bacchanals*, for instance, indicate how widely knowledge of foreign schools and earlier works was disseminated through prints.

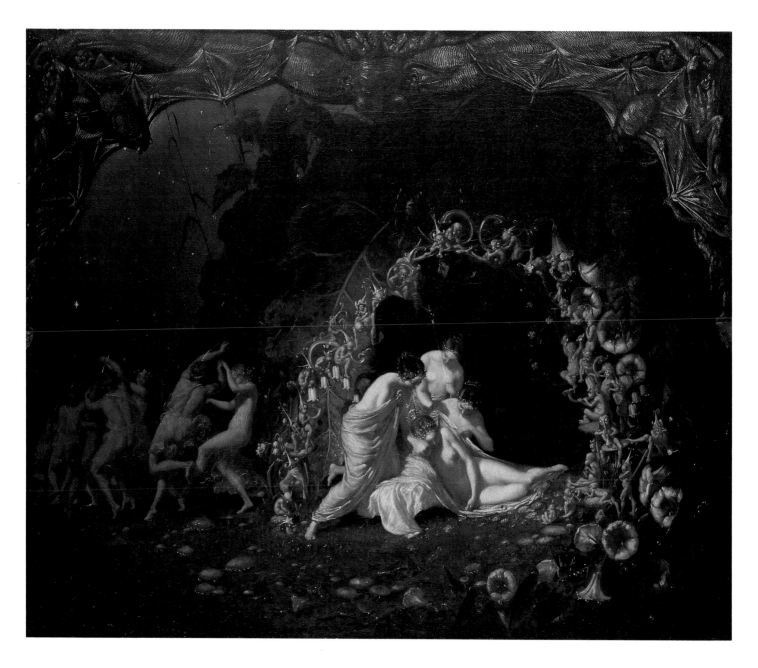

Dadd's fairy pictures of the 1840s were to be enormously influential on his successors, notably Huskisson (cat.28, 29) and Fitzgerald, whose *Fairies in a Bird's Nest* (cat.41) transforms Dadd's encircling flowers and fairies in his *Titania* into the twiggy material of which the nest is composed.

PROVENANCE: H. Farrer, bought from the Royal Academy, 1841; Samuel Ashton, 1857; Thomas Ashton; Col. C.H. Wilkinson, 1960; Miss V.R. Levine; Peter Nahum; bought Musée du Louvre, 1997

EXHIBITIONS: Royal Academy, 1841, no.207; *Art Treasures Exhibition*, Manchester, 1857, no.477; London, 1974, no.57

24 Richard Dadd

THE BOOK OF BRITISH BALLADS

Edited by Samuel Carter Hall, 1st series published by Jeremiah How, London, 1842; 2nd series, London, 1844
Both volumes covered in buff cloth with stamped Moorish-style arabesques in gold and blue to the spines, front and back covers; closed 27 × 19.6 cm

THE BRITISH MUSEUM, LONDON (ROBIN DE BEAUMONT COLLECTION), 1992-4-6-124 (1 AND 2)

The Book of British Ballads, 1st series
Open to show illustrations by Richard Dadd to 'Robin Goodfellow', wood engraving by W.J. Green, pp.86–90

The Book of British Ballads, 2nd series
Open to show illustrations by Alfred Crowquill (pseudonym of A.H. Forrester) to 'The Luck of Eden-Hall', wood engraving by T. Armstrong, p.90

In spite of the great impact of the English translation of the brothers Grimm's *German Popular Stories*, which was published in 1823, the literary fairy story did not develop its full impetus until the mid-1840s. Hall made a collection of traditional ballads with explanatory notes in the hope of capturing a popular market, but the main attraction of the book, as the compiler acknowledged, was the illustrations. There is an engraving on every page of the two volumes, making more than 400 in all. Hall shamelessly used his magazine, *The Art Union*, to promote the publication, reproducing the plates over several issues in 1844, and he engineered Art Union prizes for several of the artists. He had

hoped to commission more work from Dadd, but the four 'Robin Goodfellow' illustrations were completed only shortly before Dadd's descent into insanity. Among the other illustrators were John Tenniel, John Gilbert RA, Joseph Noël Paton, F.H. Pickersgill, J.R. Herbert and E.H. Corbould in the first volume, and W.B. Scott, John Franklin and 'Crowquill' (responsible for 'The Ballad of Eden-Hall' shown here) in the second volume. Carter Hall dedicated his publication to King Ludwig I of Bavaria in appreciation of his encouragement of the arts – and as a just acknowledgement of the Germanic style of the lavishly produced volumes – but added a claim for the superiority of the British engraving technique. This may be 'the book of English ballads with engravings' owned by Burne-Jones and one of the models for his *Fairy Family* illustrations (see cat.64).

Alfred Crowquill was the pseudonym of A.H. Forrester (1804–1872), an illustrator and cartoonist who worked on pantomimes and drew for *Punch* and *The Illustrated London News*. With his novelist brother as collaborator he wrote fairy stories under the pen-name of Alfred Crowquill.

REFERENCE: Goldman, 1994, pp.97, 129

sparks of light reflected in dewdrops spattered over the subject. A relentless and unmoving light is cast on the scene, recalling not sunlight, but the artificial illumination of the theatre. *Contradiction* and *The Fairy Feller* share a trance-like or hallucinatory stillness; the feat of delineating this huge cast of characters from the imagination without the help of models was phenomenal.

PROVENANCE: Given by the artist to Dr William Charles Hood, MD (1824–1870); sold Christie's, 28 March 1870, lot 332A (136 gns to Holl); Arthur Crossland; Thomas Laughton, Royal Hotel, Scarborough; Sotheby's, 18 March 1964, lot 42; Raymond F. Needler, Hull; Sotheby's, 15 March 1983, lot 25; Myron Kunin, Chicago; Christie's, 12 June 1992, lot 120

EXHIBITIONS: Jubilee Exhibition, Bradford, Corporation Art Gallery, 1930, no.468; *Victorian Paintings 1837–1890*, Mappin Art Gallery, Sheffield, 1968, no.58; *Collectors' Choice*, Ferens Art Gallery, Hull, 1970, no.49; London, 1974, no.172; *Zwei Jahrhunderte der Englische Malerei*, Munich (British Council exhibition), 1979–80, no.325; extended loan to Minneapolis, Institute of Arts, 1983; extended loan to The Art Institute of Chicago, 1991

REFERENCES: Maas, 1969, pp.151–2; David Greysmith, *Richard Dadd. The Rock and the Castle of Seclusion*, London, 1973, pl.89; Peter Fuller, 'Richard Dadd. A Psychological Interpretation', *Connoisseur*, July 1974, pp.172–7 (illus.)

27 Richard Dadd

THE FAIRY FELLER'S MASTER STROKE

1855–64 · Oil on canvas, 54 × 39.4 cm
Inscribed on the reverse: *The Fairy Feller's / Master-Stroke – / Painted for / G.H. Haydon Esqre / by Rd Dadd / quasi-1855–64*

TATE GALLERY, LONDON
Presented by Siegfried Sassoon in memory of his friend and fellow officer Julian Dadd, a great-nephew of the artist, and of his two brothers who gave their lives in the First World War, 1963

Dadd wrote a long account in verse of how he painted this picture for 'an official person' – presumably G.H. Haydon, Steward of Bethlem Hospital and deputy to the reforming and compassionate Dr Hood, physician superintendent of the hospital. The manuscript, written in Broadmoor in 1865, is entitled 'Elimination of a Picture & Its Subject'. In the poem Dadd explains the subject-matter, which is completely fantastic and without a narrative source, and identifies the characters. These form a motley audience held in trance-like immobility witnessing the Fairy Feller's prowess in splitting a hazel nut with his axe. The fairy types come from all conditions of life – men-about-town and a dandy making a pass at a nymph, a crouching, squinting pedagogue, a politician 'with senatorial pipe', an ostler from the fairy inn, a dwarf monk, a dairymaid, and two ladies' maids, one holding a mirror, the other a broom – a cast of characters reminiscent of those peopling contemporary commentaries on fashionable life in the manner of Dicky Doyle. The arch-magician, a white-bearded patriarch in a triple crown, occupies the centre of the composition; on his

left Queen Mab rides in a car of state drawn by female centaurs with a gnat as a coachman, Cupid and Psyche acting as pages and 'some strapping fairy footman' behind. The scene is viewed through a mesh of tangled grasses covering the whole surface of the picture, which intensifies the feeling that this is a forbidden scene, not intended for the eyes of mortals. The figures occupy an imaginary world, created out of Dadd's obsessive imagination. According to his own account he was painting this concurrently with his other fairy work, *Contradiction: Oberon and Titania* (cat.26), but the qualifying 'quasi' in the inscription reflects his own uncertainty about the exact date. Both were exhibited in 1974, with the manuscript poem, and Patricia Allderidge analysed the actions of the fairy characters in great detail. These two fairy paintings are recognised as Dadd's masterpieces, although they were unseen during his lifetime. Both were executed in the confines of the asylum and they have inevitably come to be regarded as 'mad' paintings. The assurance and solidity of the figures and the realism of the natural settings are the more remarkable when we recollect that these works were painted 'amidst the most revolting conversation and the most brutal behaviour' (this comes from an account of Dadd at work in the 1850s, possibly on one or other of the two fairy paintings). From Dadd's account of the *Fairy Feller* we learn that 'imagination would not be deliberately invoked; so he gazed at the canvas and thought of nothing, until pure fancy began to give form to the cloudy paint which he had already smeared over it' (quoted in London, 1974). While the obsessive vision and the teeming incident that makes every inch of surface worthy of minute attention – and the inhuman intensity of the figures is remarkable even in the context of Victorian fairy painting – the fact remains that Dadd was an artist of unusual sensitivity and perception even before madness overtook him. In the final analysis, no other fairy works can even remotely match these for power of imagination and expression.

PROVENANCE: 1864, given by the artist to G.H. Haydon, 1864; Alfred Morrison of Fonthill; by descent to Lady Gatty, and to her daughter, Lady Sassoon; 1963, presented by Siegfried Sassoon to the Tate Gallery

EXHIBITIONS: Ashmolean Museum, Oxford (as *A Fantasy*), 1935–7; *British Romantic Painting*, Paris, 1973, no.93; London, 1974, no.190; *The Victorians: British Painting: 1837–1901*, National Gallery of Art, Washington DC, 1997, no.21

REFERENCES: Sacheverell Sitwell, *Narrative Pictures*, London, 1937, p.72 (illus.); Maas, 1969, p.151 (illus.); Phillpotts, 1978, pl.14

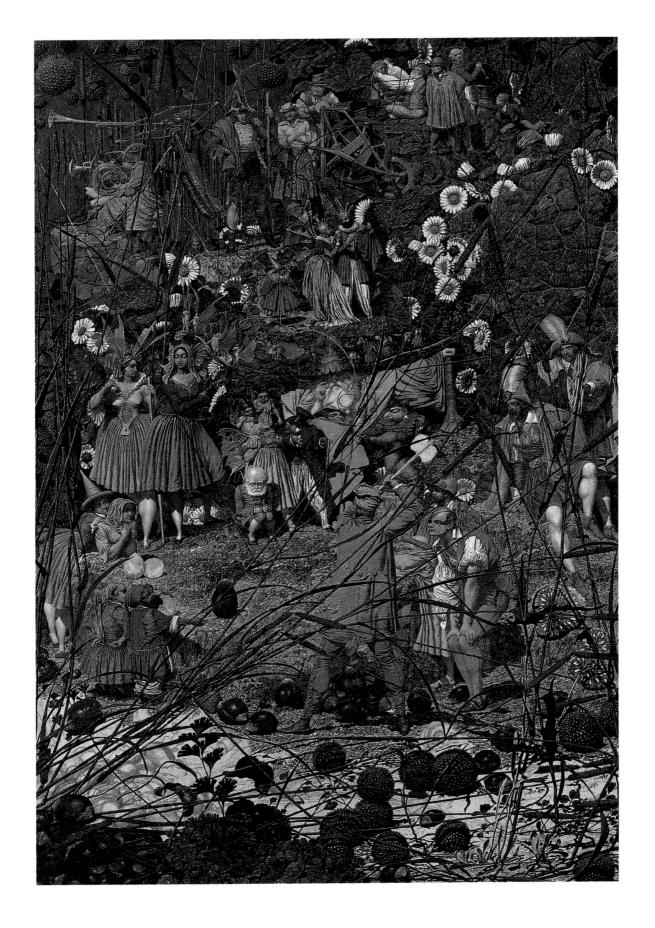

ROBERT HUSKISSON

BORN NOTTINGHAM, 1819; DIED LONDON, 1861

Genre and portrait painter, best known for his fairy subjects.
He was christened Robert Locking Huskinson (*sic*) in
Nottingham in 1819, a son of Henry Huskinson, probably the
Nottingham portrait painter of that name, and was a member
of a large Huskinson family from Langar, Nottinghamshire. By
1839 he had moved to London with his younger brother,
Leonard, who was also a painter, and both began to exhibit at
the Royal Academy using the alternative Huskisson form of
their name.

In 1847 Huskisson exhibited *The Midsummer Night's
Fairies* at the Royal Academy and the following year his
illustrations to accompany Mrs S.C. Hall's *Midsummer Eve: A
Fairy Tale of Love* (cat.30) were published, *The Mother's
Blessing* (see cat.31) being the frontispiece to Part One. Samuel
Carter Hall, opportunist editor of *The Art Union*, later *The Art-
Journal*, owned two of Huskisson's fairy paintings.

By 1853 Huskisson had painted a copy of William Etty's
Rape of Proserpine for the great collector Lord Northwick
(1769–1859). He must have visited Northwick's Thirlestane

House in Cheltenham on at least one occasion since he painted
an interior which was in Northwick's collection when he died
(now in the Yale Center for British Art, New Haven). In his
Autobiography W.P. Frith mentions meeting Huskisson at a
party at Thirlestane. Huskisson stopped exhibiting in 1854, but
remained living at the same London address that he had shared
with his brother until his early death.

28 Robert Huskisson

THE MIDSUMMER NIGHT'S FAIRIES

1847 · Oil on panel, 28.9 × 34.3 cm

TATE GALLERY, LONDON
Purchased 1974

The full title of this painting includes a misquotation from *A
Midsummer Night's Dream*: 'There sleeps Titania some time of
the night, / Lulled in these flowers with trances [instead of
dances] and delight'. Huskisson was clearly influenced by
Richard Dadd's treatment of this same subject, shown at the
Royal Academy only six years earlier (fig.6, p.20). The pose of
Titania is adapted from Giulio Romano's *Sleeping Psyche* in the
Sala di Psiche in the Palazzo del Tè in Mantua. This painting,

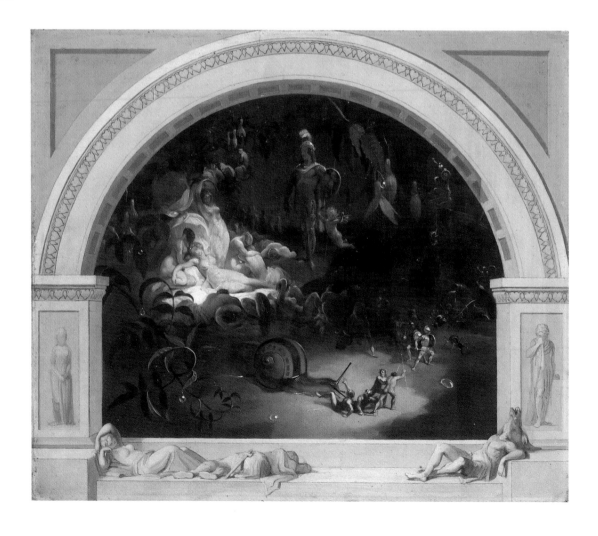

exhibited at the Royal Academy in 1847, was Huskisson's first success in the fairy genre. The critic in *The Art Union* (edited by Samuel Carter Hall) remarked that the painting was 'hung most advantageously ... and attracted very great attention, inasmuch as the name of the painter was heretofore comparatively unknown', concluding, however, that the artist was 'destined to play a premier role in British art'. At about the same time Hall acquired *The Midsummer Night's Fairies*. Predictions of Huskisson's future celebrity were wide of the mark, and he has remained the most elusive of the fairy painters.

PROVENANCE: Samuel Carter Hall, by 1848; sold at Foster's, 1855; Sir George Walker; sold Christie's, London, 5 May 1971; Charles and Lavinia Handley-Read; bequeathed to Thomas Stainton; bought by the Gallery, 1974

EXHIBITIONS: Royal Academy Summer Exhibition, 1847, no.54; *The Sacred and Profane in Symbolist Art*, Art Gallery of Ontario, Toronto, 1969, no.18; *Victorian and Edwardian Decorative Arts, The Handley-Read Collection*, Royal Academy, London, 1972, no.A43; *The Paintings, Watercolours and Drawings from the Handley-Read Collection*, Fine Art Society, London, 1974, no.36

REFERENCES: *The Athenaeum*, 29 May 1847, p.577; *The Art Union*, vol.9, 1847, p.186; *The Art-Union Journal*, vol.10, 1848, plate facing p.306, (engraved by Fred. Heath); Maas, 1969, pp.160, 161 (illus.); Phillpotts, 1978, pl.18

29 Robert Huskisson
'COME UNTO THESE YELLOW SANDS'

1847 · Oil on panel, 34.9 × 45.7 cm

PRIVATE COLLECTION, COURTESY OF THE MAAS GALLERY, LONDON

The subject is taken from Ariel's song in Shakespeare's *Tempest*. Huskisson's debt to Richard Dadd's treatment of the same subject (fig.6, p.20) is obvious, in fact this is almost a version of Dadd's painting. Huskisson has emphasised the dramatic lighting of the scene, referring the viewer to its origins in the theatre. Advances in theatre lighting, with the introduction of gas lamps and limelight, are clearly reflected in fairy paintings from the mid-1840s. Huskisson's are among the finest of the fanciful painted frames that fairy theatre inspired. They suggest most powerfully the theatricality of the subject-matter, with an emphatic proscenium arch, inner slip and sculptural figures in shallow relief on the plinth.

PROVENANCE: 1847, Samuel Carter Hall

EXHIBITION: London, 1974, no.248

REFERENCE: Maas, 1969, p.150

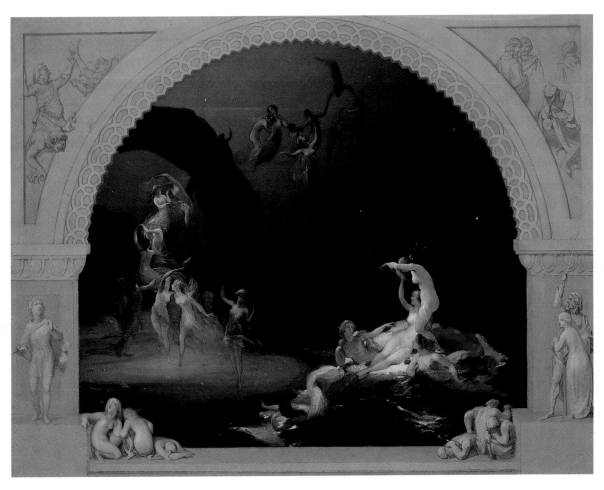

30 Robert Huskisson

MIDSUMMER EVE: A FAIRY TALE OF LOVE

Edited by Mrs S.C. Hall (Anna Maria Fielding), Longman, Brown, Green & Longman's, London, 1848
Purple cloth with gold stamped decoration, closed 23.7 × 15 cm, 270 pp. Open to show the frontispiece *The Mother's Blessing*

PRIVATE COLLECTION, COURTESY OF THE MAAS GALLERY, LONDON

In 1847 *Midsummer Eve: A Fairy Tale of Love* was serialised in twelve monthly parts in *The Art Union*, volume 9. The story is not very compelling, and the characters emerge as long-winded, sanctimonious and sentimental. However, through the *Art Union* magazine, Mr and Mrs Hall were in a position to offer a valuable showcase for young artists, illustrators and engravers and even to attract some of the foremost illustrators of the time. Each number of the serialisation was profusely illustrated with vignettes, several to a column. As well as Huskisson, the contributors included Sir Joseph Noël Paton, William Frost, Kenny Meadows, Clarkson Stanfield, W.E. Wehnert, Thomas Creswick, F.W. Hulme and J. Franklin. Some of these artists had already collaborated with S.C. Hall on *The Book of British Ballads* (cat.24). The anonymous illustrations are tantalising; the initials 'FG' may indicate early works by Fitzgerald, and the plates engraved by Measom without artists' signatures look very much like the work of Richard Doyle. Measom also engraved for *In Fairyland* (cat.54). For the publication of *Midsummer Eve* in gift book form by Longman's, in addition to Huskisson's frontispiece, twelve full-page plates were added – Maclise provided one, as did Frost and Noël Paton – and some further sixty vignettes and tail-pieces.

EXHIBITION: Brighton, 1980, no.B46

31 Robert Huskisson

THE MOTHER'S BLESSING

1848 or before · Oil on panel, 25.4 × 20.3 cm

PRIVATE COLLECTION, COURTESY OF THE MAAS GALLERY, LONDON

This subject was engraved for the frontispiece to Mrs S.C. Hall's *Midsummer Eve: A Fairy Tale of Love*, Part I, published in 1848, for which Huskisson made numerous other illustrations. Huskisson has encircled the conventional group of mother and child with flying fairies among flowers and ferns.

EXHIBITION: Brighton, 1980, no.D57
REFERENCE: *The Art Union*, vol.10, 1848, p.26 (engraved by W.T. Green); Maas, 1969, pp.159 (illus.), 160

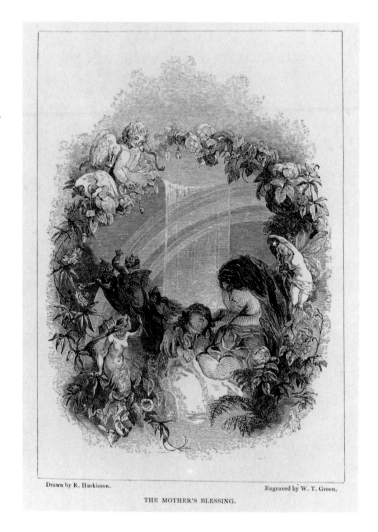

Drawn by R. Huskisson. Engraved by W. T. Green.

THE MOTHER'S BLESSING.

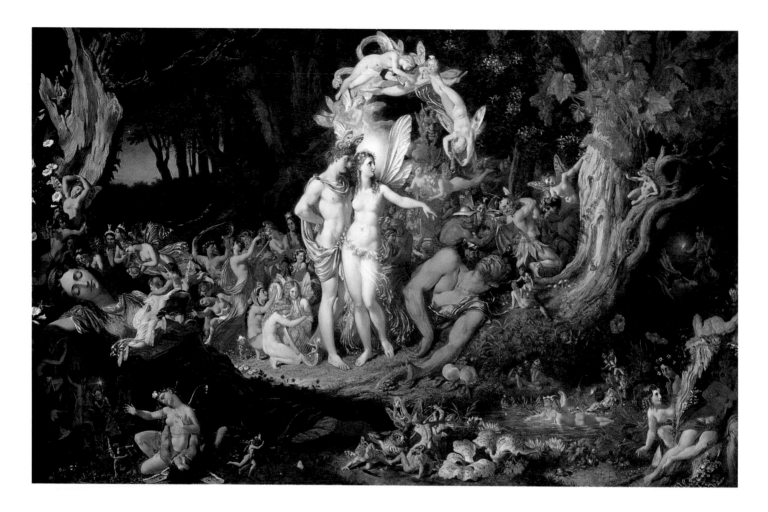

Sir Joseph Noël Paton RSA

BORN DUNFERMLINE, 1821; DIED EDINBURGH, 1901

Scottish painter of historical, religious, mythological and allegorical subjects, one of the most pre-eminent fairy painters of his day. Son of a damask designer, he worked at Paisley designing textiles before going to London, where he met Millais in 1843 when both were studying at the Royal Academy Schools. They remained friends, but Paton returned to Scotland, preventing him from becoming a founder member of the Pre-Raphaelite Brotherhood. An intellectual with an imagination fuelled by Celtic legends, he found early success with his Oberon and Titania paintings, executed in a microscopically detailed manner pre-dating Pre-Raphaelitism. He won prizes in the Westminster Hall competitions of 1845 and 1847, and was elected a member of the Royal Scottish Academy in 1850, though he did not exhibit at the Royal Academy until 1856. Lewis Carroll was an admirer, as was Queen Victoria, who commissioned a number of paintings, in 1864 appointed him the Queen's Limner for Scotland and in 1867 knighted him. After 1870 Paton began to concentrate on religious works, which were equally popular; some were sent on

tour with a lecturer and special lighting. He continued to produce the occasional fairy subject, historical and contemporary genre scenes, and published books of poetry, but at the end of his life his work was often deemed both academic and sentimental, lacking the spontaneous charm of his youth.

32 Joseph Noël Paton

The Reconciliation of Oberon and Titania

1847 · Oil on canvas, 76.2 × 123.2 cm
Signed and dated: *J Noel Paton Feb. 1847*

NATIONAL GALLERY OF SCOTLAND, EDINBURGH

> Oberon: *Now my Titania; wake you my sweet Queen*
> Titania: *My Oberon! What visions have I seen*
> *Methought I was enamoured of an ass*
> Oberon: *There lies your love*
> (*A Midsummer Night's Dream*, Act IV, Scene I)

The Reconciliation was entered by the artist in 1847 in the Westminster Hall Competition, where it gained a £300 prize and established his reputation, according the *The Times*

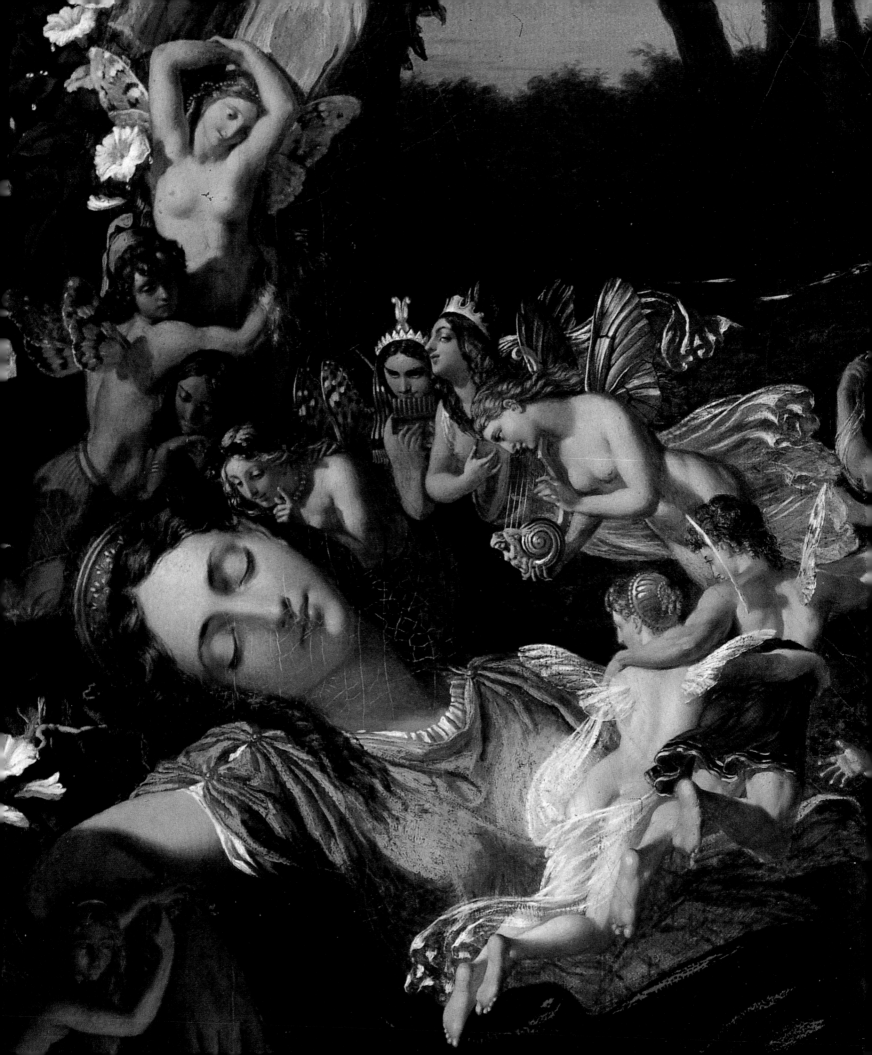

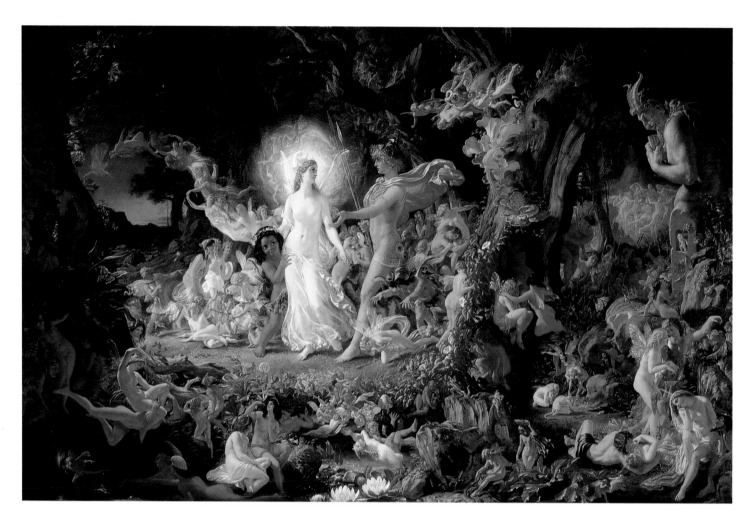

'surpassing every attempt we have seen at the illustration of the play'. There are echoes of Maclise and Dadd, and suggestively sexual encounters among the attendant fairies, but Paton's skill in giving individuality to each fairy figure marks this out as a masterpiece of the genre. The sleeping lovers, out of whose dreams the fairy throng is conjured, are a reminder of Fuseli's dictum, 'One of the most unexplored regions of art is dreams'. They anticipate Fitzgerald's preoccupation with dreams and hallucinations in fairy inspiration. Minute observation of the landscape setting – a much remarked Pre-Raphaelite trait in Paton's work – makes a real event out of Shakespeare's play, a reminder of contemporary interest in folklore and eyewitness accounts of fairies.

PROVENANCE: Bought by the Royal Scottish Academy, 1848; presented to the National Gallery of Scotland, 1910

EXHIBITIONS: Royal Scottish Academy, 1847, no.362; Edinburgh, 1967, no.4

REFERENCE: Noël Paton and Campbell, 1990, illus. facing p.64, fig.5.

33 Joseph Noël Paton
THE QUARREL OF OBERON AND TITANIA

1849 · Oil on canvas, 99.1 × 152.4 cm
NATIONAL GALLERY OF SCOTLAND, EDINBURGH

The quarrel of Oberon and Titania was over a changeling boy stolen from an Indian king whom they both wanted (*A Midsummer Night's Dream*, Act II, Scene I). At the Royal Scottish Academy in 1850 *The Quarrel* was judged to be Picture of the Exhibition. The first and smaller version – and Paton's first fairy painting – was exhibited in 1846 as his diploma work at Royal Scottish Academy (it is still in their possession), but this larger painting, intended as a pendant to *The Reconciliation* (1847, cat.32) includes many more fairy figures. It attracted great public enthusiasm. Lewis Carroll admired it, reporting, when he saw it in the Scottish National Gallery in 1857, that 'We counted 165 fairies'. Coming so soon after Maclise's *Undine* (fig.38, p.66) and Dadd's *Puck* (private collection) and *'Come Unto These Yellow Sands'* (fig.6, p.20), it is not surprising to find echoes of those paintings in the fairy multitude. Paton, however, has included many more varied

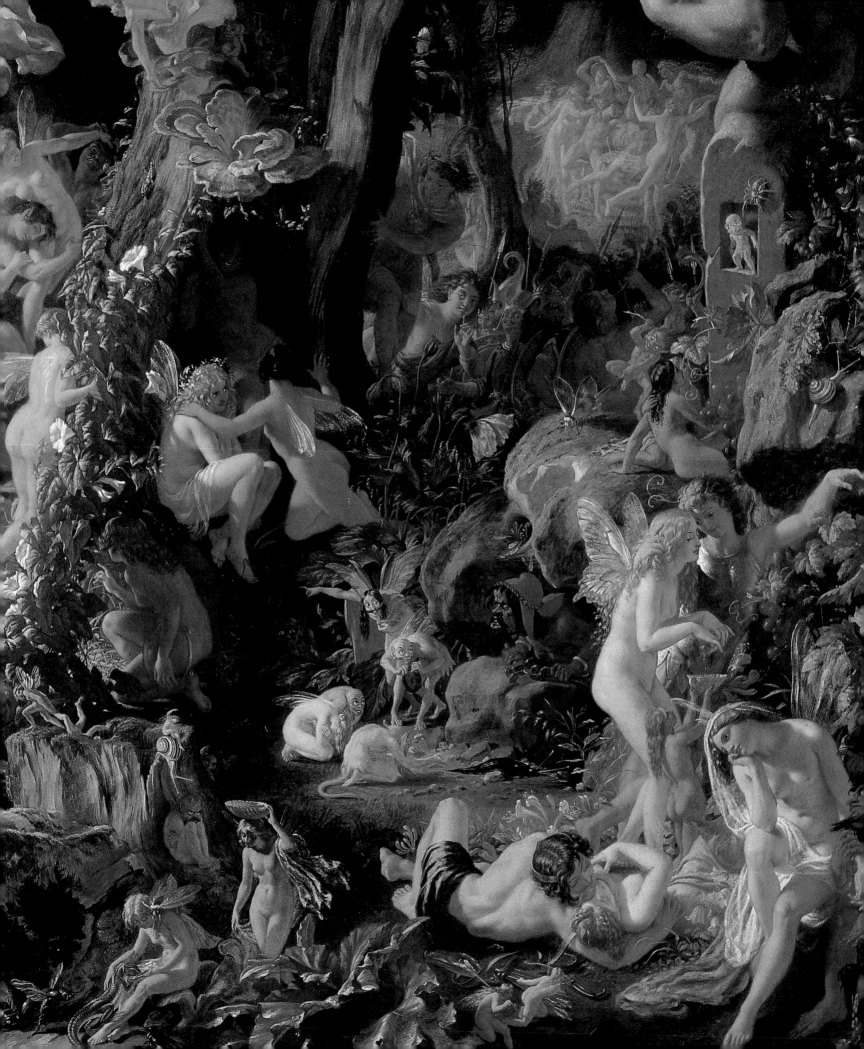

incidents, some discreetly erotic, some comic, and some illuminating other moments in the play. A detail from the left foreground was later used for an exquisite tiny picture with an arched top, *The Indian Boy's Mother* (1850, private collection, ex Handley-Read Collection, shown at the Fine Art Society, London, 1974), and a version of the main central group, much reduced in size, was painted as late as 1880 (shown at the Maas Gallery, London, 1996, no.22).

PROVENANCE: Royal Association for the Promotion of the Fine Arts, 1850
EXHIBITIONS: Royal Scottish Academy, 1850, no.151; Scottish Arts Council, Edinburgh, 1967, no.7
REFERENCE: Noël Paton and Campbell, 1990, illus. facing p.17, fig.4

34 Joseph Noël Paton
THE FAIRY QUEEN
*c.*1860 · Oil on board, 26.5 × 28 cm
SHEFFIELD ART GALLERIES AND MUSEUMS

This painting is connected with one of Paton's most ambitious subjects, *The Pursuit of Pleasure: A Vision of Human Life*, shown at the Royal Scottish Academy in 1855 (no.294; see fig.39, p.69). The fairy and her shadowy companion echo the fleeing Pleasure and one of her pursuers. The effective counterpoint of the two figures in dark and light tones, characterising good and evil, underlines the didactic intentions of the artist, who intended such Bacchanalian folly as a warning against divine wrath. Besides this, Paton exhibited a number of sketches associated with the large painting at the Royal Scottish Academy in 1850 (no.499), 1860 (no.646) and 1863 (no.319).

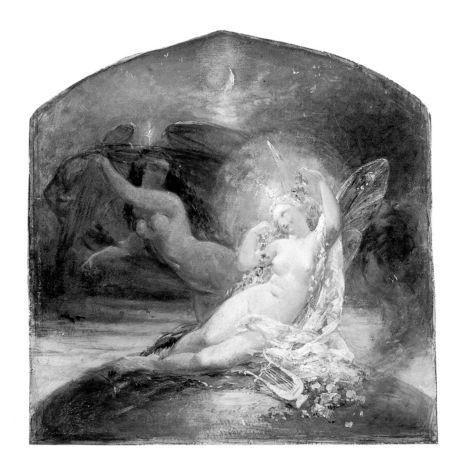

35 Joseph Noël Paton

The Fairy Raid, Carrying off the Changeling, Midsummer Eve

1867 · Oil on canvas, 90.5 × 146.7 cm
Monogrammed and dated: *JNP 1867*

GLASGOW MUSEUMS: ART GALLERY AND MUSEUM,
KELVINGROVE
Gift of A. Robertson Cross, 1965

The Fairy Raid was one of the most successful fairy paintings of the Victorian age. It was six years in the making and, by its completion, some fifteen years separated it from Paton's two *Dream* paintings. In the interim, Fitzgerald had unveiled a purely imaginary fairy world without recourse to literature; this seems to have enabled Paton to people his canvas with a large and varied cast of characters from myth and Celtic legend. Inspiration probably came from memories of his favourite childhood reading in fairy lore of the Highlands, specifically from Walter Scott's *Minstrelsy of the Scottish Borders*. The scene illustrates verses from Scott's *Lady of the Lake*. There may be an intentional double meaning in the title, since a 'fairy

rade' in Scottish folklore is a parade or ride of fairies, of which a number of sightings in the Highlands were recorded. The standing stones are a reminder of Druidism and the magic properties of the stones, which should be visited on Midsummer Eve to propitiate the fairy folk.

PROVENANCE: John Polson, Esq., Paisley; Mrs John Polson; R. Cross, Esq.; Col. A.R. Cross; presented by A.R. Cross to Glasgow Art Gallery, 1966

EXHIBITIONS: Royal Academy Summer Exhibition, 1867, no.643; Royal Scottish Academy, Edinburgh, 1869, no.425, 1880, no.25, 1888, no.25; Fine Art Society, London, 1902, no.35; Edinburgh, 1967, no.42

REFERENCE: Noël Paton and Campbell, 1990, illus. p.49

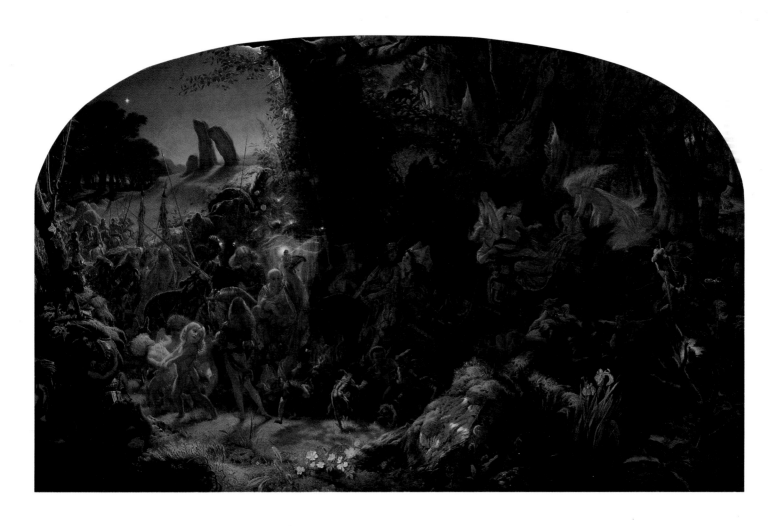

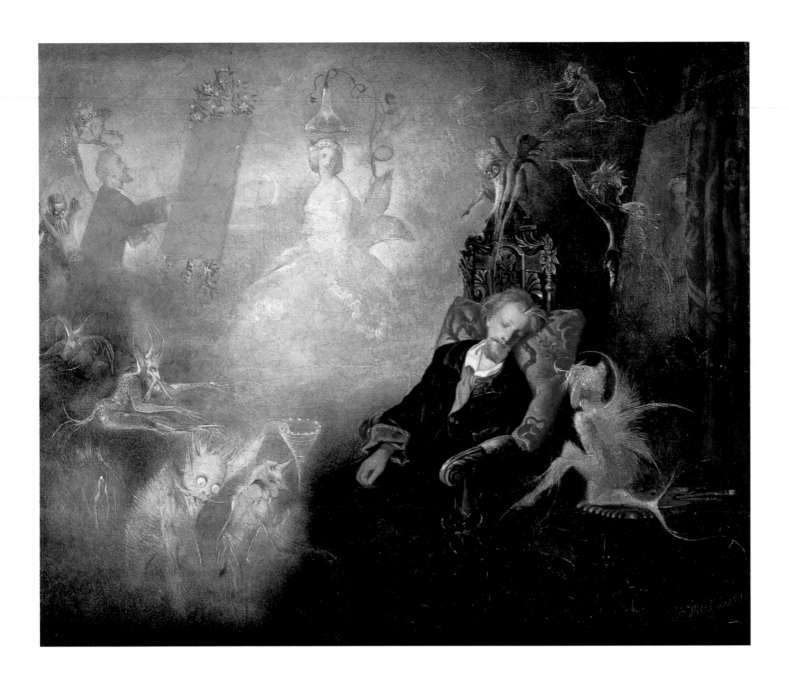

JOHN ANSTER FITZGERALD

BORN LONDON, 1823; DIED LONDON, 1906

Painter. The son of a much ridiculed poet, William Thomas Fitzgerald, Fitzgerald appears to have had little or no formal training, but from 1845 he was exhibiting at the British Institution and the Royal Academy. Although he is chiefly known for his fairy pieces, Fitzgerald seems to have made a living as a portrait painter and illustrator, although he also painted genre scenes. By the late 1850s he had become a regular contributor to *The Illustrated London News*, and in 1864 he was a candidate for the Society of British Artists. He was a member of the Maddox Street Sketching Club. He exhibited at the Royal Academy from 1845 to 1902.

Like his father, Fitzgerald played on his Irish ancestry and was remembered by members of the Savage Club for his burlesque imitations of old-time actors and theatrical managers.

36 John Anster Fitzgerald
THE ARTIST'S DREAM

1857 · Oil on millboard, 25.4 × 30.5 cm
Signed and dated: *J.A. Fitzgerald 1857*

PRIVATE COLLECTION, GREAT BRITAIN

Fitzgerald discovered his true vocation in fairy painting, and his series of 'dream' paintings, in which sleepers are plagued by hideous creatures from fairyland, give an indication of where he found the images for his fantastic world. Of all fairy paintings, Fitzgerald's have the most overt references to drug-induced hallucinations. Here the artist has fallen asleep in front of his easel on which there is a painting of a fairy. In his dream he sees the model turn her head to look at him. The artist is Fitzgerald himself, the beautiful fairy is perhaps La Sylphide, the elves and goblins are those that make up the cast of dream-induced horrors in many of his paintings. An earlier dream painting, *The Captive Dreamer* (shown at Maddox Street Sketching Club, 1856), shows a sleeping girl pillowed on a gross and slimy dragon and menaced by grotesque figures taken from the paintings of Hieronymus Bosch and Jan Bruegel the Elder. These were followed by the trio of dreaming girls (cat.37–9).

PROVENANCE: Christie's, 18 July 1986; bought by Hazlitt, Gooden & Fox Ltd

EXHIBITIONS: British Institution, 1857, no.389, as *The Dream: begot of nothing but vain fantasy which is as thin of substance as the air*; Anthony d'Offay Fine Art, *Dream and Fantasy in English Painting*, 1978, no.7

REFERENCE: Maas, 1969, pp.154–5 (illus.)

37 John Anster Fitzgerald
THE NIGHTMARE

*c.*1857–8 · Watercolour on paper, 22 × 28 cm

PRIVATE COLLECTION, COURTESY OF THE MAAS GALLERY, LONDON

This – possibly the first – version of the dreaming girl is full of incident. The girl writhes in anguish on her bed, the wreath that she wears in the background dream sequence having fallen twisted on her pillow. Her ghostly figure is shown enacting three episodes of gathering menace among a band of revellers, in 17th-century costume, some of whom are masked. First she

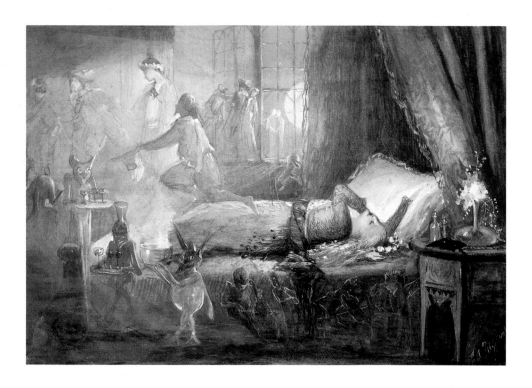

is shown under a full moon, embracing a lover; the second episode shows her being waylaid by two masked figures with swords; lastly she turns away from a kneeling man, while another man with a sword and a masked woman flee away to the left. Lying on her bed, she has changed from the flimsy white costume of her ghostly apparition into a heavily embroidered Turkish jacket and voluminous striped silk sash of brilliant colours which falls on to the bed with the fringe reaching the floor, looking like a wound with a pool of blood running down. Around her bed goblins offer drinks from a steaming bowl, the drinks are red and yellow, matching the liquid in two medicine bottles on the table by the bed. A goblin

hovering over her prone figure bows obsequiously. A goblin band, barely indicated in thin paint, plays by the bed. That the sleep is drugged cannot be in doubt. In successive versions Fitzgerald was to tone down the overt signs of drug-induced hallucination.

EXHIBITION: Anthony d'Offay Fine Art, *Dream and Fantasy in English Painting*, 1978, no.8

38 John Anster Fitzgerald
THE STUFF THAT DREAMS ARE MADE OF

*c.*1858 · Oil on board, 25.4 × 30.48 cm
Signed: *J.A. Fitzgerald*

ANDY AND SUSAN BOROWITZ

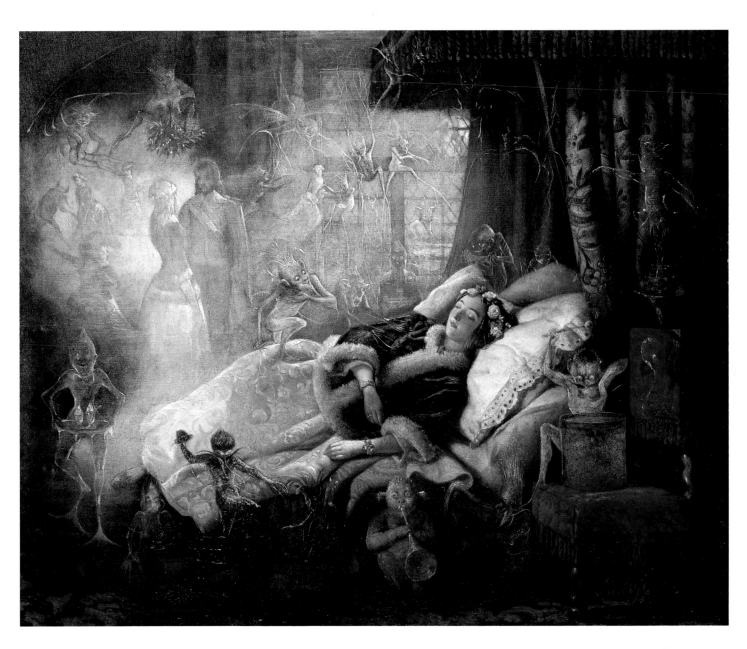

In this – possibly intermediate – version of the dreaming girl she is shown with hectic cheeks and in distress. The intensity of colour heightens the emotional impact of the painting, but the explicit references to narcotics and hallucination are toned down, and it has become possible to interpret this as a dream peopled with fairyland figures rather than a horrible nightmare.

39 John Anster Fitzgerald
THE STUFF THAT DREAMS ARE MADE OF

1858 · Oil on canvas, 36.2 × 44.5 cm
PRIVATE COLLECTION

If this were the only one of Fitzgerald's dreaming girl paintings to have come to light, which was indeed the situation until recently, it would seem to be no more than its title suggests. A young girl wearing an embroidered Turkish jacket over a flimsy white dress, with a white sash and a wreath in her hair, lies on a bed in a tranquil sleep. Dreaming, she sees herself holding hands with a bearded man in fancy historical costume, standing under a large bunch of mistletoe. In a second episode she is chased by a goblin. Grotesque but merry goblins with pointed features and stick-like limbs caper about the bed, some drinking steaming liquid from cups, some playing musical instruments. Almost all signs that the dream is induced by narcotics have been eliminated, and the subject rendered fit for public exhibition.

REFERENCE: Maas, 1969, p.155 (illus.)

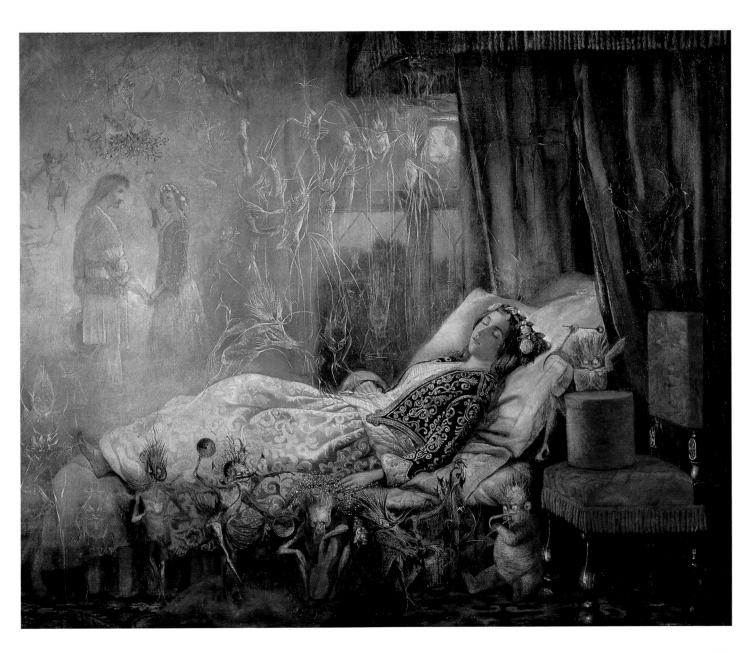

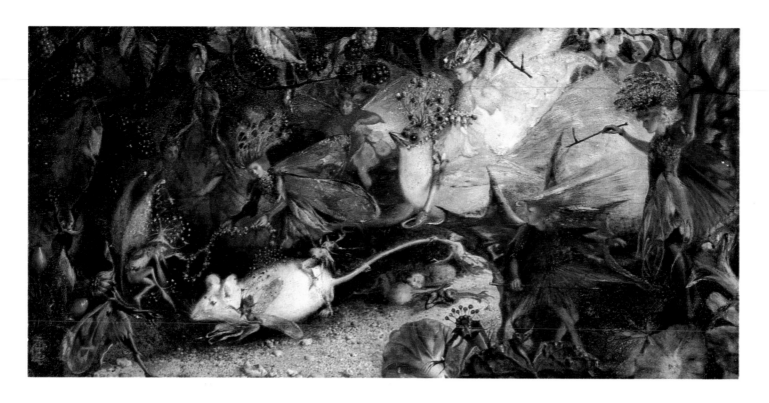

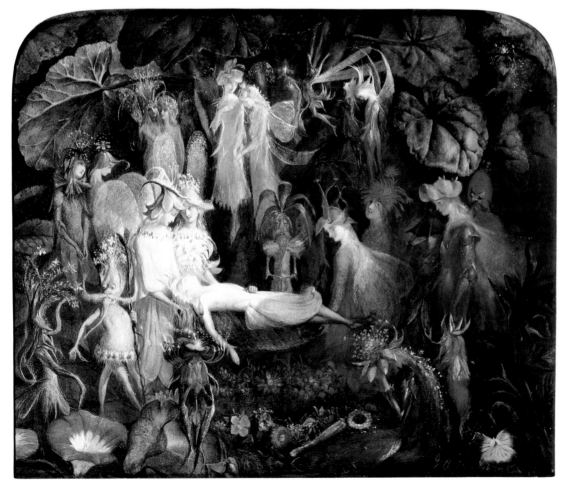

44 John Anster Fitzgerald

THE CHASE OF THE WHITE MICE

*c.*1864 · Oil on canvas, 25.4 × 47.7 cm
Monogrammed: *JAFG*

MRS NICOLETTE WERNICK

Fitzgerald was capable of imagining a light-hearted fairy world where the actions of the diminutive figures are mischievous rather than menacing, yet there is always an element of sadism. The dazzling colours and jewel-like details distract attention from the thorny weapons cruelly wielded by the fairies to goad the mice. From 1862 Fitzgerald was reworking these purely fairy subjects for Christmas numbers of *The Illustrated London News* (see fig.4, p.17).

REFERENCE: Maas, 1969, p.154 (illus.)

45 John Anster Fitzgerald

THE FAIRY'S FUNERAL

1864 · Oil on canvas, 24.8 × 29.7 cm
Signed: *J.A. Fitzgerald*

PRIVATE COLLECTION·

Sightings of fairy funerals frequently occur in folklore, and accounts gleaned from oral tradition were published by Thomas Crofton Croker and Thomas Keightley. Fitzgerald has invested the scene with a delicate melancholy, confirming his capacity for subtle nuances of mood in his fairy episodes.

EXHIBITION: British Institution, 1864, no.443

46 John Anster Fitzgerald

THE CAPTIVE ROBIN

Oil on canvas, 24.8 × 29.7 cm

PRIVATE COLLECTION

Fairies lead a robin with reins made of flowers. It was held to be very unlucky either to keep or to kill a robin-redbreast because these birds were believed to bury the bodies of people who died or were murdered in the woods. This liaison with humans gave the fairies ambivalent feelings towards them, and Fitzgerald often shows fairies and robins in conflict. In one such picture the robin defends its nest against a fairy attack (private collection, on loan to Birmingham Museum and Art Gallery). Fitzgerald made a number of versions of the death and burial of Cock Robin, presumably illustrating the popular rhyme. Another theme is fairies feeding a fledgling bird, but there are subtle indications that the food may be poisonous.

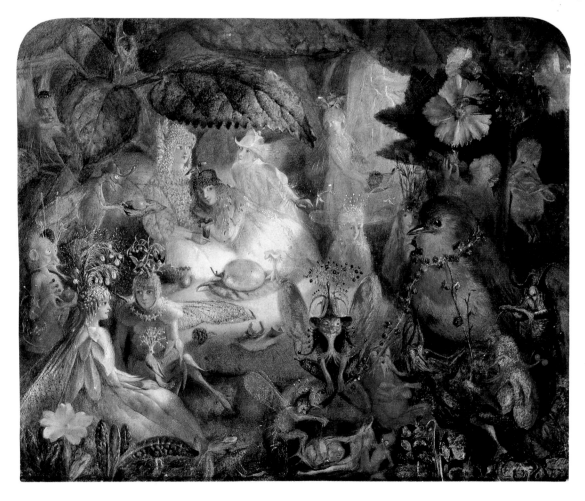

55 Richard Doyle

WOOD ELVES PLAYING LEAPFROG OVER TOADSTOOLS

*c.*1870–80 · Watercolour on paper, 11.7 × 34.5 cm
Monogrammed: *RD*

PRIVATE COLLECTION

This watercolour has similarities with the designs for *In Fairyland* (cat.54). Doyle has used a favourite device of juxtaposing the elves with large leaves to suggest the diminutive stature of the fairy folk, as, for example, most conspicuously in *Under the Dock Leaves* (cat.57). Like those works, this watercolour may date from the 1870s.

PROVENANCE: Jonathan Simpson, Bolton, Lancashire (handwritten label on the original backboard)

56 Richard Doyle

THE FAIRY TREE

Watercolour with sepia ink and gouache on tinted paper, 75 × 63 cm

ON DEPOSIT AT THE COTSEN CHILDREN'S LIBRARY, PRINCETON UNIVERSITY LIBRARY

One of Doyle's most celebrated watercolours and his most ambitious fairy piece, the branches of the tree support more than 200 figures. The fairy king in the centre has the long, luxuriant mustaches that seem to have fascinated the artist and to have been the hallmark of a fairy leader, for example: see also the Elf King in Plate IV of *In Fairyland* (cat.54).

PROVENANCE: William E. Wiltshire III, Richmond VA; Alexander Martin; sold Sotheby's, London, 29 November 1989, lot 337; deposited at the Library, 1996

EXHIBITION: London, 1983, no.125

REFERENCE: Maas, 1969, p.156

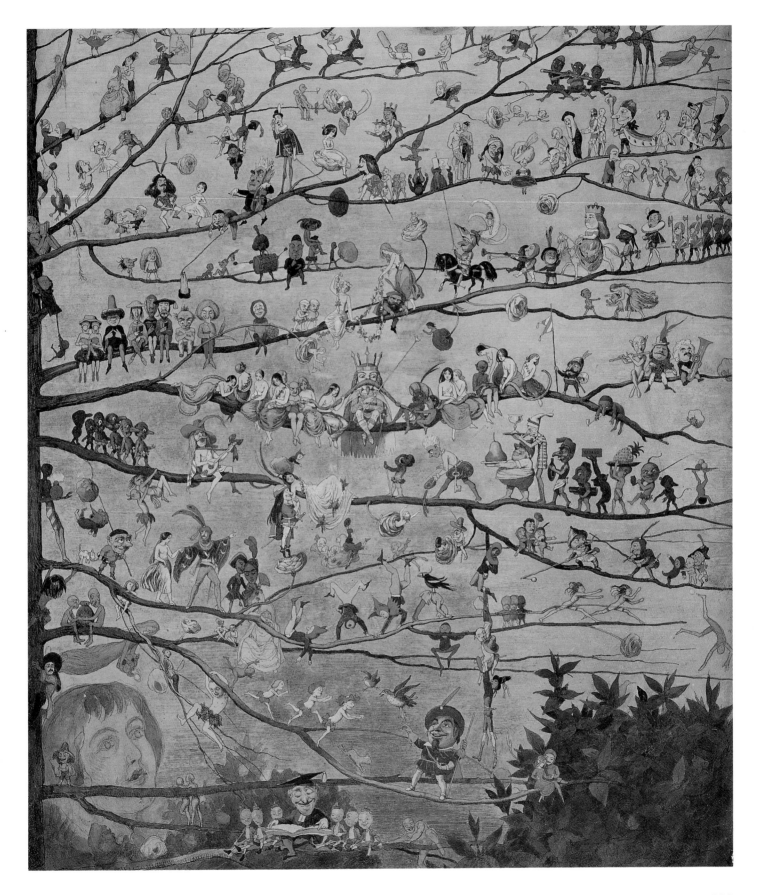

57 Richard Doyle

UNDER THE DOCK LEAVES: AN AUTUMNAL EVENING'S DREAM

1878 · Watercolour, 49.6 × 77.7 cm
Monogrammed and dated: *RD 1878*

THE BRITISH MUSEUM, LONDON, 1886–6–19–17

This ambitious and technically accomplished watercolour
would be remarkable as a pure landscape in its breadth and
minuteness of observation, but the element of fantasy and the
imagined fairy world add a further dimension. It shows Doyle's
most effective employment of giant leaves to suggest the
diminutive stature of his fairy protagonists. The fairies are
incandescent, eerily lighting up the underside of the leaves. The
tiny kingfisher, depicted on the same scale as the fairies, is a
sign of calm weather.

PROVENANCE: 1886, bought by the Museum

EXHIBITIONS: Brighton, 1980, no.D31; London, 1983, no.128

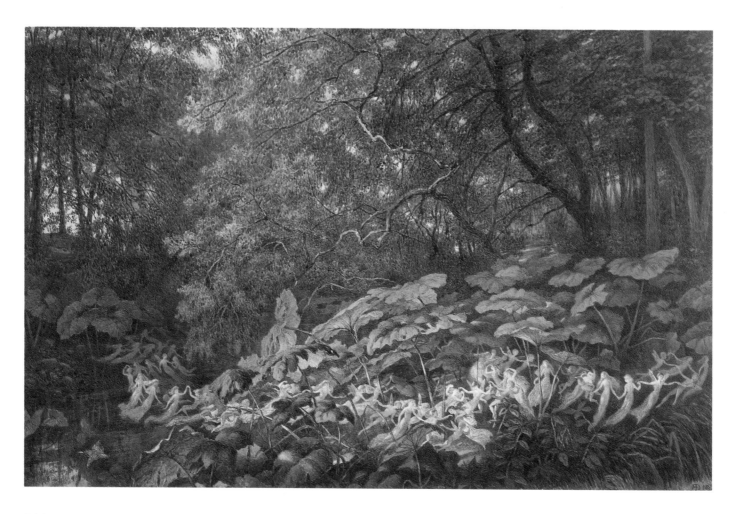

THOMAS HEATHERLEY

BORN *c*.1824; DIED LONDON, 1913

Painter of genre and figurative subjects. He exhibited infrequently and is best known as the founder of Heatherley's Academy, where many famous Victorian artists studied, including Burne-Jones (*q.v.*), Rossetti, Arthur Hughes (*q.v.*) and Walter Crane (*q.v.*).

Thomas Heatherley attended the Newman Street Art School in 1850, studying under James Matthews Leigh who had been William Etty's only pupil. Heatherley soon became Leigh's assistant and was to take over the running of the school at his death in 1860. Heatherley was principal there for the next 27 years, and the art school took his name. He built up a large collection of skeletons, armour, pottery, furniture and costumes. In 1887 he left the school in the hands of his nephew John Crompton, and retired to Keswick in the Lake District.

He exhibited three works, *Poor Charlie's Birthday*, *The Dull Book* and *After the Battle*, at the British Institution (1858–66), two works at the Royal Society of British Artists, Suffolk Street (1868–72), and one work at the Royal Academy, *Princess Elizabeth in the Tower* (1871).

58 Thomas Heatherley

FAIRY SEATED ON A MUSHROOM

c.1860 · Oil on canvas, 29.8 × 24.1 cm

PRIVATE COLLECTION, COURTESY OF THE MAAS GALLERY, LONDON

Heatherley's fairy paintings are distinctive, apparently showing knowledge of Hieronymus Bosch and Jan Bruegel the Elder. Whatever the intended implications of the mushrooms, they are an important feature in this composition. Apart from sexual innuendo, they may refer to hallucination and the world of apparitions. The unusual back view of the nude figure must owe a debt to the seated figure in J.A.D. Ingres's *La Baigneuse de Valpinçon* (1808; Musée du Louvre), repeated as the central figure in *The Turkish Bath* in 1863 (Musée du Louvre).

EXHIBITION: Brighton, 1980, no.D54
REFERENCE: Phillpotts, 1978, pl.30

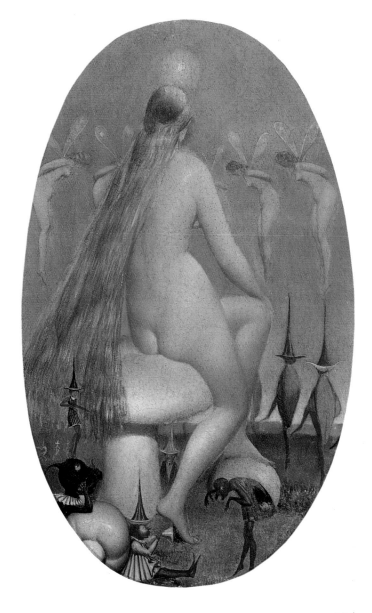

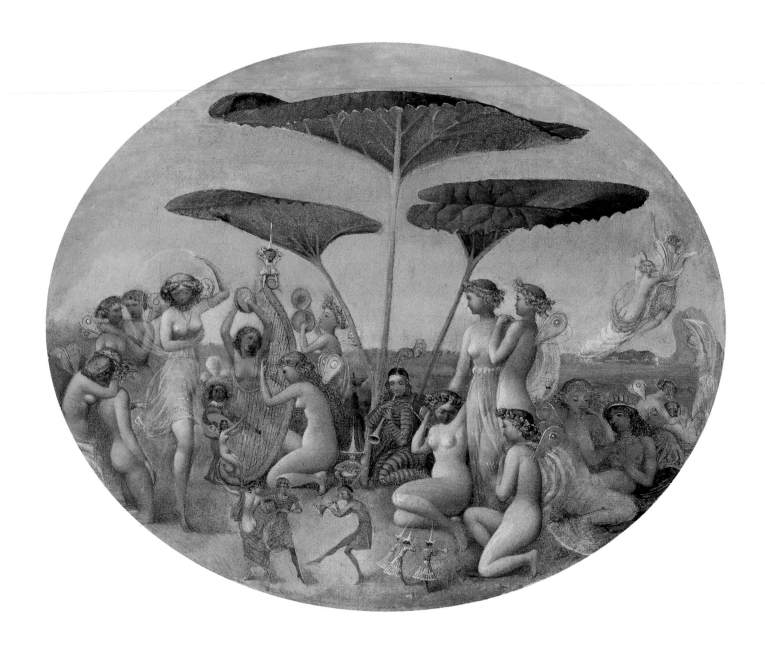

59 Thomas Heatherley

THE GOLDEN AGE

c.1862 · Oil on linen over millboard, oval: 23.2 × 28.3 cm
Inscribed on backboard: *The Golden Age by Heatherby*

PRIVATE COLLECTION

The title of this painting is written on the original backboard, together with the artist's name incorrectly given as 'Heatherby'. It is clearly by the same hand as the other fairy painting (cat.58) attributed to Thomas Heatherley. Again there is a reference to Ingres, this time to his picture of the same title, *L'Age d'Or* (Fogg Art Museum, Boston), a reduced replica of the unfinished mural made for the Duc de Luynes, Château de Dampierre, of 1862. With such a great discrepancy of scale it is hard to say whether Heatherley is taking more from Ingres than the subject and the mood.

JOHN GEORGE NAISH

BORN SUSSEX, 1824; DIED ILFRACOMBE, DEVON, 1905

Naish made his reputation in the 1850s as a painter of fairy and mythological subjects. He studied at the Royal Academy Schools and exhibited his works there over a fifty-year period from 1843, showing *Titania* in 1850. In 1850–51 he studied in Paris, Bruges and Antwerp. His *Elves and Fairies* (cat.60), exhibited at the British Institution in 1856, was noted for its close examination of detail by *The Art-Journal*. In the 1860s he moved to Ilfracombe, and his nymph and fairy subjects were replaced by landscapes of Devon, Cornwall and the Scilly and Channel Islands, showing the influence of the Pre-Raphaelites.

60 John G. Naish

ELVES AND FAIRIES: A MIDSUMMER NIGHT'S DREAM

1856 · Oil on panel, 35.6 × 45.7 cm

PRIVATE COLLECTION

Fairies sport butterfly wings, an elf rides on a moth and others attack a caterpillar. Brilliantly coloured geraniums, nasturtiums and fuchsias dominate Naish's fairy scene. The flowers are not those that decorate Titania's bower as described by Shakespeare – indeed, they are not even of Shakespeare's time, but are the blooms popular with Victorian gardeners – and their hyper-reality is in the same decorative vein as Simmons's *Titania* (cat.49). In flower-lore the scarlet geranium stands for 'comforting' or 'stupidity', the nasturtium for 'patriotism' and the fuchsia for 'taste' – which can hardly be the meanings intended here.

EXHIBITION: British Institution, 1856, no.306
REFERENCES: *The Art-Journal*, 1856; Phillpotts, 1978, pl.25

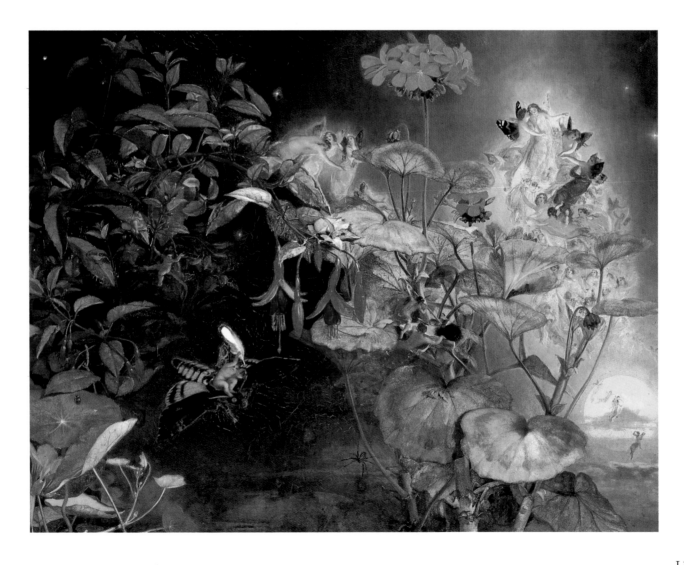

CHARLES ALTAMONT DOYLE

BORN LONDON, 1832; DIED, MONTROSE, 1893

Watercolourist and illustrator. He was the youngest son of the caricaturist John Doyle (1797–1868) and brother of Richard ('Dickie') Doyle (*q.v.*). He joined the Edinburgh Office of Works at the age of nineteen. Doyle painted several strange fantasies and nightmarish scenes including elves. He exhibited a number of watercolours and pen and ink studies at the Royal Scottish Academy. He illustrated John Bunyan's *Pilgrim's Progress* and produced several illustrations for *London Society* (1862–4) and also for humorous books. He died of epilepsy in a lunatic asylum. His interest in the occult was inherited by his son, the author Sir Arthur Conan Doyle.

61 Charles Doyle

THE FAIRY QUEEN, A PROCESSION

1882 · Watercolour with pen and ink, 21.6 × 52.7 cm
Signed and dated: *C.A. Doyle 1882*

THE MAAS GALLERY, LONDON

Watched by a fairy queen, members of the fairy procession wield an old-fashioned plough while others carry wild flowers – or weeds – taken from the wheatfield from which they emerge. The figures, some comic, are dressed in medieval costume, and the concept has something in common with Richard Doyle's inventive borders and end-pieces for the satirical magazine *Punch*.

EXHIBITION: London, 1996, no.10

62 Charles Doyle

SELF-PORTRAIT, A MEDITATION

*c.*1885–93 · Watercolour with pen and ink, 21.6 × 52.7 cm

THE BOARD OF TRUSTEES OF THE VICTORIA AND ALBERT MUSEUM, LONDON

This introspective study was made after epilepsy and alcoholism had forced Charles Doyle's incarceration in 'Sunnyside', as he ironically named the Montrose Royal Lunatic Asylum. The theme of personally experienced visions and hallucinations is common to several Victorian fairy painters.

EXHIBITIONS: *Charles Doyle Commemorative Exhibition*, London, 1924; London, 1983, no.186

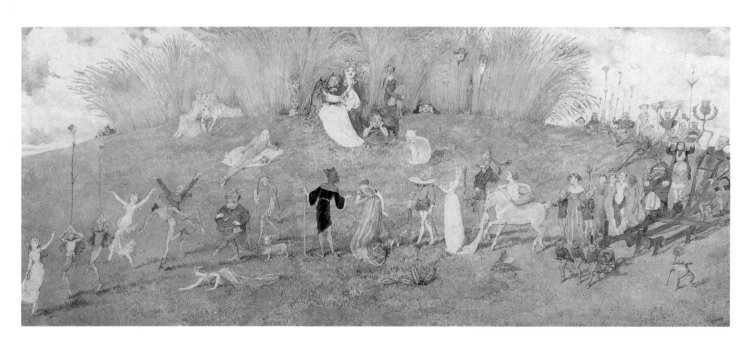

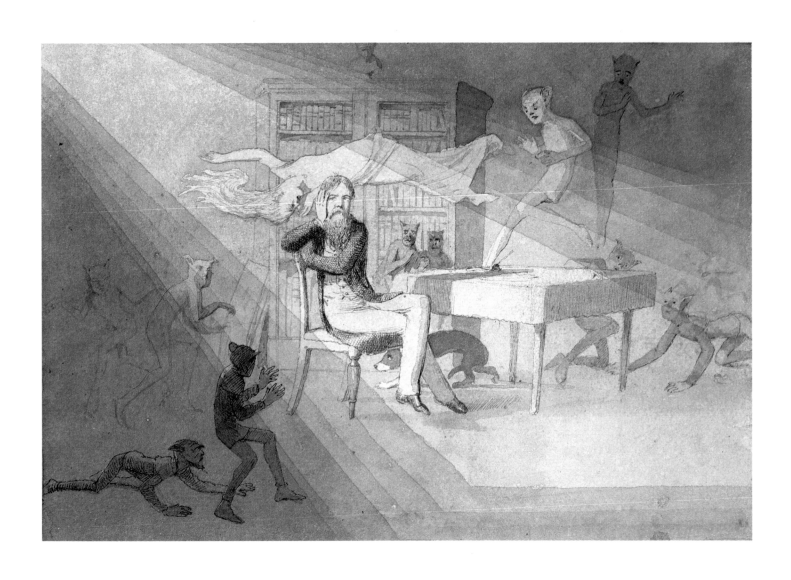

JOHN ATKINSON GRIMSHAW

BORN LEEDS, 1836; DIED LEEDS, 1893

Painter. He began to paint while working as a clerk for the Great Northern Railway. After his marriage to a cousin of T.S. Cooper he worked full time as an artist. His subjects were usually town views, dockyards or autumn lanes, or interior scenes. His early work shows a jewel-like quality in the Pre-Raphaelite vein, and his fairy paintings are products of a lifelong interest in the illusory effect of mists, reflections and half-light. Grimshaw's poetic works show virtually no brush-strokes; to achieve their atmospheric finish he experimented with sand and other ingredients which he added to oil paint and he also used photographic techniques, reproducing his images via an enlarger on to a board or canvas. Grimshaw painted mainly for private patrons and rarely exhibited, showing only five paintings at the Royal Academy between 1874 and 1886.

65 John Atkinson Grimshaw

IRIS

1886 · Oil on canvas, 81.3 × 121.9 cm
Signed and dated: *Atkinson Grimshaw 1886*; verso inscribed: *Atkinson Grimshaw / Knostrop Hall / nr Leeds / 1886*

LEEDS MUSEUMS AND GALLERIES (CITY ART GALLERY)

This was the last of Grimshaw's works to be exhibited at the Royal Academy. In the 1870s and 1880s he made a series of paintings of nude or lightly draped symbolic or supernatural figures silhouetted in a brilliant nimbus of light and hovering against a backdrop of a romantic and atmospheric wooded landscape. The first, *Dame Autumn*, dates from 1871, and the model was said to be the family's German governess. *Iris* was painted after 1878, when Mrs Rühl, the governess, returned to Germany, and the figure is that of a former actress, Miss Agnes Leefe, Grimshaw's studio assistant and model as well as companion to his wife and children. Grimshaw painted a number of versions of *Dame Autumn* and *Iris*, as well as other similar subjects, including *Diana the Huntress*, the *Spirit of Night* and a spectral *Ariadne on Naxos*. Iris, the messenger of the gods, was sent to wither flowers in autumn, but she stopped to admire the water lilies, and as a punishment was turned into a rainbow. Grimshaw's eerily lit figures reflect the interest in spiritualism and supernatural manifestations, a new departure in fairy representation. An earlier version of *Iris* was painted in 1876 (see Ferrers Gallery, London, 1964, no.5).

PROVENANCE: Walter Battle; bought from him by Leeds City Art Gallery, 1897

EXHIBITIONS: Royal Academy Summer Exhibition, 1886, no.977; Grimshaw Memorial Exhibition, Leeds City Art Gallery, 1897, no.174; Yorkshire Area Museum Service, 1970, no.3; *Early Days*, Leeds City Art Gallery, 1974, no.33; *Atkinson Grimshaw, 1836–1893*, Leeds City Art Gallery, 1979, no.63; Brighton, 1980, no.D50

REFERENCES: Phillpotts, 1978, pl.38; Alexander Robertson, *Atkinson Grimshaw*, Oxford, 1988, pp.58–9, pl.45

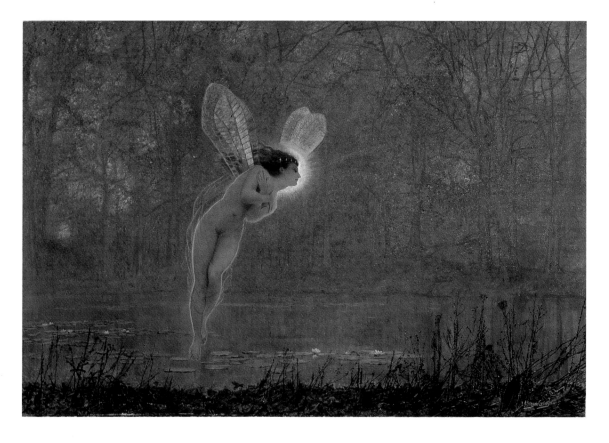

JOHN LAMB 'SECUNDUS' (JOHN LAMB THE YOUNGER)

BORN LONDON, 1839; DIED ACTON, 1904

Painter and commission agent of Muscovy Court, London. His work was exhibited from 1889 to 1909, mainly at the Dudley Gallery. Son of John Lamb 'Primus' (*q.v.*), with whom he collaborated on a panorama of a journey from London to Hong Kong, the younger John Lamb was the third generation of the family to serve the Rothschilds as a packing and shipping agent. He became neglectful of the business and nearly lost his post, but he distinguished himself in his efforts towards equipping a hospital ship sent by Queen Alexandra to the Boer War, and was rewarded with a royal gift. Two sisters, Eliza and Helen Lamb, both exhibited work in the 1870s and 1880s.

66 John Lamb 'Secundus'
'ON A BAT'S BACK'

*c.*1880 · Watercolour on paper, 61 × 91.5 cm

MRS VIOLET LUCKHAM

Here a realistically observed eastern landscape does duty for Prospero's island, with the cast of characters playing a very minor part in the composition. Ariel on a bat's back flies through the fronds of the palms. An ethereal fairy troupe dances out of the palm-grove on the right, and on the left Caliban is so indistinctly sketched that he can barely be discerned. The value of this work lies less in its depiction of fairy realms than in the light it throws on the long-standing relationship between fairy painting, theatre and other popular entertainments, in which panoramas were an important element. The Lambs, father and son, made a panorama which drew inspiration from a popular panorama illustrating the overland route to India, and it is likely that the elder Lamb would have known of the panorama of Madras made in the 1840s by William Daniel with the assistance of E.T. Parris (*q.v.*), who had made his own fairy paintings only two years before John Lamb 'Primus' exhibited his *Midsummer Night's Dream* (cat.9). The fact that both Lambs tried their hands at fairy subjects underlines the connection between an interest in exotic locations and the imagining of fairyland. It may be that Dicky Doyle took his inspiration for his 'Tempest' subject, *The Enchanted Fairy Tree* (cat.52), from a panorama such as the Lambs'.

PROVENANCE: By descent in the family of the artist

WALTER CRANE RWS RI

BORN LIVERPOOL, 1845; DIED HORSHAM, SURREY, 1915

Designer and illustrator. The son of Thomas Crane, a portrait painter, he moved to London in 1857 where he was apprenticed to W.J. Linton and studied at Heatherley's Academy. He exhibited *The Lady of Shallot* at the Royal Academy in 1862.

His art shows the influence of Botticelli and the Pre-Raphaelites. In 1879 he designed the frieze in the Arab Hall at Leighton House and in 1881 was chosen by Burne-Jones to complete the decoration of George Howard's dining-room at 1 Palace Green, Kensington, with the story of Cupid and Psyche. A poet and socialist, he became associated in the late 1880s with William Morris as well as designing his own wallpapers, books, textiles and tapestries.

Crane travelled extensively, spending several years in Italy, and in 1891 visited America. Along with that of other illustrators such as Aubrey Beardsley, his work also shows the influence of Japanese prints. His illustrations for children's books are much loved, and he should be credited with the invention of Mr Michael Mouse, a distinguished ancestor of the Walt Disney character. He was a constant exhibitor at the Grosvenor Gallery from its foundation in 1877.

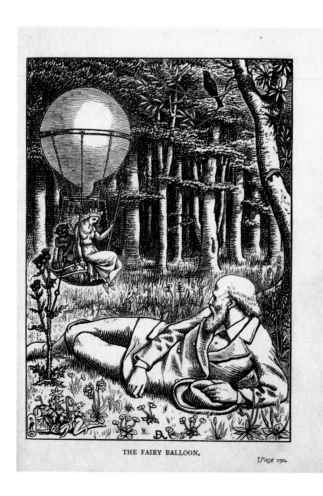

THE FAIRY BALLOON. [*Page* 190.

67 Walter Crane

KING GAB'S STORY BAG AND THE WONDERFUL STORIES IT CONTAINS

by Heraclitus Grey (pseudonym of Charles Marshall), Cassell, Petter & Galpin [1869]
Green cloth, gilt and black stamped front cover and spine, black rules to back cover, 206 pp., closed 17.1 × 13 cm; frontispiece with seven wood-engraved plates
Open to show 'The Fairy Balloon', p.190
THE BRITISH MUSEUM, LONDON (ROBIN DE BEAUMONT COLLECTION), 1992–4–6–122

This is a very rare book, which suggests that it may have been issued in a small edition. In *Illustrators of the Sixties* (1928) Forrest Reid made a rare digression from the subject of illustration to commend the text, remarking 'a good book this'. The present copy has a fine cover designed by Crane, which repeats the motif of the fairy in a balloon from the plate shown here. Crane was busy with a variety of commissions in the 1860s for topographical works and popular novels as well as for fairy subjects. He has let his fancy play with the idea of fairies and flight, uniting fantasy with modern technology by giving the fairy a balloon to travel in. His early black-and-white illustrations, with their Pre-Raphaelite delicacy, contrast with the bold colour designs that he developed for the 'Picture Books' published by Edmund Evans. Crane was anxious that his reputation should rest on his 'more ambitious' work as a painter, but he was forced to acknowledge the influence of his illustrations on children's book production as well as on fashion and interior decoration.

REFERENCES: Forrest Reid, *Illustrators of the Sixties*, London, 1928, p.233; Goldman, 1994, p.129

EDWARD ROBERT HUGHES RWS

BORN LONDON, 1851; DIED ST ALBAN'S, HERTS, 1914

A nephew of Arthur Hughes and assistant to William Holman Hunt, Hughes began his career among the Pre-Raphaelites, albeit at a late stage in the history of the movement. Like Burne-Jones, whom he knew, he inclined towards Symbolism, but his work, mainly in watercolour strengthened with gouache, displays the meticulous observation of nature and minute technique associated with Pre-Raphaelitism. His subjects were usually literary and mythological; in his rare fairy paintings he comes close to Eleanor Fortescue-Brickdale (*q.v.*).

68 E.R. Hughes

MIDSUMMER EVE

Watercolour with gouache on paper mounted on board, 114.3 × 76.2 cm
Signed: *E.R. Hughes RWS*
PRIVATE COLLECTION

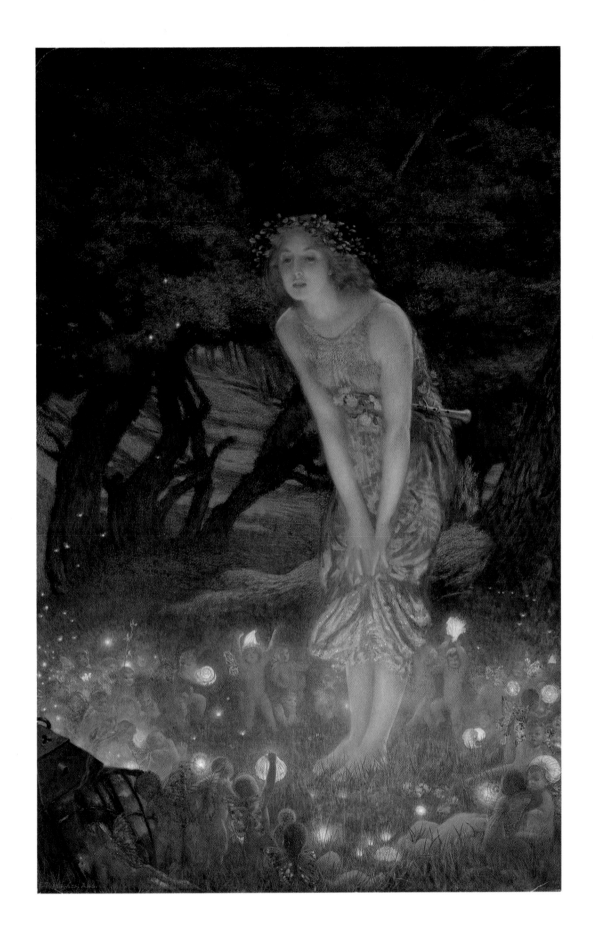

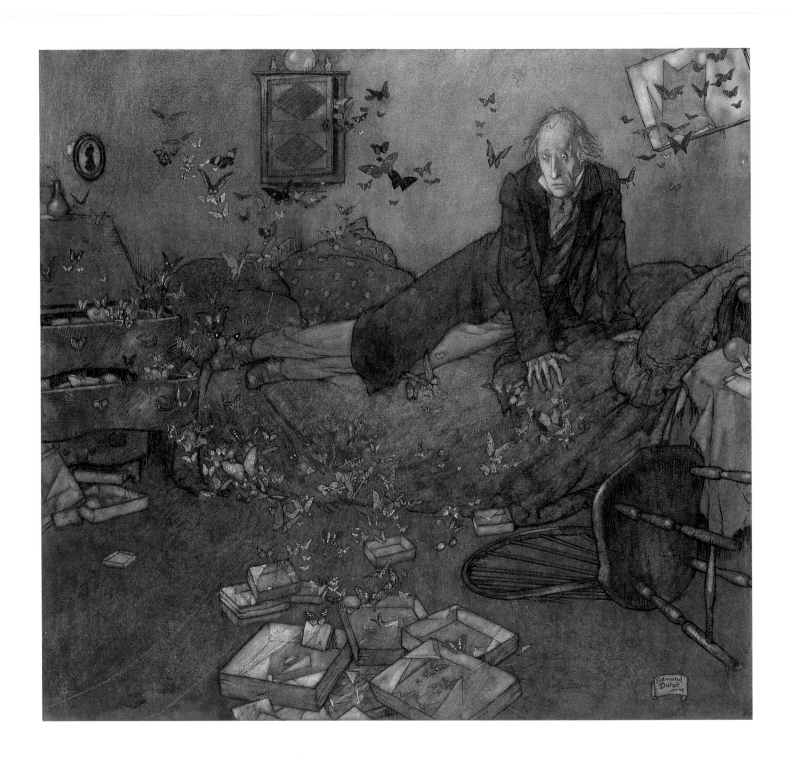

This watercolour was made to illustrate Sir Arthur Quiller Couch's *The Sleeping Beauty and other Fairy Tales*, published by Hodder & Stoughton in 1910. Dulac is frequently compared to Arthur Rackham. Both were beautiful draughtsmen, but Dulac's work is more versatile, humorous and cosmopolitan. Sometimes he seems to be looking at the work of the Scottish *fin-de-siècle* artists such as C.R. Mackintosh, the Misses Macdonald, John Duncan, David Gauld, Jessie M. King and Annie French; at other times Eric Gill or William Nicholson serve as models and later the Franco-Indian styles of Art-Deco Paris. There are few fairies with wings in Dulac's work, reinforcing the similarities with the Scottish artists, who also relied for a supernatural effect on colour and atmosphere.

EXHIBITIONS: Rhode Island, 1979, no.72; Brighton, 1980, no.D38
REFERENCE: White, 1976, pp.46–7

74 Edmund Dulac

THE ENTOMOLOGIST'S DREAM

From *Le Papillon Rouge*
1909 · Pen, ink and watercolour, 17 × 29.5 cm
THE BOARD OF TRUSTEES OF THE VICTORIA AND ALBERT MUSEUM, LONDON

This is one of three elaborately wrought illustrations for a fantasy entitled *Le Papillon Rouge* confected by Dulac in 1909 for the Christmas number of Henri Piazza's *L'Illustration*, the Parisian equivalent of *The Illustrated London News*. Although not strictly a fairy subject, this drawing makes the connection between butterflies and the butterfly-winged fairies imagined by artists from the time of William Blake in the late 18th century and parallels the butterflies that pull a fairy seated on a flower through the air in Doyle's illustration (cat.54). The cloud of butterflies escaping from their case provides a link with Fitzgerald's *The Artist's Dream* (cat.36), in which the imaginary or dead creatures seem to come alive by supernatural means.

EXHIBITION: Rhode Island, 1979, no.67
REFERENCE: White, 1976, p.41, pl.9

ESTELLA CANZIANI

BORN LONDON, 1887; DIED LONDON, 1964

Painter. She was half-Italian, her father being a Milanese civil engineer; her mother was an artist, Louisa Starr, who also painted fairy subjects. Canziani trained at the art school run by Sir Arthur Cope and Erskine Nicholl in Kensington and later at the Royal Academy Schools. She was interested in folklore and Italian peasant life and made a collection of traditional Italian goldsmiths' work which she gave to the Birmingham Museum and Art Gallery. She worked chiefly in watercolour, illustrating her own books on travel and costume, for example *Costumes, Traditions and Songs of Savoy and Piedmont*. As a child she knew the Millais and Holman Hunt families, and she lived all her life at 3 Palace Green, Kensington, London.

75 Estella Canziani

THE PIPER OF DREAMS

1914 · Watercolour heightened with bodycolour, 46.9 × 34.2 cm
Signed with a pictogram *C* in a star
Verso: label: *The Medici Society Ltd, 7 Grafton Street, Bond Street, London. W.*

CAROLINE PARKER

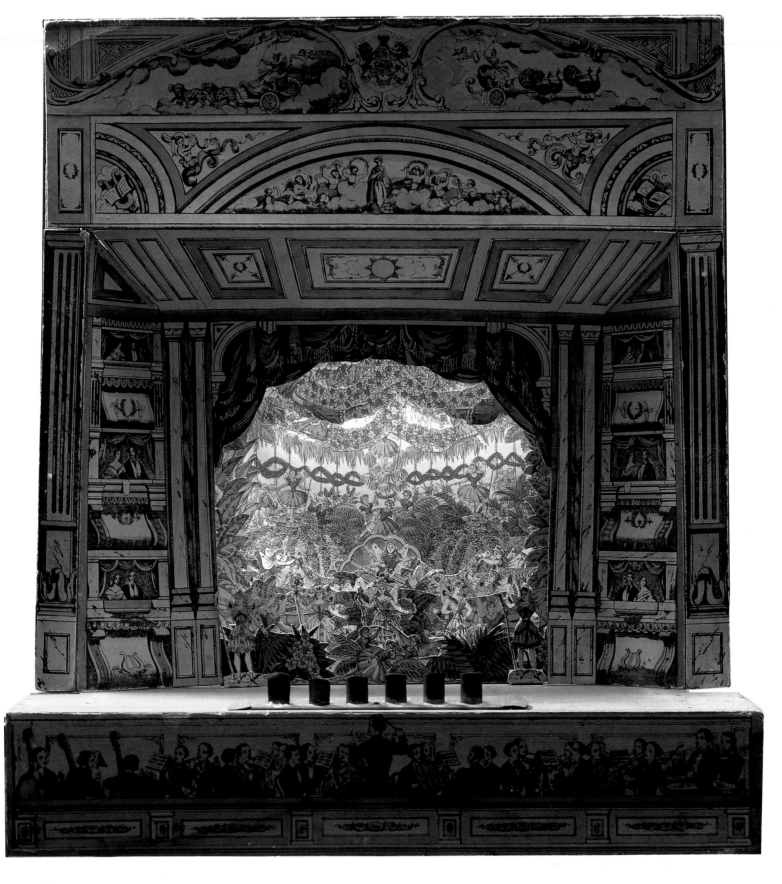

152

This painting was begun in the spring of 1914, when the artist was staying with the classical scholar Gilbert Murray. The model for the boy piper was the Murrays' son Basil (a finished study of Basil for this painting is in the Victoria and Albert Museum), and the background was the wood behind the artist's country cottage. The original title, *Where the Little Things of the Woodland Live Unseen*, was deemed by Murray to be 'above the public'. It was exhibited at the Royal Academy in 1915, where it hung prominently in the watercolour room and sold on Private View Day. Its very irrelevance may be the key to its enormous popularity. The reproduction rights were acquired by the Medici Society and it was an instant best-seller, becoming a sort of talisman for the troops in the trenches. Sales were at an unprecedented level for a reproduction: 250,000 copies were sold in the first year, and it inspired a piece for the piano with the same name by Daisy Wilson-Gunn.

PROVENANCE: Miss Elsie Mortimer, Surrey; The Medici Society, London; Maas Gallery, London

EXHIBITIONS: Royal Academy, 1915, no.947; Maas Gallery, London, 1996, no.3

REFERENCES: Estella Canziani, *Round About Three Palace Green*, London, 1939, pp.204–5, and frontispiece; Mary Clive, *The Day of Reckoning*, London, 1964, p.41 (illus.); *The Medici Society, 75th Anniversary, being a short history of the Company*, London, 1983 (illus.)

76
WEBB'S TOY THEATRE

c.1880 · Hand-coloured lithographic prints mounted on board, 59 × 52 × 52.2 cm

COURTESY OF POLLOCK'S TOY MUSEUM

The theatre, with proscenium arch, orchestra pit and tin footlights, was published and probably designed by W. Webb of 140, Old Street, London. It is fitted with the backdrop, topdrops and wings and many figures for the transformation scene (Scene IX, no.9) from *The Sleeping Beauty*, designed by James Tofts and published by Mr Pollock. The first toy theatre version of *The Sleeping Beauty*, dating from 1851, was based on Charles Green's popular pantomime produced at the Queen's Theatre, Tottenham Street, for Christmas. The hero, Prince Charming, a character now associated with *Cinderella*, was making what was possibly his earliest appearance. This version was designed for the larger toy theatre which had been developed to rival the new German model. James Tofts, the scenic artist commissioned to provide the enlarged sets *c*.1880, was encouraged to give his talents full play to achieve a thoroughly up-to-date effect.

In the 1870s the 'new' fairies with modernised costumes shown here had been introduced in pantomime. With the development of sophisticated stage machinery the transformation scene became the highlight of the pantomime, replacing the old Harlequinade, and scenic artists reserved their greatest effects for this moment. A transformation scene was added to *The Sleeping Beauty* when Green's pantomime was revived in the 1880s.

When Sergei Diaghilev, the celebrated Russian impresario, was searching for an English theme for a new ballet, Sacheverell Sitwell drew his attention to toy theatre productions. *The Triumph of Neptune*, a pantomime inspired by Victorian theatre prints with a libretto by Sitwell and music by Lord Berners, was first produced in 1926, and it is apparent that the scenery was based on Tofts's sets for *The Sleeping Beauty*.

The unchanging character of the toy theatre is indicated by the figures in the stage boxes, one couple strongly resembling Queen Victoria and Prince Albert as they appeared in the 1840s in the early years of their marriage. The influence of the theatre on fairy painting was of the greatest importance. The popular success of toy theatre and of other home entertainments such as *tableaux vivants* brought the magic of live theatre within the compass of families at home. Richard Doyle records in his *Diary* for 1840 (published in facsimile in 1885) the engrossing enterprise of staging a show in a toy theatre. Fairy painting has its own place in the panoply of phantasmagoria that blurred the distinction between reality and the supernatural, and the relationship between the toy theatre and the painted fairy scene conceived as a peepshow within its proscenium-shaped frame is apparent.

REFERENCES: Antonia Fraser, *A History of Toys*, London, 1966, p.141 (illus.); George Speaight, *A History of the Toy Theatre*, London, 1969

LIST OF ARTISTS

Henry Singleton 1766–1839

J.M.W. Turner 1775–1851

Alfred Chalon 1780–1860

William Essex c.1784–1869

George Cruikshank 1792–1878

Francis Danby 1793–1861

E.T. Parris 1793–1873

John Lamb the Elder 1798–1873

Thomas Grieve 1799–1882

R.J. Lane 1800–1872

Edwin Landseer 1802–1873

Daniel Maclise 1806–1870

David Scott 1806–1849

Theodore von Holst 1810–1844

William Bell Scott 1811–1890

Richard Dadd 1817–1886

Robert Huskisson 1819–1861

Joseph Noël Paton 1821–1901

John Anster Fitzgerald 1823–1906

John Simmons 1823–1876

Richard Doyle 1824–1883

Thomas Heatherley 1824–1913

John G. Naish 1824–1905

Charles Doyle 1832–1893

Arthur Hughes 1832–1915

Edward Coley Burne-Jones 1833–1898

John Atkinson Grimshaw 1836–1893

John Lamb the Younger 1839–1904

Walter Crane 1845–1915

Edward Robert Hughes 1851–1914

Arthur Rackham 1867–1939

Eleanor Fortescue-Brickdale 1872–1945

Thomas Maybank fl.1898–1925

Edmund Dulac 1882–1953

Estella Canziani 1887–1964

Facing page Richard Doyle, 'The Prince Enters the Wood: All light and white as a fleecy cloud / A female form floats gracefully' (detail of cat.53)

INDEX

PHOTOGRAPHIC CREDITS

All works of art are reproduced by kind permission of the owner.
Specific acknowledgements are as follows:

© Jorg P. Anders, fig.10
Beedle & Cooper, cat.39
Courtesy Mr and Mrs Carter/photo by Prudence Cuming Ass. Ltd., cat.72
Glynn Clarkson, cat.29, 31
The British Library, Colindale, fig.12, 16
Edinburgh, © National Galleries of Scotland/photographer Antonia Reeve, cat.18, 19, 32, 33
Harold Gimber, cat.42, 43, 45, 46
© Glasgow Museums, cat.35
© Hans Humm, 1994, fig.2
London, The Bridgeman Art Library, cat.6, 49; fig.33
London, © British Museum, cat.5, 24, 25, 53, 57, 63, 64, 67; fig.29
London, Christie's Images, cat.23, 36; fig.5
London, Courtauld Institute of Art; reproduced by permission of the
Chatsworth Settlement Trustees, fig.18
London, courtesy of Maas Gallery/photos by Prudence Cuming Ass. Ltd., cat.8, 30, 41
London, courtesy of Pollock's Toy Museum/photo by Prudence Cuming Ass. Ltd., cat.76
London, Prudence Cuming Ass. Ltd., cat.52, 55, 59
London, Rodney Todd-White & Son, cat.3, 15
London, © Royal Academy of Arts/photo by Prudence Cuming Ass. Ltd., cat.17; fig.35
London, © Tate Gallery, cat.1, 2, 20, 27, 28; fig.34
London, courtesy of the Trustees of the V&A, cat.4, 10, 50, 54, 62, 69, 73, 74; fig.22
London, courtesy of the Trustees of the V&A/photographer G. Brandon, cat.11
Courtesy of Mrs Violet Luckham/photo by Prudence Cuming Ass. Ltd., cat.66
Neil McAllister, cat.9
Manchester, courtesy of The Whitworth Art Gallery, University of Manchester, fig.31
Courtesy of the Raymond Mander and Joe Mitchenson Theatre Collection, fig.15, 21
New Haven, Yale Center for British Art, Paul Mellon Fund, cat.7
New York, Ali Elai, cat.68
New York, The Forbes Magazine Collection, All Rights Reserved, cat.22
New York, courtesy of Sotheby's Inc., cat.60
Princeton University Libraries, cat.56; fig.25, 26, 27
Tenterden, The National Trust, Ellen Terry Memorial Museum, fig.14
Nicholas Toyne, cat.70